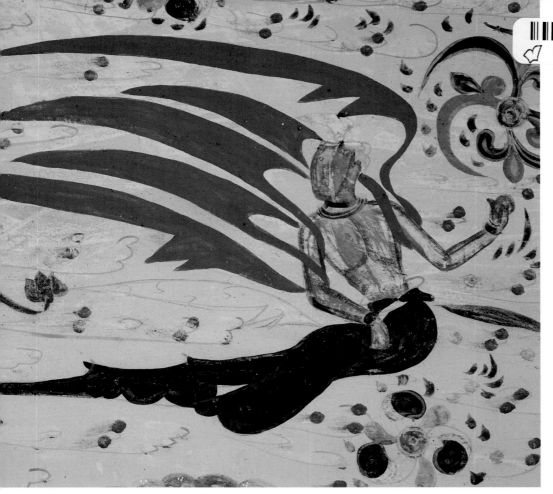

CAVE TEMPLES OF

Mogao

Art and History on the Silk Road

Roderick Whitfield

Susan Whitfield

Neville Agnew

Photography of the Mogao caves by
Lois Conner and Wu Jian

The Getty Conservation Institute
and the J. Paul Getty Museum
Los Angeles

Front cover: A king on horseback; from a mural illustrating a Buddhist parable about the laws of karma (see pp. 56–57). Cave 257, Northern Wei dynasty.
Photo by Lois Conner, 1995

Back cover: Exterior view of Cave 96; and Buddha images from Cave 390.
Photos by Dusan Stulik, 1991, and Wu Jian, 1999

Title page: An apsarasa, or flying celestial being, one of many heavenly fig-ures in the Chinese Buddhist pantheon. Cave 285, Western Wei dynasty.
Photo by Wu Jian, 1999

Contents page: Horse and rider; from an epic mural celebrating Dunhuang's liberation from Tibetan rule. Cave 156, Late Tang dynasty.
Photo by Wu Jian, 1999

Foreword: Statue grouping of a seated Buddha accompanied by bodhisattvas, with other bodhisattvas painted on the wall behind. Cave 45, High Tang dynasty.
Photo by Lois Conner, 1995

The Getty Conservation Institute works internationally to advance conservation in the visual arts. The Institute serves the conservation community through scientific research, education and training, model field projects, and the dissemination of information. The Institute is a program of the J. Paul Getty Trust, an international cultural and philanthropic institution devoted to the visual arts and the humanities.

This is the fourth volume in the Conservation and Cultural Heritage series, which aims to provide information in an accessible format about selected culturally significant sites throughout the world.

Tevvy Ball, *Project Editor*
Anita Keys, *Production Coordinator*
Vickie Sawyer Karten, *Series and Book Designer*

All photos of the Mogao cave temples by Lois Conner and Wu Jian are reproduced in this volume with the kind permission of the Dunhuang Academy.

The poem on page 24 is from The Poetry of Wang Wei, *trans. Pauline Yu (Bloomington and Indianapolis: Indiana University Press, 1980), 176-77. Used by permission.*

Printed by CS Graphics, Singapore
Separations by Professional Graphics, Rockford, Illinois

Library of Congress Cataloging-in-Publication Data

Whitfield, Roderick.
 Cave temples of Mogao : art and history on the silk road / Roderick Whitfield, Susan Whitfield, Neville Agnew ; photography of the Mogao caves by Lois Conner and Wu Jian.
 p. cm. — (Conservation and cultural heritage)
 Includes bibliographical references.
 ISBN 0-89236-585-4 (pbk.)
 1. Art, Buddhist—China—Tun-huang Caves. 2. Art, Chinese—T'ang-Five dynasties, 618–960. 3. Mural painting and decoration, Buddhist—China—Tun-huang Caves. 4. Mural painting and decoration, Chinese—China—Tun-huang Caves. 5. Tun-huang Caves (China) I. Whitfield, Susan. II. Agnew, Neville, 1938– III. Title. IV. Series.

N8193.C6 W478 2000
951'.45—dc21 00-044262

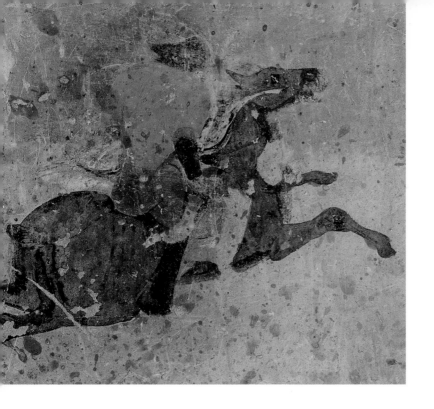

Contents

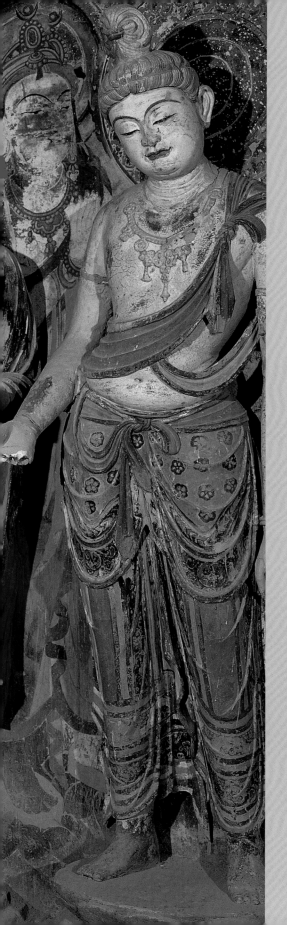

Foreword

The cave temples of Mogao, situated near the old Silk Road oasis of Dunhuang in northwestern China (and therefore also known as the Dunhuang caves), are among the world's most important sites of Buddhist art and afford an unparalleled overview of one thousand years of Chinese painting. Yet while Dunhuang and Mogao are well known in scholarly circles, their fascinating story remains relatively unknown to the broader public.

I am therefore particularly happy to write a foreword to this important publication of the J. Paul Getty Trust, which is among the first books on Mogao in English for a general audience. Here the reader will find the remarkable story of this site, the magnificent art, the ancient manuscripts, and the conservation work being done to preserve Mogao for future generations.

Since its inception in 1944, the Dunhuang Academy has focused its work on research on and conservation of Mogao and, since 1980, when Mogao was opened to the public, on presenting the site to visitors as well. In the spirit of open exchange that is the tradition of Dunhuang and Mogao throughout their long history as a mecca on the Silk Road and the gateway through which Buddhism came to the East, we have always welcomed collaboration with foreign organizations and scholars. Among these has been a long-term partnership with the Getty Conservation Institute, beginning in 1988 and continuing uninterrupted until today. It is my expectation and hope that this productive collaboration, which is based on common goals of preservation and mutual professional and personal respect, will continue well into the future. In the year 2000, the centenary of the discovery of the ancient manuscripts in the Library Cave at Mogao is being commemorated by a major international conference at Dunhuang.

Today, more than two hundred thousand visitors a year from throughout the world are making the long journey to Dunhuang and Mogao, drawn by the wonders of the art, the aura of antiquity, and the severe beauty of the desert. Our role is to welcome and inform them and to ensure that their visit is truly memorable. This book, with its fine photographs, will surely enrich their experience. As for those who may read this book elsewhere in the world, we hope that it will allow them to appreciate the beauty and vibrant history of the Mogao cave temples—and, perhaps, inspire them to come see these splendors for themselves.

Fan Jinshi
Director, Dunhuang Academy

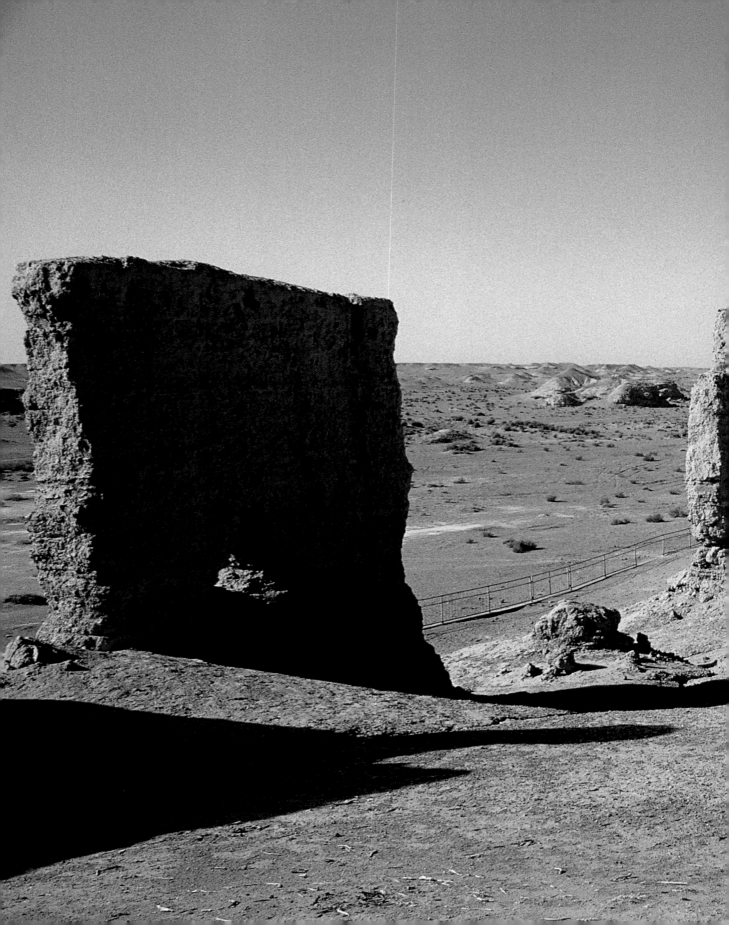

At the Desert Gateway to China

Until the late nineteenth century, the landlocked fastness of central Asia was virtually unknown to the West. A few fragmentary and often ambiguous accounts had been brought back and published by travelers, arousing in their readers a sense of the region's exotic mystery. When Europeans finally came to China, as traders, adventurers, and missionaries, it was by sea to the south and, later, to the north. The hinterland of the far northwest of China, as we know it today, or Chinese Turkestan, as it was known in the nineteenth century, kept its secrets.

Ruins of the military complex known as the Jade Gate, one of several forts guarding the Silk Road near Dunhuang.
Photo by Francesca Piqué, 1997

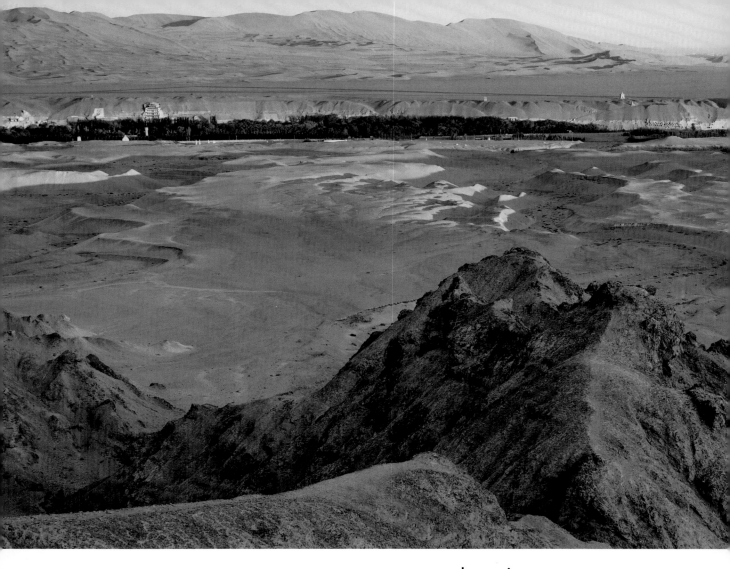

*Whenever faith exists it will not be altered
by human affairs. Those who believe deeply in
the Buddha consider it possible that when
he arrives the wind and waves will be calmed.
Thereby he will be welcomed to the Dunhuang
temples and be worshiped forever.*

Inscription in Cave 323, Tang dynasty

Imagine the immensity of the Eurasian landmass, the largest in the world, spread across one quarter of the planet's circumference, from the North Sea to the Yellow Sea. In the north of this vast region lie the steppes, the plains and plateaus of Europe and Siberia; to the south the massifs of the Himalayas, with their spurs and offshoots, plunge into the heart of central Asia. Between plain and mountain range are deserts of cruel extremes—the Ordos, the Gobi, and, worst of all, the dread Taklamakan in the Tarim Depression,

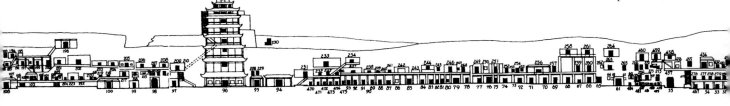

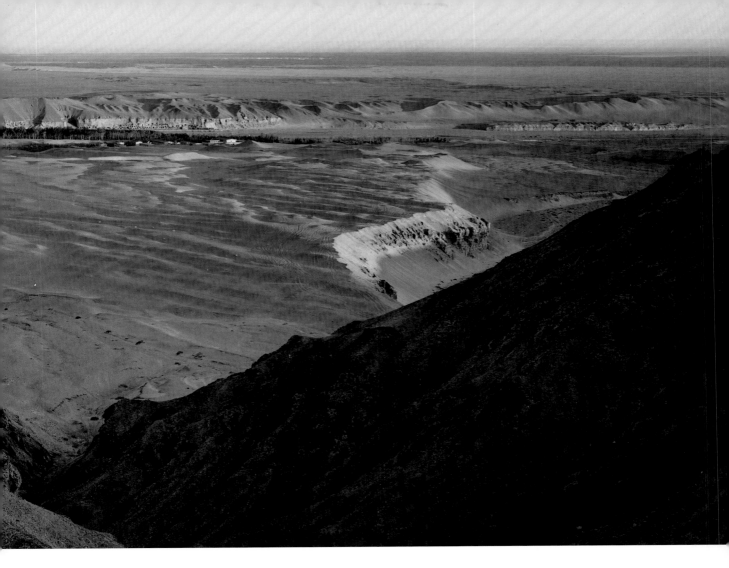

encircled by the majestic Kunlun Shan, Pamirs, and Tian Shan. Both bridge and barrier to human migrations since early peoples came this way in the diffusion that was to populate the world, central Asia has played an important role in shaping the histories of both Asia and Europe.

Our story of the ancient Buddhist cave temples of Mogao and their wonderful art, near the oasis town of Dunhuang in north-western China, is the story of this region, through which swept the Huns and, nine hundred years later, the hordes of Genghis Khan. It is also the story of the fabled Silk Road, a term coined in the nineteenth century by the German explorer Baron Ferdinand von Richthofen for the great network of trading routes that in ancient times stretched from China to the Mediterranean. It is the story, too, of Buddhism, which traveled north and east from India along the trading routes, overcoming vast distances, deserts of awesome hostility, and great snow-clad ramparts, to take root and flourish in new soil quite different from the land of its origins.

Above: The cave temples of Mogao, cut into the cliff face along the Daquan River, are surrounded by austere desert. Beyond the plateau above the cliff rise the Mingsha Shan — the Dunes of the Singing Sands.
Photo by Lois Conner, 1991. Used by permission

Below: Elevation showing most of the decorated caves at Mogao.

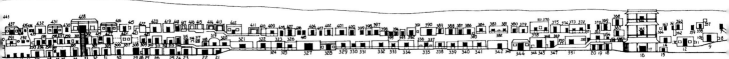

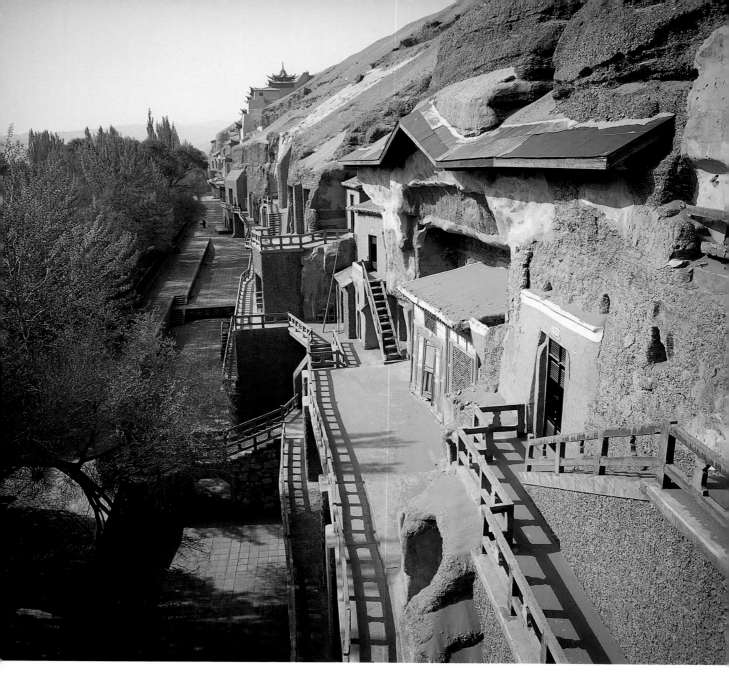

Modern exterior facade of the Mogao grottoes.

Photo by Guillermo Aldana, 1991

And, of course, it is also the story of silk. When this fabric was first discovered by the West, citizens in such cities as Rome began to covet it, spending fortunes on this and other luxury items flowing west from the Orient. The philosopher Pliny the Elder lamented the drain on the Roman economy caused by such purchases. Silk was said to be worth its weight in gold, and China was said to guard the secret of its fabrication so zealously that anyone who betrayed it risked death. In much of the ancient world, silk was a common currency, used for paying taxes, for purchasing goods, for buying slaves, and for the payment of tribute by one empire to another.

We do not know exactly when the Silk Road began. According to a recent archaeological discovery of silk in the hair of an Egyptian mummy dating to 1000 B.C.E., the trade routes may have existed much longer than previously believed. Over the millen-

nia, contacts gradually developed, first perhaps regionally, until at some point a network of caravan routes formed to connect China with the nations and tribes of central Asia, as well as with India and Persia. This network eventually brought the Roman Empire into indirect, tenuous contact with the East, specifically with the Han Empire of China and its capital Chang'an (today's Xi'an), at the height of the powers of these two great states.

By the late fourth century, Dunhuang had developed into a bustling desert crossroads, lying just before—or just after— the most arduous stages of the journey on the caravan routes linking China and the West. Traders and other travelers who undertook the perilous trek stopped at this oasis—surrounded not only by desert dunes but also by a large and fertile agricultural district—to load their camels for the long marches ahead, as well as to pray for safe passage or render thanks for their survival along the way. Three sites for Buddhist shrines would eventually develop in the Dunhuang region: the Western Qianfodong, or Western Thousand Buddha Caves, about 35 kilometers west of the town; the Yulin Caves, 170 kilometers to the east; and the first and most important site, Mogao, some 25 kilometers to the southeast, near the Mingsha Shan, or Dunes of the Singing Sands. Each of these fairly remote places had a stream with a strip of trees, a few fields, and tall cliffs suited to the cutting of meditation niches and cave temples. At Mogao, which was less than a day's journey from Dunhuang, the cliff is almost two kilometers long—large enough to accommodate the spiritual and artistic activity of more than a thousand years.

The first caves at Mogao—called in Chinese *Mogaoku*, or Peerless Caves—were dug in the late fourth century by wandering monks; the last were fashioned in the mid-

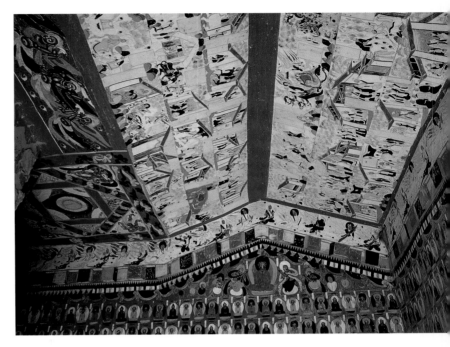

The walls of this sixth-century cave temple are adorned by the Thousand Buddha motif, symbolizing the omnipresence of Buddha-nature in the universe. The ceiling mural narrates the life of the Buddha in eighty-six scenes. Cave 290, Northern Zhou dynasty.

Photo by Wu Jian, 1999

fourteenth century under the Yuan dynasty of the Mongols. During the intervening millennium, more than one thousand caves were hewn from the cliff, and perhaps five hundred of them were decorated. The Mogao cave temples, which would also become known as Qianfodong, or Caves of the Thousand Buddhas, would blossom into one of the Silk Road's great meccas of Buddhist art and culture. One can easily imagine the impact on the believer of the time who stepped across the threshold from searing desert into a brilliantly painted vision of paradise. Within the dim interior, the flying celestial beings called *apsarasas* swoop across the walls; polychrome sculptures of the Buddha, attended by bodhisattvas and fierce temple guardians, sit at the center of the chamber; and gorgeous geometric panels adorn the ceilings. So, too, can one understand the awe of a Persian emissary to China's Ming court who came via the Silk Road in the early fifteenth century and who remarked that the Buddhist

murals were "of such character that all the painters of the world would be struck with wonder."[1]

When the Silk Road was abandoned under the Ming dynasty, oasis towns such as Dunhuang were left desolate, and for centuries Mogao was all but forgotten. Then in 1900 a cache of hidden manuscripts was discovered sealed away in one of the caves. The astonishing archive of the Library Cave, as it would come to be known, is one of the greatest treasure troves of information ever found. Sealed in the early eleventh century, it contained up to fifty thousand documents—no one is sure of the exact number. There were thousands of copies of sutras, as well as letters, contracts, poems, prayer sheets, and various official documents. Elsewhere in China the historical record had mostly been lost to warfare, fire, and the deterioration of the ages. At this isolated and remote oasis, however, the dry desert air preserved a time capsule of the medieval Chinese world.

The nearly five hundred decorated caves cut into the cliff face at Mogao, the clay sculptures they contain, and the manuscripts together constitute one of the world's most significant cultural artifacts. The art of the Dunhuang caves includes more than ten major genres, such as architecture, stucco sculptures, wall paintings, silk paintings, calligraphy, woodblock printing, embroidery, literature, music and dance, and popular entertainments. It has also yielded a remarkable richness of historical information, such as the depictions in wall paintings of ancient musical instruments that have long since disappeared but that have now been re-created for use in concerts today.

While Mogao was fortunate to have survived in such good condition, the site has not by any means been immune from damage. Over the centuries, weathering of the cliff face and the instability of the weak rock led to the collapse of entire sections of the cliff. Windblown sand from the great dunes just to the west of the grottoes drifted into many caves. Wall paintings cracked and peeled, particularly where moisture had seeped in through cracks and fissures in the cliff. Passersby lit fires in the caves, coating the paintings with soot. Refugees used some caves as living quarters following the Russian Revolution. Vandals defaced paintings and destroyed sculptures. And, like other Silk Road sites, Mogao suffered the predations of foreigners in the early years of the twentieth century, when a number of archaeologists and explorers, such as Aurel Stein and Paul Pelliot, ventured into the region and spirited away to museums in the West many of the treasures of the hidden archive.

Among the threats facing Mogao today are increased visitor numbers, as tourists from all over the world come to this remarkable place. In 1961 the State Council of the People's Republic of China listed Mogao as a nationally protected site, allowing Mogao—along with other sites long famous internationally, such as the Great Wall and the Forbidden City—to take its place among the honored treasures of the nation. When China began to open to the outside world in the 1980s, it petitioned for Mogao to be inscribed on the Unesco list of World Heritage sites, which acknowledges certain places in the world, both cultural and natural, as part of the global heritage of humankind. In 1987 Mogao joined twenty-two other Chinese sites on the World Heritage list—treasures such as the terra-cotta warriors of Xi'an; Chengde, the summer resort of the Qing emperors; Qufu, the birthplace of Confucius; and the Sacred Mountain of

Tai — all of which reflect China's commitment to the preservation of the places of its great history.

The Dunhuang Academy was established in 1944 to study and safeguard the treasures of this desert gateway to China. It focuses on scholarly research, on preservation of the site, on the study and conservation of the wall paintings, and since 1980, when Mogao was opened to visitors, on interpreting the site for the public. In 1988 the Getty Conservation Institute began discussions with the Chinese on a joint conservation project at Mogao and thus started a fruitful collaboration with the Dunhuang Academy. This project included research into causes of deterioration, introduction of new methods and materials for the conservation of wall paintings, development of innovative techniques to control sand migration, and monitoring of climate outside and inside the caves, as well as issues of site management. The partnership continues with a focus on the taxing problems of conserving the wall paintings — the single greatest challenge facing the site — using the large Tang-dynasty Cave 85 as a model.

This book is one outcome of this international cooperation. It aims to acquaint the reader with the extraordinary beauty of the caves and their art and to brush in with broad strokes the vast historical canvas of which they are a part. And, too, it hopes to convey something of the challenges and excitement inherent in the efforts to hold back the forces of destruction, so that the rock-cut temples of Mogao may continue to delight and inspire for many generations to come.

NOTES

1. K. M. Maitra, trans., *A Persian Embassy to China: Being an Extract from Zubdatu't Tawarikh of Hafiz Abru* (1934; reprint, New York: Paragon Book Reprint Corp., 1970), 39.

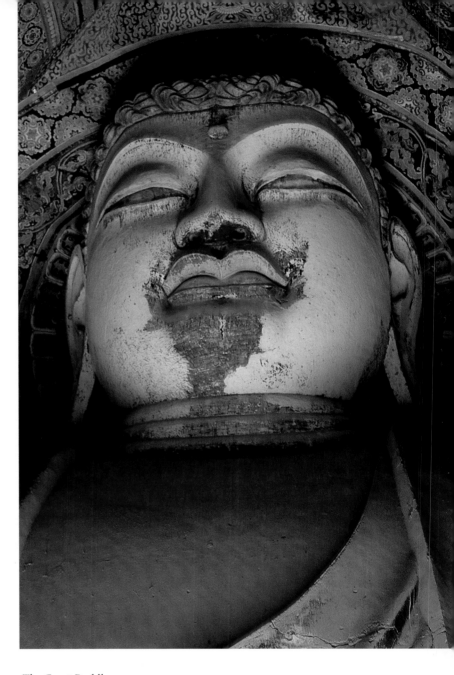

The Great Buddha in Cave 130, one of three monumental statues at Mogao, is a seated figure of the future Buddha, Maitreya, some twenty-six meters high. High Tang dynasty.

Photo by Guillermo Aldana, 1991

The Blazing Beacon

Even in remote antiquity the sand-swept height overlooking the desert river valley was known as the Wonderful Cliff or the Precipice of the Immortals. It had probably been considered a locus of spiritual power for centuries when in 366 a wandering monk named Yuezun, "resolute, calm, and of pure conduct . . . traveling the wilds with his pilgrim's staff, arrived at this mountain and had a vision of a golden radiance in the form of a thousand Buddhas. Thereupon he erected scaffolding and chiseled out the cliff to make a cave."[1]

Dunhuang was founded in defense against the nomadic Xiongnu tribe, ancestors of the Huns, who were skilled horsemen. On the Chinese frontier, an effective cavalry was the supreme weapon of war. Cave 156, Late Tang dynasty.
Photo by Wu Jian, 1999

There will be camps in desert battlefields where the beacons on our watchtowers will throw their beams in answer to the barbarians' moon.

Zu Yong, "Looking at Jimen," Tang dynasty

Yuezun and "Buddhist Master Faliang, who came from the east" and who added another cave nearby, may well have chosen the site because of its serenity. This cliff was about twenty-five kilometers from the hustle and bustle of Dunhuang town, which by the late fourth century had become an important oasis and trading center. Meditating in their high niches, with the wind sweeping off the great Dunes of the Singing Sands that rise above, they could hardly have foreseen the illustrious future of this place, and of nearby Dunhuang, over the tumultuous millennium to come.

Because Dunhuang lay on one of the great thoroughfares of antiquity, its fortunes, and those of the Mogao cave temples, would be perpetually bound up with larger historical currents, with the ebb and flow of empires and ideas across the plains, deserts, and mountains of central Asia. Their story ranges east to the capitals of the burgeoning Chinese nation; north to the Mongolian steppe, then ruled by various Turkic empires, ancestors of the people who would settle in Anatolia; south to India and Tibet; and west along the trading routes to the oasis kingdoms and beyond, to the Persian and Arab empires in Iran and Syria. This desert crossroads would absorb many such influences as it blossomed into a vibrant center of commerce and culture on the great Silk Road.

At the time Yuezun had his vision, Dunhuang was already almost five hundred years old. It had been founded as a military command in 111 B.C.E., when China, united under the Han dynasty, was expanding from its base in the Yellow River valley, almost a

Han Dynasty (202 B.C.E.–220 C.E.)

Ca. 1500 B.C.E. First known presence of Chinese silk in Bactria (present-day Afghanistan); early trade routes cross central Asia.	**174 B.C.E.** Nomads known as Xiongnu control area around future site of Dunhuang.	**139 B.C.E.** Zhang Qian sent on mission to Western Regions by Chinese emperor Wudi; Zhang spends ten years as prisoner of Xiongnu; returns in 126 with news of unknown territories to the west, spurring growth of Silk Road.	**121 B.C.E.** Chinese drive out Xiongnu, take area around Dunhuang, and start building defensive walls.

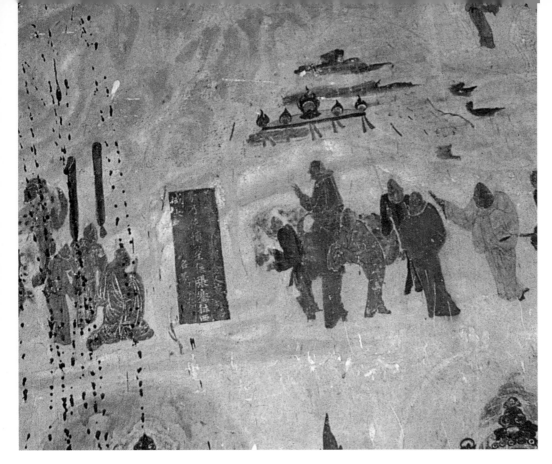

Scene from a mural showing the Chinese emperor Wudi dispatching his emissary, General Zhang Qian, to the Western Regions to seek assistance in the war against the nomads. This mission, which lasted some thirteen years, spurred the growth of the Silk Road. Cave 323, High Tang dynasty.

Photo by Seigo Otsuka. Courtesy NHK Publishing (Japan Broadcast Publishing Co., Ltd.)

thousand miles to the east. Nearby lay the westernmost stretches of the Great Wall, which at this time was built not of stone but of stamped earth and brush. The garrison defended the region against the neighboring Xiongnu—fierce nomads from the central Asian steppes whose incursions from the north had inspired the construction of the Great Wall some hundred years earlier. Probably ancestors of the Huns, these mounted bowmen would swoop down on farmsteads "like flocks of birds," kill and plunder, then vanish into the vast lands they had come from.[2] Soldiers manning watchtowers would light signal fires to warn of the approaching nomad armies—hence the name *Dunhuang*, which means "blazing beacon" and refers to the town's original function as a frontier outpost of the Chinese empire.

Exasperated by the constant raids of the Xiongnu, the Chinese emperor Wudi had sent an emissary named Zhang Qian west in 139 B.C.E. to enlist the help of other central Asian tribes. While that part of the mission failed, Zhang journeyed almost to the edge of the Greek world, returning thirteen years later bearing news of countries hitherto unknown—Bactria, Persia, Ferghana—in the lands to the west. Ferghana, he reported, was a country of vineyards and fortified cities, where Chinese silk was prized and where there were heavenly horses that sweated blood. In 104 B.C.E. Wudi mounted a military campaign. The first force sent west

III B.C.E. Dunhuang established as military outpost to guard frontier against Xiongnu.

105 B.C.E. Chinese princess sent to marry foreign ruler passes through Dunhuang on her way west.

Ca. 100 B.C.E. After initial defeat, Chinese army sets off from Dunhuang and marches far into Western Regions; Silk Road trading routes further develop.

88 B.C.E. China establishes Dunhuang Prefecture.

125 C.E. After battle with resurgent Xiongnu, Western Regions open again to China.

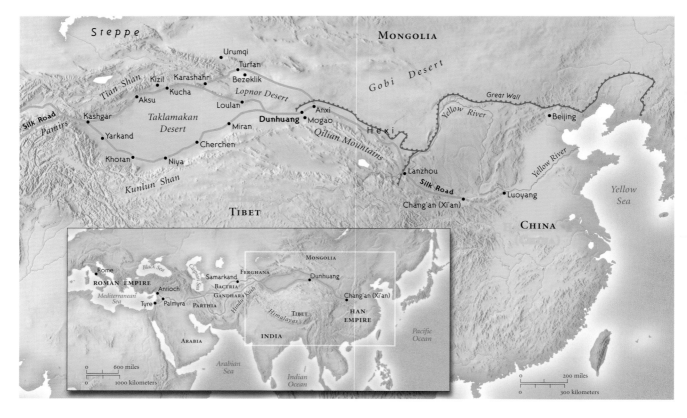

The Silk Road. As the caravan route left China, it passed through the Hexi region, west of the Yellow River, before beginning the arduous desert stages of the journey.

incurred heavy losses. After retreating to the just-established post of Dunhuang for reinforcements, the army, now sixty thousand strong, set off again.[3] It marched more than a thousand miles, conquering Ferghana and extending Chinese control far into the Western Regions.

New missions would follow, and with them came diplomacy and commerce. The network of trading routes that came to be known as the Silk Road began in the Chinese capital Chang'an. After wending west through Dunhuang, the route forked into northern and southern branches, skirting the fiercest deserts before rejoining at Kashgar to climb into the majestic Pamirs, the so-called Roof of the World.

From there, branches headed south to India and north across the Russian steppe; the main track descended across such empires as Persia and Parthia to the shores of the Mediterranean, and it continued from there by sea on to Rome. The land route covered more than four thousand miles, much of it through some of the bitterest desert on earth.

Most forbidding was the Taklamakan, known in Chinese as Liusha, the Flowing Sands. Travelers who did not die of thirst or starvation might be engulfed by shifting dunes, scoured by fearsome sandstorms called burans, or driven mad by hallucinations. Marco Polo, who claimed to have passed through the Taklamakan in the

Three Kingdoms, Western Jin, Sixteen Kingdoms (220–439)

220 End of Chinese Han dynasty brings turbulent period during which various petty kingdoms rule Dunhuang.	**336** Dunhuang passes into control of Former Liang dynasty.	**366** The monk Yuezun digs meditation cave in cliff at Mogao. The monk Faliang digs another.	**Before 385** More than ten thousand households moved from southern China to Dunhuang district.	**386** Famous Kuchean translator monk Kumarajiva probably passes through Dunhuang; in 401 he arrives to great acclaim in Chinese capital.

late 1200s, thought that it was haunted by demons. So did the famous seventh-century monk Xuanzang, who twice traversed the Taklamakan on his epic pilgrimage to India (see p. 24). The "free-flowing" sands, he wrote in his classic account of the journey, drift and disperse "with the wind. . . . There are no landmarks, [so] travelers pile up bones to mark the way. . . . Searingly hot winds" make "men and animals . . . confused and fall ill. At times one can hear soughing, or sobbing, but . . . suddenly one does not know where to turn. . . . Thus many perish. [Such] are the effects of ghosts and spirits."[4]

In such an unforgiving land, human life "could exist only . . . at the foot of the

The progress of a Silk Road caravan is used to illustrate the Lotus Sutra. The narrative reads right to left: the caravan heads up a steep incline; at the crest, a camel tumbles into the precipice; the caravan descends the mountain, with a merchant holding a donkey's tail to keep it from going over the edge; the animals drink at an oasis well; finally, the caravan is attacked by brigands

in striped robes. In the scene at the far left, the merchant has prayed to a bodhisattva, and the bandits bow in new-found piety. Over the centuries, some pigments in this painting have turned black under the influence of light and humidity; the original colors were much lighter. Cave 420, Sui dynasty.

Photo by Wu Jian, 1999

Northern Liang Dynasty (419–40)

Northern and Southern Dynasties (439–589)

400 Chinese pilgrim monk Faxian stays one month at Dunhuang on his way to India to collect Buddhist texts; notes that Dunhuang is "chief town of this frontier region."

419 Northwest regions pass to control of succession of non-Chinese rulers, starting with Northern Liang, who take control of Dunhuang in 421.

421–33 Caves 268, 272, and 275 built.

439 Dunhuang passes to control of Northern Wei dynasty (386–535), which reunites all northern China. More than twenty caves built in this period.

445 Northern Wei army passes through Dunhuang on its way to Western Regions.

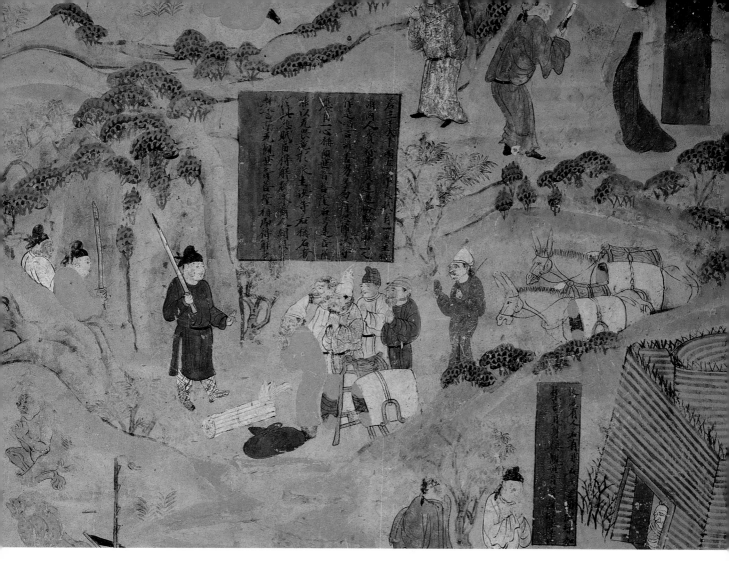

surrounding mountains, along a double rosary of cultivated oases."[5] These oases, irrigated by the glacial melt streams flowing down from the mountain ranges that ring the Taklamakan, were the key to the Silk Road's existence. Situated a few days' march from each other, they offered respite from the elements as well as from marauding nomads and bands of murderous brigands who lurked along the way. As commerce increased, these oases grew into prosperous settlements, with a few, such as Turfan and Kucha, eventually developing into important kingdoms.

Fed by the waters of the Qilian range and protected by the armies of Han China, the military post of Dunhuang blossomed into a prosperous town. It was encircled by walls and surrounded by wheat fields and fruit orchards. There were inns to accommodate travelers, stables for their horses and camels, and open-air markets crowded with goods of every sort. Government stud farms bred horses for the imperial courier

471–99 Buddhist caves cut at Yungang, near Northern Wei capital of Pingcheng (Datong). Some of the artisans may also have worked on Mogao caves.

Ca. 495 Northern Wei capital moves to Luoyang on Yellow River; Buddhist cave site started at Longmen, forty kilometers south of city.

523 Yuan Rong, member of Northern Wei imperial family, becomes governor of Dunhuang region; commissions Cave 285 and copying of Buddhist sutras.

535 Northern Wei splits into Western (535–57) and Eastern Wei (535–50). Dunhuang comes under control of Western Wei. At least twelve caves built during this period.

538–39 Cave 285 completed.

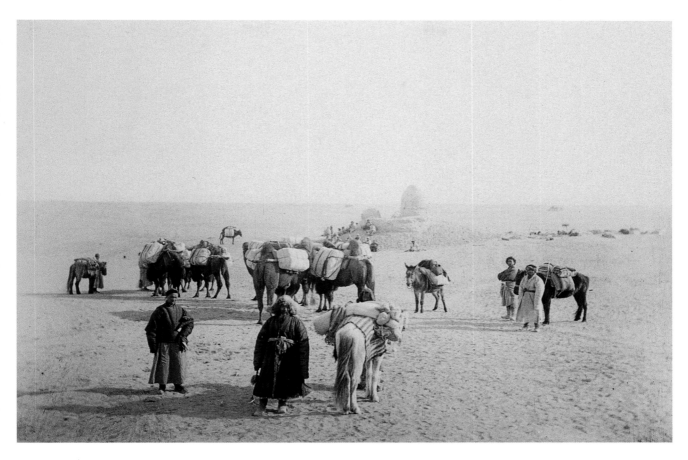

service. In the fall, roadside stalls would be piled high with fragrant melons, pomegranates, and peaches. Among the travelers thronging the streets were nomadic horse traders from the Gobi; merchants from Samarkand trading in jade from Khotan and Chinese silk; and itinerant dance troupes from India performing in the marketplaces.

Indeed, during the Silk Road's thousand-year heyday, every imaginable luxury passed through Dunhuang along the great trading network. Merchant caravans heading west from China carried silk, furs, ceramics, jade, and spices; those heading east brought linen, ivory, gems, and gold. Many other items were traded as well, from oranges and lemons to peacocks, ostriches, and the famous "blood-sweating horses" from Ferghana. Few merchants traveled the route's full length; goods were usually traded along by a succession of middlemen based in the oasis towns.

Material goods, however, were not the only commodity to travel along the trading

Merchant caravan near Miran, on the southern arm of the old Silk Road. The merchants' style of travel would have changed little since the heyday of the great desert trading routes, more than one thousand years earlier.

Photo taken in 1907. By permission of The British Library, Stein photo 392/26 (250)

Sui Dynasty (589–618)

557–81 Northern Zhou dynasty succeeds Western Wei in northern China; Dunhuang comes under its control. Cave 290 built.

565–76 Northern Zhou royal relative Prince Jianping governor of Dunhuang. Cave 428 built.

574–78 Persecution of Buddhism by Northern Zhou ruling house; a monastery in Dunhuang reportedly destroyed.

581 Sui dynasty conquers Northern Zhou, and Dunhuang transfers to its jurisdiction.

589 Sui dynasty reunites whole of China. More than eighty caves built, twenty caves restored, and lecture hall erected in this period.

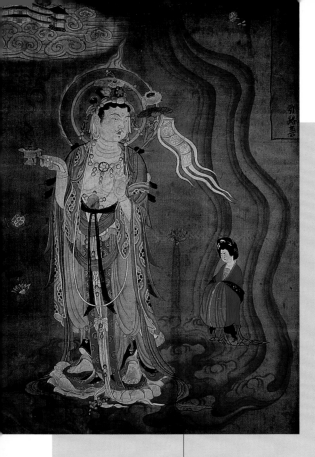

A bodhisattva leads a finely dressed lady— likely a recently deceased noblewoman—toward the Pure Lands, seen at top. This painting on silk may have adorned one of the Mogao cave temples. Late Tang dynasty.

Stein painting 47.
© Copyright The British Museum

Buddhism

Buddhism spread from northern India into China some five hundred years after the life of the historical Buddha, who was born a prince in 563 B.C.E. to the Shakya clan in the foothills of the Himalayas in present-day Nepal. He was hence known as Shakyamuni, or Sage among the Shakyas. After encountering scenes of suffering, as a young man he decided to abandon the palace and seek the truth. For six years he followed the extreme asceticism of Indian masters but then rejected this, as he had rejected his life of pleasure and privilege, turning instead to his own "Middle Way." Shakyamuni realized enlightenment while meditating under a fig tree *(Ficus religiosa)*—which has since come to be known as the *bodhi* tree, or tree of enlightenment.

The Buddha, or Awakened One, founded the *sangha* (community of monks) and began to preach the dharma — the remedy for the afflictions of disease, old age, and death. In a lifetime of teaching, he would expound the Four Noble Truths: life is suffering, suffering is caused by desire, the end of desire means the end of suffering, and the end of suffering is achieved by following the Noble Eightfold Path. Through such practices as right thinking, right conduct, and mindful meditation, it is possible to develop powers of insight and concentration and disengage from the attachments and desires that perpetuate samsara, the world of suffering. The teachings also included concepts from traditional Indian cosmology, such as karma and reincarnation, according to which each sentient creature bears a karmic debt it has accrued in past lives; this debt can be discharged by following the Middle Way, which leads to enlightenment and, eventually, to nirvana. At the First Council, held soon after his death, Shakyamuni's sermons—called sutras—were recited and given canonical status. At the Second Council, they were recited again. Some four or five hundred years later they coalesced in written form, eventually combining with new sutras, rules of monastic life, and philosophical commentaries fashioned over the centuries by monks and believers to form the massive Buddhist canon.

By the beginning of the common era, there were several movements among the adherents of Buddhism. Hinayana tradition generally required the practitioner to follow the monastic life; its ideal is represented by the arhat — the monk who has become fully enlightened and who, upon dying, will reach nirvana. Mahayana Buddhism emphasized the ideal of the compassionate bodhisattva, who has achieved enlightenment but who, for the good of humanity, chooses to forgo nirvana until all sentient beings have achieved enlightenment as well.

It was Mahayana Buddhism that predominated in China, where a number of distinct schools emerged. Ch'an (in Japanese, Zen) incorporated aspects of Daoism in emphasizing the direct, wordless experience of enlightenment. The Pure Land school emphasized the sutras, maintaining that individual effort was not enough and that believers could invoke the aid of the great bodhisattvas, who would intercede on their behalf. Mahayana also emphasized the existence of a universal Buddha nature, of which Shakyamuni, the historical Buddha, was but one manifestation. In Pure Land belief, this meant the existence of countless transcendent Buddhas, who were worshiped as deities in their own right and who reign over their own divine abodes, or Pure Lands—described by the sutras as blissful places adorned by flowers, fine fragrances, and song. Many of the Mogao cave temples represent these transcendent Buddha worlds.

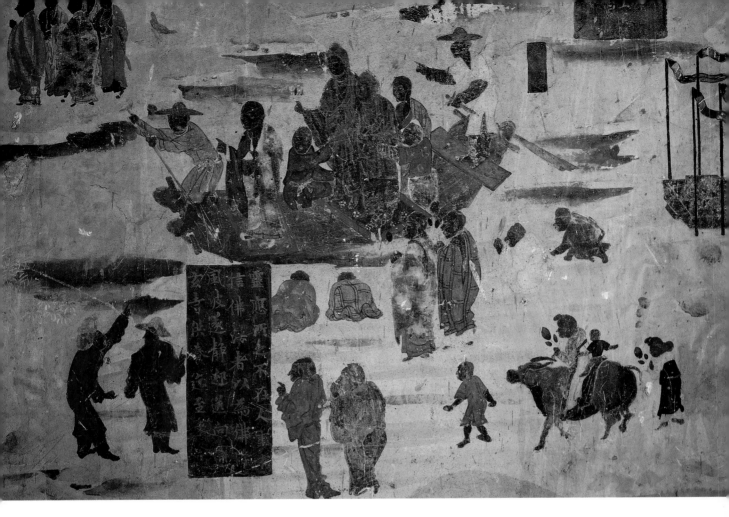

routes: ideas, artistic styles, and religious beliefs were also exchanged between one civilization and another. Indian and Greek influences made their way into central Asian and Chinese art. Nestorian Christians, Manichaeans, Jews, and Zoroastrians carried their religions from western Asia to the kingdoms of the Silk Road. And Buddhism was borne by a steady stream of monks and missionaries north from its birthplace in India, east with the caravans, through the desert portal of Dunhuang, and so into China.

Buddhism's arrival in China has over the centuries been recounted in various leg-ends. According to one of the most vener-ated versions, a radiant figure appeared in a dream of the first-century Han emperor Mingdi. When consulted the next morning, his advisers decided that this mysterious apparition must have been the Buddha, founder of a religion they had heard of in the Western Regions, who had attained sal-vation and whose golden body was able to fly. The emperor's envoys, sent to learn of this sage's teachings, returned bearing copies of the Buddhist scriptures.

Whatever the original inspiration, important Buddhist civilizations developed in a number of Silk Road kingdoms, and by

Two Buddha statues on a boat are welcomed by their followers, who "believe that the Buddhas could abate the wind so that the waves would become calm." In the tumul-tuous period following the collapse of the Han dynasty, the mural suggests, Bud-dhism offered spiritual solace that Daoism and other religions could not provide. Cave 323, High Tang dynasty.

Photo by Lois Conner, 1995

590 Indian monk Dharmagupta passes through Dunhuang on his way to capital, where he translates Buddhist texts.

ca. 600 Founding of Central Tibetan Kingdom.

601 Sui emperor sends monks carrying incense and sacred relics to thirty pre-fectures of empire, including Dunhuang.

609 Sui emperor makes western tour; envoys from twenty-seven western Asian kingdoms pass through Dunhuang on their way to imperial audience at Zhangye.

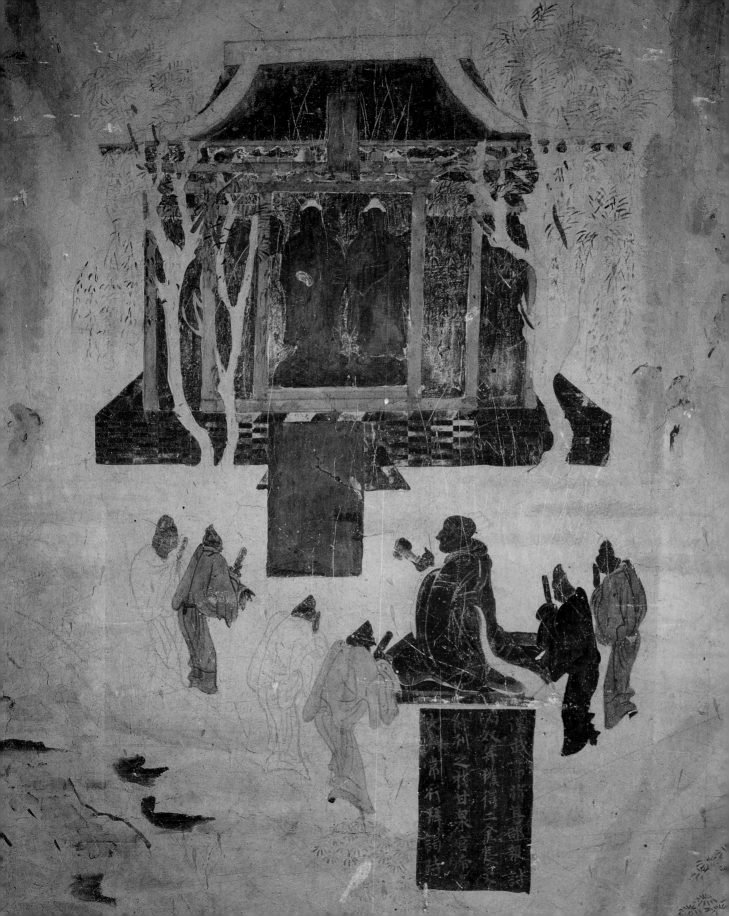

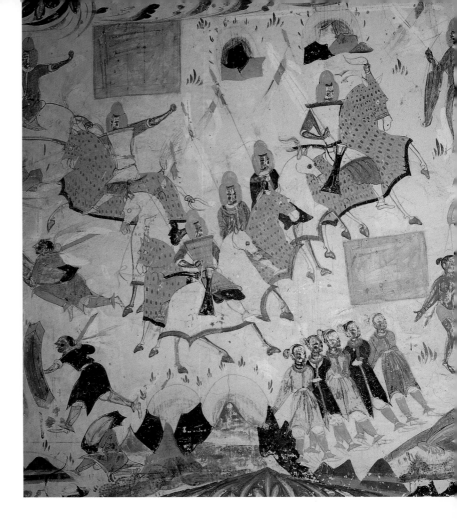

the first centuries C.E., the new religion had begun to make inroads into China as well. China's fragmentation following the collapse of the Han dynasty in 220 ushered in a 350-year period of warfare and strife known as the Age of Division. The northwest became a battleground of rival warlords, several of whom would briefly rule Dunhuang. As popular faith in the traditional Confucian social and political order declined, the teachings of the Buddha, with their emphasis on detachment from worldly experience and on the transcendent bliss of nirvana, offered relief from the abundant sorrows of daily life.

In the mid-fifth century, the small kingdoms of the north were succeeded by Turkic nomads, called the Toba, who unified northern China and established the Northern Wei dynasty, which soon brought the Silk Road oases under their control. While the Northern Wei emperors absorbed much of traditional Chinese culture, they also converted to Buddhism and played an important role in establishing the religion in the land they now ruled. Following the lead of the imperial court, powerful families and the educated classes embraced the new religion. Common people, meanwhile, sought solace in the many deities of the Chinese Buddhist pantheon. Chinese Buddhism developed a remarkable range of beliefs and practices, from the austerities of monastic life to the pageantry of popular ceremony, from a philosophy of scholar monks to a religion of universal salvation.

New caves were opened at Mogao from the late fourth century. While those of Yuezun and other early monks had been

Opposite: Many Mogao murals, painted centuries after the events they depict, combined legend and historical fact. Here the Chinese emperor Wudi, during whose reign Dunhuang was founded, kneels in homage to two Buddha statues. They are identified as "golden men"

obtained in 120 B.C.E. by a great Han general during his campaigns against the nomads. While there may have been some contact with Buddhism during Wudi's reign, he never worshiped the Buddha. Cave 323, High Tang dynasty.

Photo by Lois Conner, 1995

Above: Following the fall of the Han dynasty in 220, northwestern China was plagued by warfare. Here, soldiers do battle, arrayed in the kind of armor worn in medieval China. Their prisoners stand in line. Cave 285, Western Wei dynasty.

Photo by Lois Conner, 1995

Tang Dynasty (618–907)

618 Tang dynasty established in China, beginning period of great flowering of art and poetry and imperial expansion of Chinese empire. Dunhuang comes under Tang control in 619. Over one hundred caves built in first half of Tang dynasty.

629 Chinese monk Xuanzang sets out on journey to collect Buddhist texts in India; returns in 644; welcomed back into China at Dunhuang.

642 Completion of Cave 220, commissioned by Cui family; first influence of Tang art at Mogao.

695 Cave 96 commissioned by Empress Wu, China's only female ruler, and soon built, with colossal Northern Great Buddha statue thirty-three meters high.

698 Cave 332 built by Li family; now several hundred caves and niches in Mogao cliff face.

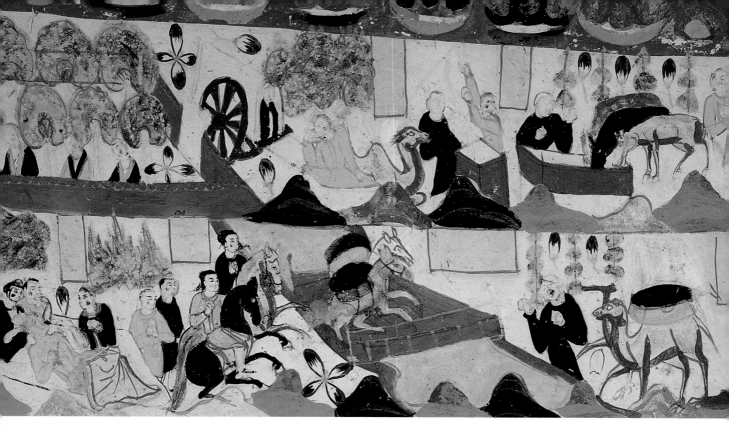

This narrative sequence in two registers shows a caravan being accommodated at an oasis way station. Providing facilities such as wells and bridges was a way for believers to gain merit. Cave 296, Northern Zhou dynasty.

Photo by Lois Conner, 1995

intended as meditation cells, the grottoes soon began to fulfill other functions as well. The original fellowship of monks developed into an important monastery and religious mecca. Travelers who had survived the Silk Road stopped to give thanks, while those about to head west across the great deserts prayed for protection against the trip's many dangers. Other visitors would come to worship or to meditate; to accrue karmic merit by sponsoring a cave, a devotional painting, or the copying of a sacred text; or to make offerings such as gems or silk.

The shrines had secular functions, too. The construction of a large cave was well beyond the means of most individuals, but local merchants, hoping to ensure the success of their trading missions, banded together to sponsor caves. The grandest

temples were funded by important clergy and by the governors of Dunhuang, including two related to the Wei ruling house. Prominent local families, women's groups, military officers, foreign dignitaries — even the rulers of neighboring Silk Road kingdoms—all served as donors. In this way the Mogao grottoes became central to the life of the entire region. Over the course of a millennium, as many as one thousand caves would be hollowed out of the cliff. At least five hundred were decorated and used as temple shrines. Others were used as living quarters for monks.

After more than three centuries of division, China was reunified when successors of the Northern Wei conquered the country and established the Sui dynasty, with its capital at the old Han capital of Chang'an, in 581. The new regime officially

707 Buddhist and Daoist temples established in every prefecture by imperial command, including Longxing Temple at Dunhuang.

747 Confederation of Turkic Uighur tribes form united kingdom on Mongolian steppe.

750 Territories of Arab caliphate reach as far east as Samarkand; Arab capital moved east from Damascus to Baghdad.

751 Chinese army defeated by Arab forces at Talas River, in what is today Kirghizistan, marking end of Tang empire's expansion.

755 Rebellion and civil war break out in China; Chinese troops withdrawn from western garrisons.

760s Tibetan army marches north into trading routes, conquering many Silk Road towns.

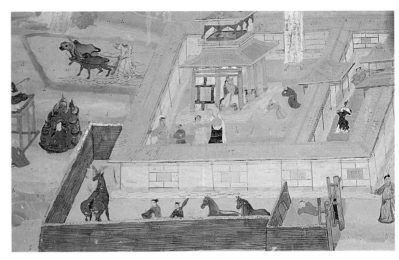

The murals at Mogao are rich in the details of daily life. This domestic scene shows horses being stabled. Cave 85, Late Tang dynasty.

Photo by Neville Agnew, 1998

sanctioned Buddhism, increasing the link between Mogao and metropolitan China. Soon after the dynasty's founding, for example, an imperial envoy arrived at Mogao from the capital to commission the construction of a new cave.

The Sui dynasty was short lived, but the unity it brought to China lasted, ushering in the Tang dynasty—the golden age of Chinese civilization—which would reach its summit during the High Tang period of the late seventh and early eighth century. Chang'an blossomed into the world's most cosmopolitan city. Its one million inhabitants included eighty thousand foreigners, who were drawn there by its tolerance, thriving markets, and flourishing cultural life. Foreign amusements such as polo fascinated the wealthy, who also consumed myriad luxuries imported on the Silk Road.

The emperor's court gathered the famous painters of the age and set the trend for the rest of China. The empire achieved its greatest reach, with garrisons established west across the Taklamakan as far away as Kucha, Khotan, and Kashgar.

Once more under the protection of the greatest empire on earth, Dunhuang enjoyed peace and considerable prosperity. Commerce was complemented by agriculture, with thousands of farmers working government land in an arrangement known as the equal field system. Dunhuang's sixteen Buddhist monasteries, granted tax privileges from the Chinese government, ranged from small communities of perhaps a dozen monks to large institutions with over one hundred monks and nuns. A few possessed hundreds of acres, worked by families of serfs—masons, shepherds,

781–848 Tibetan troops capture Dunhuang in about 781, beginning period of Tibetan rule, which lasts almost seventy years; over fifty caves built during this time.

840 Breakup of Uighur empire in Mongolia; many Uighurs move south to Silk Road oases, establishing bases at Turfan and elsewhere.

842 Breakup of first Tibetan empire.

848 Local general Zhang Yichao drives Tibetans out of Dunhuang; Zhang family will pay allegiance to China but rule Dunhuang quasi-autonomously until about 920. Over seventy caves built during this period.

851–62 Local monk Hongbian named abbot of Hexi (region west of Yellow River); builds Caves 16 and 17.

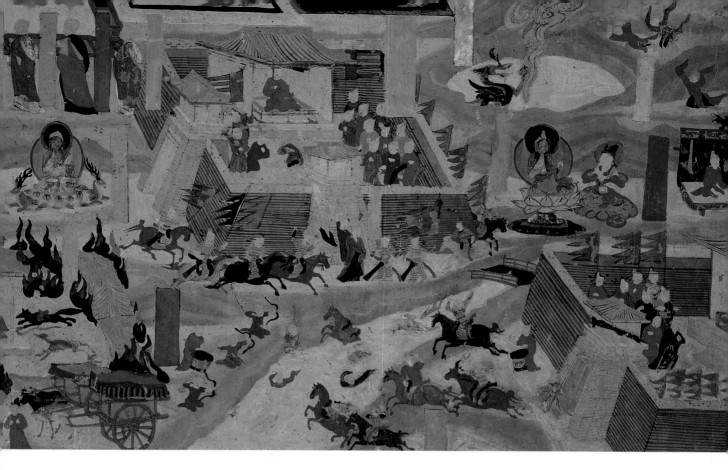

camel herders. Monasteries filled various social functions, such as hosting women's clubs. As elsewhere in China, they were also centers of scholarship and learning. Several housed important libraries.

Mogao itself, twenty-five kilometers across the desert from the thriving entrepôt of Dunhuang, had emerged as one of the great centers of Buddhist culture. Buddhist masters from India and central Asia, passing through on their way to Chang'an, would stop to meditate in the famous painted caves or to consult the manuscripts in the monastery libraries. Elaborate devotional ceremonies reflected the pageantry and popular appeal of Chinese Mahayana Buddhism. In the annual June festival, for example, people

from throughout the region made the pilgrimage to the temples for several days of ceremony; silk banners adorned the cliff face, and the fragrance of incense wafted through the desert air. Visitors might also meditate, seeking rebirth in the Pure Lands and other divine abodes—way stations on the path to nirvana—depicted in countless murals. The grottoes' decorated walls evoked the sights, sounds, and fragrances of these Buddha worlds.

The exuberance and ambition of Tang culture, which permeated the entire empire, are clearly evident at Mogao. The shrines of this period are often sumptuously decorated. Mahayana Buddhist themes predominate, reflecting the growing importance of Buddhism in Chinese

Five Dynasties (907–60)

862 Cave 85 commissioned by Zhai Farong, head of powerful Dunhuang family; completed some five years later.

By 865 Cave 156 built, showing scenes of General Zhang defeating Tibetans; annals of Mogao inscribed on north wall of the antechamber.

907 Fall of Chinese Tang dynasty; Liang dynasty briefly takes over northern China. News of change will not reach Dunhuang for several years.

910 Dunhuang's ruler Zhang Huaifeng learns of fall of Tang dynasty and establishes Kingdom of the Golden Mountain, incorporating Dunhuang and neighboring region.

Ca. 920 Cao Yijin becomes ruler of Dunhuang, commissions Cave 98. Cao family rules Dunhuang for more than a century, during which twenty-six caves built and nearly three hundred refurbished.

life and institutions. During the Tang dynasty, Chinese emperors also sponsored a number of works at Mogao, including two colossal Buddha statues.

Mogao was by now a showcase for imperial China, and certain Tang murals betray an epic, even militarist, sweep more in keeping with the imperatives of the bustling Chinese nation than with the gentle Buddhist search for nirvana. Chinese control over its vast domains remained tenuous, however, as China was coming into conflict with three other empires bordering the Taklamakan. To the west, Islamic armies of the Arab caliphate, whose capital had been moved east from Damascus to Baghdad, had nearly reached the Pamir Mountains. To the north, where the troublesome Xiongnu had roamed centuries before, the peerless horsemen of the Turkic peoples kept sweeping across the Gobi from the Mongolian steppe. And to the south stood the recently formed Tibetan empire, with its powerful military, casting a covetous eye on the profitable Silk Road oases. Chinese armies, often supplied from Dunhuang, ranged across central Asia in bloody wars of attrition. In 751 Arab forces defeated the Chinese at Talas River, northeast of Samarkand, marking the territorial limits of both empires.

An even worse calamity followed, bringing the loss of many of the empire's possessions and the end in Dunhuang of this period of peace. In 755 the general An Lushan led a rebellion that plunged China into civil war. When the emperor recalled his troops from the western garrisons,

Ninth-century drawing of a monastery, probably at Mogao, during the period of the Tibetan occupation of Dunhuang. Pelliot Tibétain 993.

Courtesy Bibliothèque nationale de France, Paris

Song Dynasty (960–1276)

947–51 Cao Yuanzhong commissions Cave 61.

960 Song dynasty established in China; Dunhuang, ruled by Cao clan, now far outside Chinese borders.

964 Khotan royal family visits Dunhuang to worship Buddha and dedicate copy of Lotus Sutra.

966 Cao Yuanzhong and his wife restore colossal Buddha statue in Cave 96.

1006 Arab armies hostile to Buddhism take city-state of Khotan, an ally of Dunhuang.

Ca. 1010 At Mogao, thousands of manuscripts, most of them Buddhist texts, sealed away in secret chamber next to Cave 16.

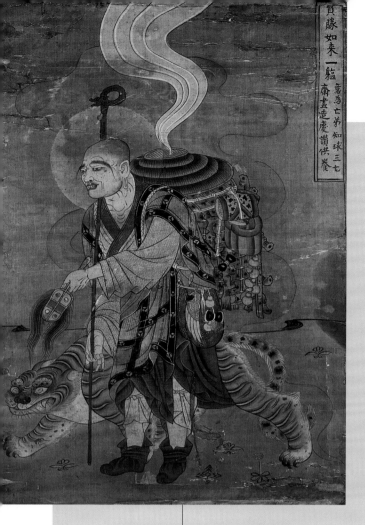

負䑛如来一軀
意為亡弟知球三七
齋畫造慶讚供養

The figure of the pilgrim monk seems to have become a holy image in its own right. This painting on silk depicts a monk carrying a load of scrolls in the basket on his back. Northern Song dynasty.

From Cave 17, Mogao. Musée des arts asiatiques-Guimet, Paris. © Photo RMN-Ravaux

*In Wei City morning rain
dampens the light dust.
By the travelers' lodge, green upon
green—the willows' color is new.
I urge you to drink up yet
another glass of wine:
Going west from Yang Pass, there
are no old friends.*

Wang Wei (699–759)

Journey of a Silk Road Pilgrim

Over the centuries, hundreds of Chinese Buddhist monks traveled to India, exploring the genesis of their philosophy and their faith. Perhaps the most celebrated journey took place during the early Tang dynasty, when the monk Xuanzang, a brilliant linguist and philosopher who was dissatisfied with Chinese Buddhist texts and desired to study the original Sanskrit scriptures, set off on a remarkable sixteen-year expedition. It would take him from the Chinese capital to India and back again, across the great civilizations of the Silk Road.

In spite of being forbidden to leave by the Tang emperor Taizong, the monk left China in 629, heading along the northern arm of the Silk Road. He stopped in the oasis of Turfan, then continued through the Buddhist stronghold of Kucha, one of the most important kingdoms in central Asia, and on up into the Tian Shan. Here, he wrote, great glaciers "rise mingling with the clouds," and a third of his horses and men died crossing the perilous passes.

Arriving in Tokmak, he became friendly with the Great Khan of the Western Turks, a powerful nomadic ruler whom the Chinese had finally expelled from their own frontier and who controlled much of central Asia. The Great Khan now enjoyed good relations with China; three years earlier, he had offered the Tang emperor a gift of a jewel-studded gold belt and five thousand horses. After passing along gifts from the king of Turfan, Xuanzang was feted in the khan's yurt. The khan was adorned in green satin; his elite guard of two hundred officers, who sat on mats in two long rows, were "clad in shining garments of embroidered silk."[6] Following a feast of mutton, wine, mare's milk, rice cakes, and honey (the first two of which the monk couldn't eat because of his faith), Xuanzang regaled the diners with a presentation of Buddhist doctrine.

Xuanzang's journey took him next to Samarkand, then south to Balkh, where Alexander the Great had headquartered nine centuries before, and on to Bamiyan, where colossal statues of the Buddha—one over fifty meters high—were carved into a cliff face. Then it was up through the Hindu Kush Mountains and afterward south toward India. The monk's party was assailed by bandits, whom he is said to have disarmed through his fearless piety. Soon he entered Peshawar, the former capital of Gandhara, second only to northern India as a realm of Buddhist worship. Finally, after more than a year of arduous travel, he crossed the Ganges into the Buddhist holy land,

where he would spend a decade in study and debate.

When he embarked on his return journey to China, Xuanzang carried 657 scrolls in Sanskrit and Pali, as well as relics and Buddhist images. The trip home proved adventurous as well, as bandits once again plagued the monk's small party. Upon reaching the oasis of Khotan on the southern Silk Road, Xuanzang wrote to inform the Chinese emperor that he was returning a loyal subject. Taizong instructed officials to welcome him back into China at Dunhuang. There the monk rested and visited the Mogao caves, which soon would commemorate him and his journey.

When Xuanzang finally arrived in the capital of Chang'an, thousands thronged the streets to welcome him home. In his honor, Taizong established a translation center, where Xuanzang spent the last twenty years of his life translating the precious texts he had carried from India — many copies of which would find their way to Dunhuang. Even now, many of his translations are considered standard throughout Asia. Xuanzang's exploits, meanwhile, soon passed into the realm of myth. The various legends about this "second Buddha" would eventually coalesce into an epic novel called *The Journey to the West*, one of the classics of Chinese popular literature.

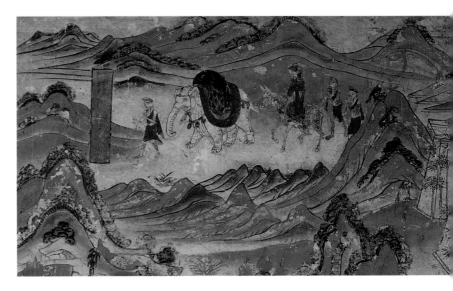

Tibet sent armies north into the trading routes it had long coveted. Tibet conquered many Silk Road towns and struck deep into China, even briefly occupying Chang'an in 763. Tibetan armies soon controlled the region around Dunhuang, whose governor appealed to the Uighurs, a Turkic people based on the Mongolian steppe, hoping that their swift cavalry might offset the Tibetans' relentless infantry. The Uighurs failed to arrive, and after a ten-year siege, Dunhuang fell in about 781.[7]

In many respects the Tibetan occupation, which lasted almost seventy years, proved providential: it protected Mogao from the anti-Buddhist and antiforeign suppressions of the fervently Daoist emperor who acceded to the Chinese throne in 841. Buddhism in China suffered greatly: monasteries reverted to lay use, nuns and priests were forced to rejoin the world, and Buddha statues were melted down to make coins. Yet the construction of new caves continued at Mogao, with many featuring Tibetan Buddhist symbolism.

The inhabitants of Dunhuang, however, repeatedly rebelled against Tibetan

This mural commemorates Xuanzang's journey to India in search of Buddhist scriptures. He is shown traversing the Pamirs on his return trip; the white elephant was a gift from an Indian king. When the caravan was attacked by bandits, the elephant stampeded into a river and drowned. Cave 103, High Tang dynasty.
Photo by Wu Jian, 1999

This panoramic mural commemorates the victory of Zhang Yichao, the Dunhuang-born general who drove the Tibetan occupiers out of Dunhuang in 848. Horsemen, guards, musicians, and others celebrate the victory. This moment marked a transition in the fortunes of Dunhuang, since Zhang went on to rule the region as a quasi-autonomous state. Cave 156, Late Tang dynasty.

Photo by Wu Jian, 1999

rule.[8] In 848 a local general named Zhang Yichao chased the Tibetans from his town, as well as from most other oases along the eastern Silk Road, a victory commemorated in an epic mural at Mogao. Although China gratefully awarded him the title Commander General of the Return to Allegiance Army and although he maintained relations with Chang'an, Zhang and his descendants also strengthened Dunhuang's independence; in effect, from this time onward, Dunhuang was quasi-autonomous. The Chinese capital, still beset by rebellion and unrest, now paid little attention to the western outposts, which had become vestiges of a once-great empire.

In the centuries following the fall of the Tang dynasty in 907, the various rulers of Dunhuang vied with other regional powers to preserve their autonomy. Cao Yijin, from another local family, succeeded the Zhangs in about 920. The Cao clan would govern Dunhuang for five generations. Sincere Buddhists, they also used the religion—and the art of the Mogao cave temples—to solidify their regime, commissioning new shrines to publicize their

political alliances. The House of Cao consolidated its power by marriage pacts with the Uighurs, who had lost their empire on the Mongolian steppe and settled along the northern Silk Road and who would play an increasingly important role in Dunhuang's affairs. Cao rulers also formed alliances with such kingdoms as Khotan, whose royal family visited Dunhuang and became patrons of the Mogao caves, where they are depicted in large murals. Dunhuang's state-sponsored Buddhist culture was more important than ever; of the town's twenty thousand inhabitants, more than one thousand were monks and nuns.[9]

Then, in 1006, Islamic forces conquered Dunhuang's ally Khotan. Shortly afterward, monks at Mogao sealed away thousands of Buddhist manuscripts in one of the caves; perhaps they were alarmed by distant rumblings of new invaders, hostile to Buddhism, from far across the Taklamakan.

When the Song dynasty was established in China, Dunhuang lay well outside Chinese borders. By 1072 the town had come under the control of the Tanguts,

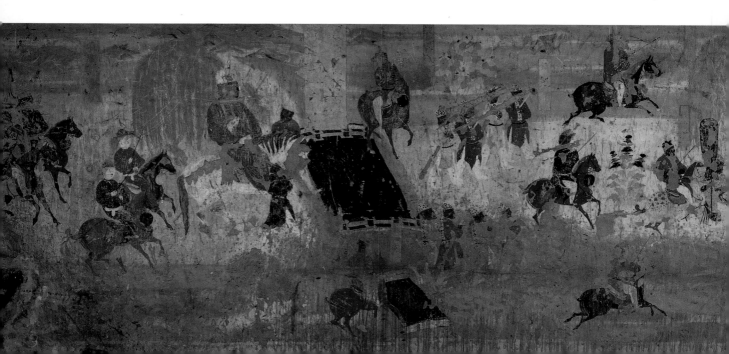

who earlier in the century had established the Western Xia dynasty, based not far from Dunhuang in northern Gansu. For more than one hundred years, the Western Xia maintained an advantageous position in their relations with the Chinese Song, as well as with Tibet, to the south, and other empires to the north and west. Some eighty caves were built or redecorated at Mogao in a distinctive style that reflected the Western Xia preference for Tibetan Tantric Buddhism.

Finally, in the third month of the year 1227, the residents of Dunhuang experienced perhaps the most definitive invasion of all, when the cavalry of Genghis Khan, consolidating his conquest of northern China about a decade earlier, swept down from the Mongolian steppe. Mongol armies wiped out the Western Xia empire and sacked and destroyed Dunhuang. They would go on to conquer all of China and form the largest empire that the world had ever seen.

Under the Mongols, new works continued at Mogao until at least 1357. The Yuan dynasty caves, in part because Tibetan

*Last year we fought at the source of
 the Sangkan,
This year, along riverbeds in the Pamirs;
We have washed our swords in the surf
 of Parthian seas,
And pastured our horses among the snows
 of the Tian Shan. . . .
Our armies are old and gray . . .
The House of Han lit the beacons of war,
And still the beacons blaze.*

Li Bo, "Fighting South of the City," Tang dynasty

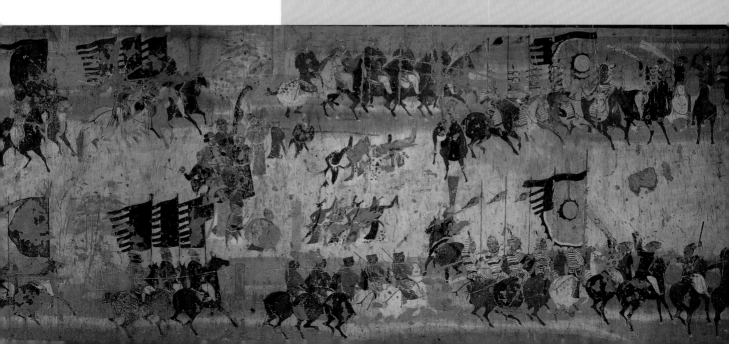

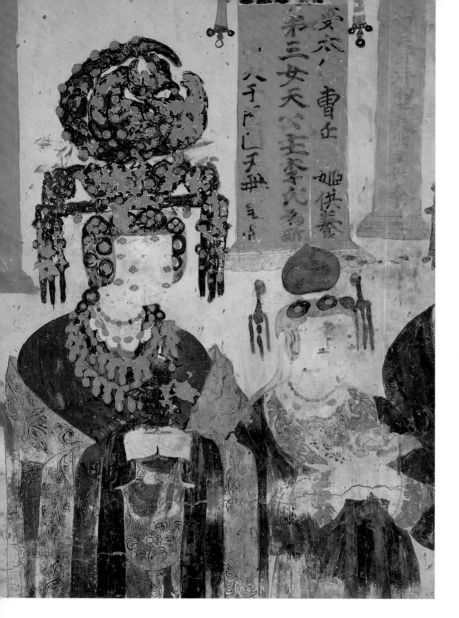

monks had gained favor at the Mongol court, continued to show Tantric influences. However, by the time the Mongol emperor Kublai Khan completed the conquest of China in the late thirteenth century, the millennium of Mogao's artistic greatness was at last coming to a close. New shipping routes were replacing the arduous overland tracks. Arab armies would eventually defeat the Mongols, and Islam would replace Buddhism as the dominant religion of central Asia.

The Silk Road was officially abandoned under the Ming dynasty. The Ming briefly established a garrison at Dunhuang, but in the sixteenth century it was overrun again by Tibet. Chinese rule would be reinstated in about 1715. The influx of people, ideas, and art that had thronged the desert capitals a thousand years before, however, had long since reversed into an outflow. Power shifted to other centers, especially along the coast, and the oases that had once flourished along the edges of the Taklamakan were reclaimed by desert sands. The frontier at last was silent. The great Buddhist civilizations of the Silk Road—including Dunhuang and the Mogao caves—would remain essentially undisturbed for some five hundred years.

The rulers of Dunhuang formed marriage alliances with other Silk Road empires, and the art of the Mogao caves was often used to promote these political ties. This portrait of Cao Yanlu's wife, a daughter of the king of Khotan, shows her wearing an elaborate headdress and necklace made of the fine jade for which Khotan was renowned. Cave 61, Five Dynasties.
Photo by Wu Jian, 1999

Western Xia Dynasty (ca. 1038–1227)

Ca. 1038 Western Xia empire established; its rulers practice Esoteric, or Tantric, Buddhism, as in Tibet. By 1072 the Western Xia control Dunhuang. They continue to build and renovate caves at Mogao in Tantric style.

1165 Western Xia king visits Dunhuang.

1227 Western Xia empire wiped out by the Mongols, who overrun and destroy Dunhuang; Mogao caves unharmed. Over next 130 years, several new caves favoring the Tibetan Buddhism preferred at Mongol court built at Mogao.

1274 Marco Polo reported to travel by Dunhuang on his journey to court of the Mongol emperor Kublai Khan.

The Uighurs, who founded an empire in the Silk Road oasis of Turfan after being chased from the Mongolian steppe, played an increasingly important role in Dunhuang's affairs. This Uighur king is being attended by servants. Cave 409, Western Xia dynasty.

Photo by Wu Jian, 1999

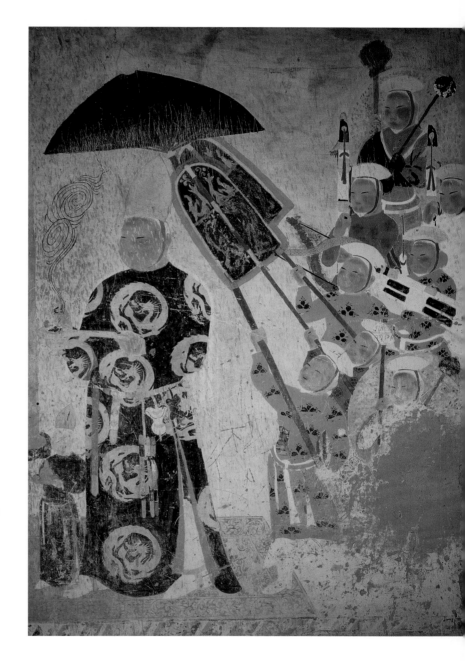

NOTES

1. A tablet at the Mogao caves, dated 698, recounts the earliest known activity at the site.
2. This image is from the great Han historian Sima Qian (ca. 145–ca. 85 B.C.E.), whose *Historical Records* was a seminal work of Chinese history.
3. Hao Chunwen, *Dunhuang de lishi he wenhua* (History and culture of Dunhuang) (Beijing, 1993), 12.
4. Xuanzang, "Da Tang Xiyuji," in Ji Xuanlin et al., ed., *Da Tang Xiyuji jiaozhu* (Beijing: Zhonghua Shuju, 1985), 1030–31. See also Hiuen Tsiang [Xuanzang], *Si-yu-ki, Buddhist Records of the Western World,* trans. Samuel Beal, quoted in Sally Hovey Wriggins, *Xuanzang: A Buddhist Pilgrim on the Silk Road* (Boulder, Colo.: Westview Press, 1996), 166–67.
5. René Grousset, *De la Grèce à la Chine* (Monaco: Les Documents d'Art, 1948), xxxii.
6. Wriggins, *Xuanzang,* 31.
7. The exact date is debated among scholars.
8. Roderick Whitfield, *Dunhuang: Caves of the Singing Sands,* 2 vols. (London: Textile and Art Publications, 1995), 318.
9. Hao Chunwen, *Tang houqi Wudai Song chu Dunhuang sengni de shehui shenghuo* (Social life of monks and nuns at Dunhuang in the later Tang, Five Dynasties, and early Song dynasty) (Beijing: CASS, 1998). See also Susan Whitfield, *Life along the Silk Road* (Berkeley: University of California Press, 2000), 220–21.

Yuan Dynasty (1279–1368)

1279 Mongols conquer China, establish Yuan dynasty.

1280 Dunhuang town is rebuilt.

Before 1357 Cave 3 painted; last confirmed artistic activity at Mogao.

Ming Dynasty (1368–1644)

1368 Ming dynasty established in China. Under the Ming, the Silk Road will be officially abandoned; Dunhuang and other Silk Road oases decline.

1404 Ming dynasty establishes garrison at Dunhuang.

Ca. 1516 Dunhuang retaken by Tibetans.

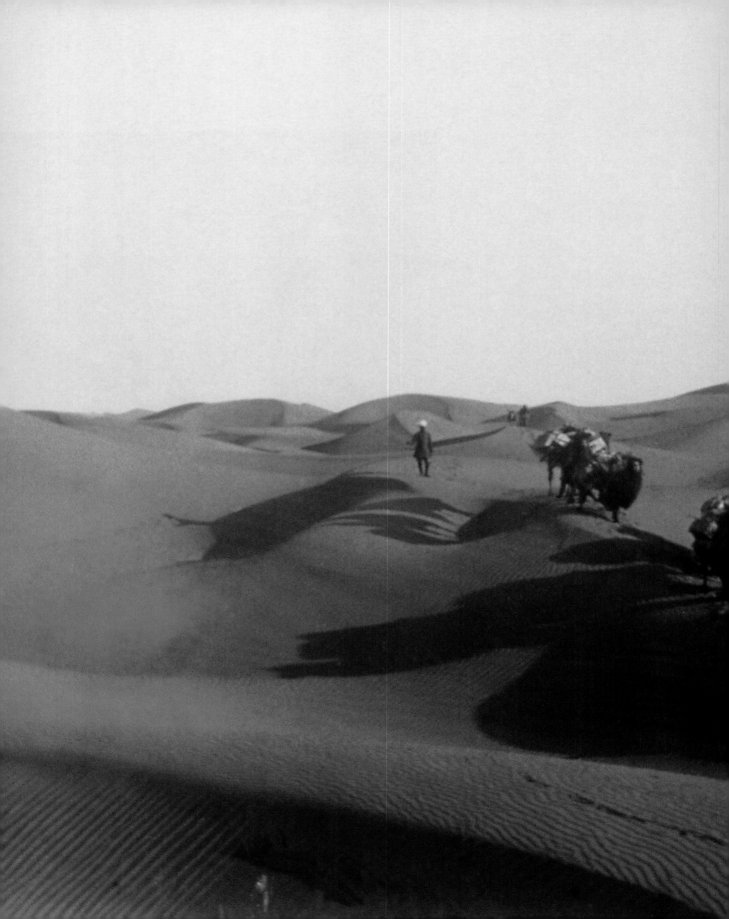

Lost Treasures of the Silk Road

In April 1906 the British-Hungarian explorer Aurel Stein left Kashmir with a small caravan, heading west through the melting spring snows of the Hindu Kush, then north down into the Taklamakan. This, Stein's second foray into the region, would earn him great fame as well as considerable enmity; and, along with the expeditions of several hardy contemporaries, it would open a controversial new chapter in the history of the Silk Road and the Mogao caves.

Caravan of Aurel Stein crossing the sand dunes in the fierce Taklamakan on the route to Dunhuang in 1907.

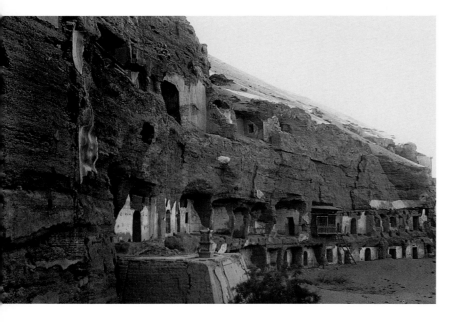

Part of the cliff face at Mogao as it appeared when Aurel Stein arrived in 1907.

By permission of The British Library, Stein photo 392/56 (689)

By the late nineteenth century, the once-thriving oasis of Dunhuang had become a remote, dusty town of few inhabitants in the wastelands of central Asia. The Mogao grottoes, although continuing to serve as a local religious center, particularly during the annual festivals in May and June, were largely abandoned. Wind-blown sands drifted into the caves, and the wooden temple facades built on the cliffs had fallen into decay. And yet, in a way, Dunhuang and Mogao were once again fortunate; other Silk Road sites had been swallowed whole by the drifting dunes of the Taklamakan. The town of Niya, on the great desert's southwestern border, had perished this way in the third century. Loulan, a military garrison without religious associations or art, forgotten or abandoned by the Chinese capital, followed in the fourth. As many as several hundred others vanished in due course; traces of such towns had emerged like will-o'-the-wisps on infrequent occasion, only to disappear beneath the desert once again.

Rarely were the sands disturbed. Locals sometimes robbed a tomb; British and Russian explorers turned up the odd coin, bits of pottery, and even a few manuscripts. The British surveyor William Johnson briefly visited a buried city near Khotan in the mid-1860s—apparently the first European to do so. Russia's greatest explorer of central Asia, Col. Nikolay Przhevalsky, came across ruins in the Lopnor Desert a decade later. Przhevalsky briefly passed through Dunhuang in 1879, as did a Hungarian geological expedition.

Manchu Qing Dynasty (1644–1911)

1644 Manchu Qing dynasty established in China.	**Ca. 1715** Chinese Qing rulers reestablish power in Dunhuang region; Dunhuang and Mogao once again part of China.	**1723–25** Local officials take interest in Mogao caves. During building of present-day city of Dunhuang, stele inscription of Li family and some wall paintings discovered.	**1725** Present-day city of Dunhuang established east of ruined site of old city.	**Before 1820** Famous historical geographer Xu Song visits Mogao caves; records stele inscriptions, which give details of founding and history of site.

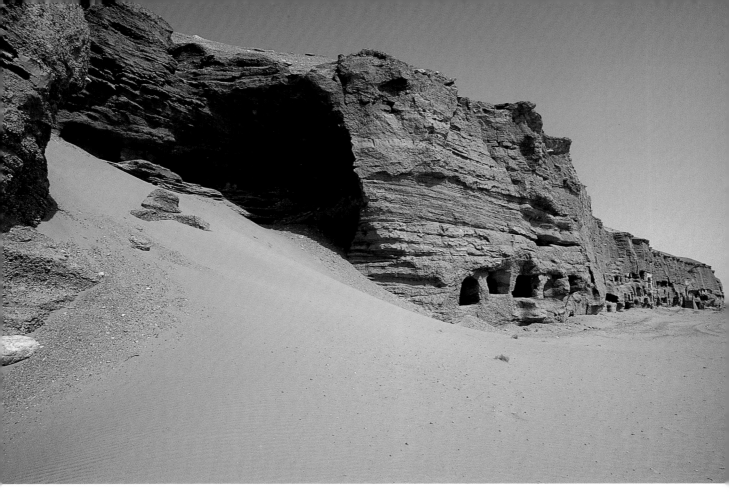

Neither party lingered, and although both of them noted the grottoes at Mogao, and the Hungarians, at least, took note of the wall paintings, apparently neither seriously explored the caves and the art within.

As the nineteenth century ended, however, word percolated back into Europe of ancient civilizations buried under the vast deserts of the region then known as Chinese Turkestan. In the decades that followed, a handful of adventurers, explorers, and archaeologists from the West would trickle into the region along the ancient trade routes, heading north from India or east from Europe or west from China; soon a race developed to claim the long-lost treasures of central Asia.

The first great excavator of the now-abandoned Silk Road was the Swedish geographer Sven Hedin, who was one of the most celebrated heroes of the West. Hedin almost died on his first expedition through the Taklamakan, but that did not prevent him from returning again and again, unearthing Borasan, Karadong, and an oasis so mysterious that he could only call it Taklamakan, although it was later identified as Dandan-uilik (Place of Houses with Ivory).

Several German expeditions, in which the kaiser himself took personal interest, soon followed. The second one was headed by Albert Von Le Coq and Albert Grünwedel,

Over the centuries, windblown sand piled up against the Mogao cliff face, and sections, as here in the northern part of the site, have collapsed in earthquakes.

Photo by Guillermo Aldana, 1991

1831–34 While posted to Dunhuang, Chinese official Xu Naigu writes poem "An Ode to the Thousand Buddha Caves."

1879 Hungarian expedition visits Dunhuang and Mogao caves.

1900 Daoist monk Wang Yuanlu discovers hidden cache of manuscripts in Cave 17, which would come to be known as the Library Cave.

1900-1901 Aurel Stein's first expedition to central Asia makes a thorough exploration of the Khotan area.

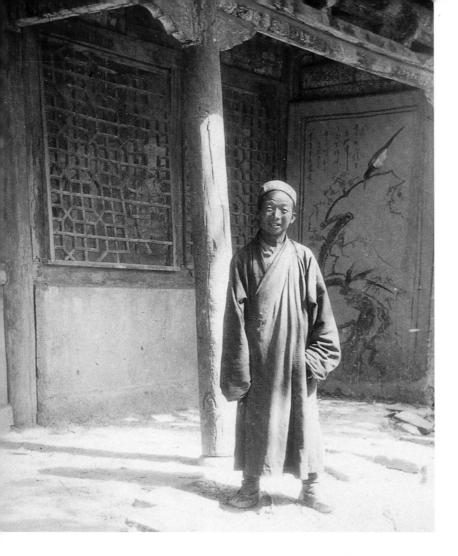

The Daoist abbot Wang Yuanlu, the self-appointed caretaker of Mogao, standing at the entrance to Cave 16. He discovered the Library Cave, which was filled with thousands of ancient manuscripts.

By permission of The British Library, Stein photo 392/26 (327)

excavating on behalf of the Ethnological Museum in Berlin. Exploring the Turfan region in 1904 and 1905, they found manuscripts and sumptuous textiles dating to the eighth century, indicating that an important Manichaean community had been settled there by pilgrims journeying east from Persia along the Silk Road. The Germans also excavated the Buddhist cave temples at Bezeklik (Place Where There Are Paintings); here they found magnificent murals depicting figures in Indian, Persian, central Asian, and Chinese dress. They removed a great number, which they sawed into pieces and packed off to Berlin. Perhaps it was fortunate that, in a fateful decision based on a simple coin toss, they opted not to pursue a rumor they had heard of a remarkable find made several years earlier at Dunhuang, some two hundred miles to the south.[1]

In the 1890s an itinerant Daoist priest named Wang Yuanlu from Shanxi Province had settled at Mogao, where he appointed himself abbot and became the unofficial guardian of the grottoes and the art they contained. He soon devoted himself diligently—if not always wisely—to their restoration.

One day in 1900, while supervising the clearing of sand from the entrance to Cave 16, Wang noticed a hidden doorway, which had been plastered over and painted so that it was concealed. His workmen broke away the plaster, revealing a small side chamber crammed from floor to ceiling with scrolls. The abbot had stumbled on a vast hoard of ancient manuscripts numbering in the tens of thousands. There

1902 Expedition to Turfan headed by Albert Grünwedel, who makes detailed records and drawings.

1907 Aurel Stein visits Dunhuang on his second central Asian expedition; negotiates with Wang Yuanlu for purchase of twenty-four cases of manuscripts and five cases of silk paintings, which are sent to British Museum.

1908 French sinologist Paul Pelliot arrives at Dunhuang and Mogao; having scanned all remaining manuscripts and documents, he makes a selection, which he sends to Bibliothèque nationale de France in Paris. At same time, Charles Nouette makes photographic record of all accessible caves.

were hundreds of other items as well, from silk banners and paintings to fine silk embroideries and other rare textiles.

News of the discovery soon reached scholars in China. In 1902 the prefect of Dunhuang sent a number of the documents to the education commissioner for Gansu Province, a noted scholar of ancient inscriptions. He suggested that the entire lot be sent for safekeeping to the provincial capital at Lanzhou, but there was no provision for the expense of transport, so authorities in Gansu ordered Abbot Wang to seal the Library Cave again.

Aurel Stein, excavating on behalf of the British Museum and the (British) Government of India, had first heard about the Mogao caves from his friend Professor Lajos Lóczy, who had been a member of the Hungarian expedition that had visited Mogao nearly thirty years before. His friend's glowing description of the art of the caves, Stein later wrote, had first aroused his interest and supplied the main cause for the extension of his expedition "so far eastwards into China."[2] Hungarian by birth, Stein would become a British citizen—he would, indeed, be knighted, largely for his discoveries in central Asia. After leaving Kashmir, he had been traveling for almost a year, most of it spent roaming the Taklamakan. In Loulan, to the west of Dunhuang, he had unearthed poignant military documents dated to 330 C.E., which described this frontier fort's final days before it was overrun by the Huns.

According to Sir Leonard Woolley, who discovered the lost Babylonian city of Ur, Stein's excursions into central Asia were

The archaeologist and explorer Aurel Stein. In addition to his discoveries at Mogao and elsewhere in central Asia, he made maps of the region that are still valuable today.

By permission of The British Library, Stein photo 392/28 (739)

1909 Chinese authorities in Beijing order remaining manuscripts to be packed and transported to capital for safekeeping. They are housed in Ministry of Education.

1910 Theft of some manuscripts from Ministry of Education. An arrest is made, but 1911 revolution precipitating fall of Qing dynasty and founding of Chinese republic means that case is not resolved.

1911 Members of Japanese Count Otani's expedition visit Dunhuang and acquire several hundred manuscripts.

1913-16 Aurel Stein's third expedition to the Taklamakan.

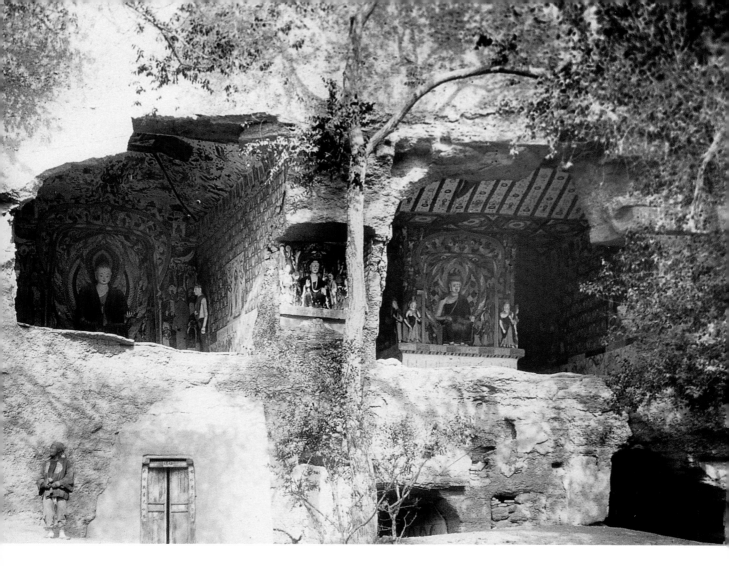

perhaps "the most daring and adventurous raid upon the ancient world that any archaeologist has attempted." While his excavations, like many in the early days of archaeology, have since occasioned controversy, there is no doubt about his stature. It was he who excavated Niya, Rawak (with its multitude of outsize statues), Dandan-uilik, and many other desert sites. It was he who discovered paintings and statuary and ruin after ruin that would change the course of central Asian scholarship. And it was he

who put Dunhuang back on the map after centuries of quiet neglect.

Stein arrived in Dunhuang in March 1907, in the midst of an icy gale—the fierce Taklamakan storm known as a buran—relieved, like so many travelers before him, to reach safe haven at this oasis. He soon heard vague rumors about a great cache of manuscripts at the Mogao caves, which were now but a short ride away. After resting for a few days, he and a few of his men headed off, passing along towering dunes

1914 Stein revisits Dunhuang and buys about six hundred manuscripts in the town.

1914–15 The Russian Oldenburg expedition visits Dunhuang; removes artifacts, murals, manuscripts, and silk paintings from Mogao.

1920–21 Over nine hundred White Russian émigrés camp out at Mogao, using caves as living quarters; build cooking fires that blacken statues and murals and write graffiti on walls. Some caves considerably damaged.

1924 American art historian Langdon Warner visits Mogao. He removes pieces of murals and one statue.

1925 Langdon Warner visits again and plans to remove larger pieces of murals but stops after opposition from locals.

that soon gave way to barren rocky hills. Then, wrote Stein, "on the almost perpendicular conglomerate cliffs rising on our right, I caught sight of the first grottoes.... In bewildering multitude and closeness, [they] presented their faces, some high, some low, perched one above the other without any order or arrangement in storeys." Approaching a bit closer, he at once "noticed that fresco paintings covered the walls.... 'The Caves of the Thousand Buddhas' were indeed tenanted, not by Buddhist recluses, however holy, but by images of the Enlightened One himself."[3]

It was not long before Stein understood the remarkable range and antiquity of the works before him, which covered the sweep of Greco-Buddhist, central Asian, and Chinese art. There were countless sculptures, including a colossal statue of a sitting Buddha, "rising through caves with a number of storeys." And, of course, there were the murals. These, he remarked, "showed the closest affinity to the remains of Buddhist pictorial art transplanted from India to Eastern Turkestan.... But in the representation of figures and faces the influence of Chinese taste made itself felt distinctly, and instead of the thin outlines and equally thin colouring there appeared often a perfect exuberance of strong but well-harmonized colours.... I could not doubt for a moment that the best of these frescoes belonged to the times of the Tang dynasty."[4]

Abbot Wang was away, however, so Stein, unable to find out much more about the manuscripts, contented himself with exploring the caves themselves. Finally, at

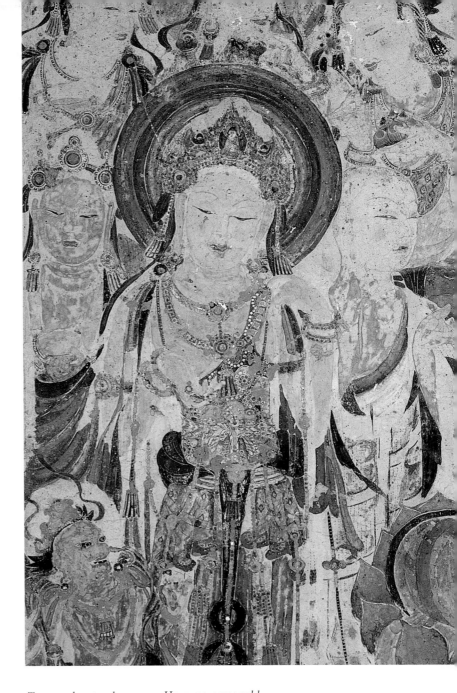

Treasure hunters have removed much of the gold leaf that originally adorned this elegant portrait of the bodhisattva Guanyin.

However, some gold remains in the jewelry and crown. Cave 57, Early Tang dynasty.
Photo by Lois Conner, 1995

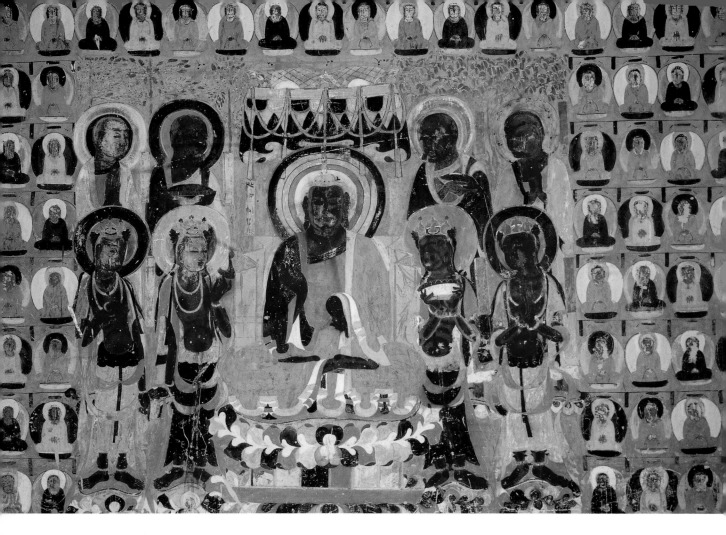

Stein was struck by the "well-harmonized colours" of many murals at Mogao. This late-sixth-century preaching scene is framed by depictions of the Thousand Buddhas. The original flesh tones have darkened. Cave 419, Sui dynasty.

Photo by Lois Conner, 1995

day's end, he reluctantly headed back to Dunhuang. "It was getting dusk before I could tear myself away from this wonderful beehive of temples in its setting of barren rocks and sand," he remembered. "The west wind which now swept [the landscape] was piercing, and in the dust-laden atmosphere complete darkness soon overtook us. So there was nothing to interfere with the pictures full of vivid colour and grave pomp, all of ages long gone by, which that day's over-abundant sight-seeing had left impressed on my mind's eye."[5]

While waiting for Abbot Wang, Stein headed off on a two-month side trip, during which he discovered the remains of the historic Jade Gate and excavated along a series of ruined watchtowers, which he correctly believed to have formed the westernmost extension of the Han Great Wall. Here he found written records on slips of wood, some with dates as early as 45 B.C.E., and bundles of tamarisk twigs, still stacked as they were when first gathered to fuel beacon fires two thousand years before.

Then, when the abbot finally returned, a delicate minuet began.

Stein immediately sized Wang up as someone who might be difficult to win over to his purposes—which were, first, to examine the Library Cave and, second, to secure as much of its contents as he could. Not surprisingly, Wang proved reluctant to give the foreigner even the slightest glimpse inside the small grotto. Authorities, who had considered transporting all of the documents to the provincial capital of Lanzhou, knew that the trove existed. The abbot knew that they knew, and he did not believe he could trust any foreigner to keep a secret arrangement secret.

Stein, therefore, decided to work on Wang's vanity. Through his diplomatic Chinese secretary and interpreter Jiang Siye, he praised the abbot's restoration work—which, in truth, appalled him. This helped to melt the ice. Next he hinted that he might be able to make a donation to the restoration fund, which warmed things even more. Then he mentioned Xuanzang.

The seventh-century Chinese pilgrim, who had passed through Dunhuang when he reentered China, now reappears in the Dunhuang story. The geographic notations that Xuanzang had made in his *Record of a Journey to the West* were so precise that they were still considered models of accuracy early in the twentieth century. Stein had long since taken him as his patron saint, using the notes to guide him in the Taklamakan when his life, literally, had depended on it. Now, when he mentioned the Tang monk, the abbot's eyes, "otherwise so shy and fitful . . . showed a gleam of lively interest."[6] Abbot Wang, it turned out, also venerated Xuanzang; he

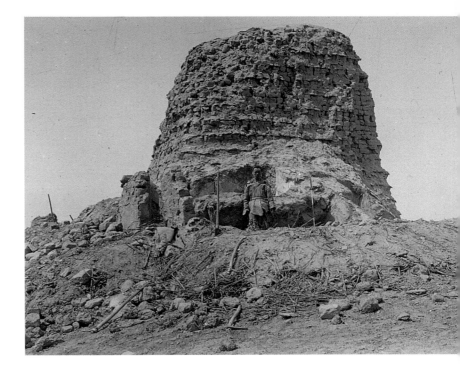

The stamped-earth core of this ruined watchtower, built during the Han dynasty more than two thousand years ago, still stands guard over the desert sands near Dunhuang. It is one of the westernmost outposts of the Great Wall of China.

By permission of The British Library, Stein photo 392/56 (698)

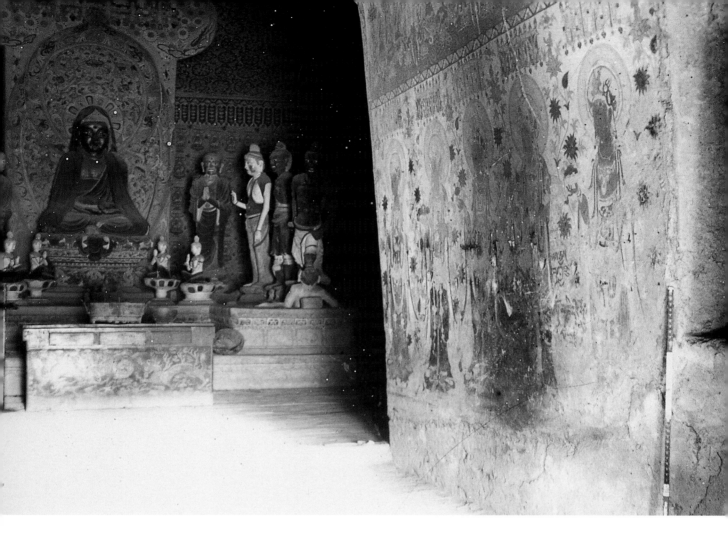

The interior of Cave 16; the secret opening leading to the Library Cave and its astounding cache of ancient manuscripts is in the foreground on the right.

quickly showed his guest the newly built loggia in front of the temple: the walls were decorated by murals—which the priest himself had commissioned from a local artist—representing scenes from the pilgrim monk's adventures. Linked by their common respect for this legendary figure, the British-Hungarian explorer and the Chinese Daoist monk found common ground; for Stein, the battle was essentially won.

It was now largely a matter of patience and time—along with a bit more cunning on Stein's part. He referred to the fact that Xuanzang had taken hundreds of manuscripts out of India to China, and that very night the abbot showed up with several scrolls hidden beneath his coat. Stein's secretary spent the night examining them; at dawn, he arrived at Stein's tent, where he

elatedly informed the explorer that, according to their colophons, the manuscripts were Chinese versions of Buddhist sutras that had been brought from India and translated, more than twelve hundred years earlier, by none other than Xuanzang himself.

Astonished, Stein quickly pressed his advantage, suggesting to Abbot Wang that from beyond the grave Xuanzang had chosen this moment to reveal these sacred Buddhist texts to Stein so that "his admirer and disciple from distant India" could return "to the old home of Buddhism some of the ancient manuscripts which chance had placed in [Wang's] keeping."

Within hours the door to the secret chamber was opened.

Once again, Stein was amazed. "Heaped up in layers," he wrote, "but without any order, there appeared in the dim light of the

priest's little lamp a solid mass of manu-
script bundles rising to a height of nearly
ten feet, and filling, as subsequent measure-
ment showed, close on 500 cubic feet. . . .
Not in the driest soil could relics of a ruined
site have so completely escaped injury as
they had here in a carefully selected rock
chamber where, hidden behind a brick
wall, . . . these masses of manuscripts had
lain undisturbed for centuries."[7]

This would indeed be Stein's greatest
coup, one of the richest finds in the history
of archaeology. There were perhaps as
many as fifty thousand documents in all,
the majority of them Buddhist. In some
cases there were hundreds, in some cases
thousands of copies of the best-known
sutras, handwritten with brushes dipped in
lustrous black ink on paper—a material
unknown in the Western world until the
eighth century, when Chinese taken pris-
oner in a battle with the Arabs passed on
their knowledge to artisans in Samarkand,
but used in China for almost a thousand
years before that. Some bore dates (the ear-
liest from 406, the latest from 996); some
were illustrated—and some were not man-
uscripts at all but books *printed* six hun-
dred years before Johannes Gutenberg's
famous Bible. Many more were entirely
secular, and these in particular would illu-
minate aspects of Chinese history, art, and
literature that until then had remained in
total obscurity. There were also documents
in such languages as Tibetan, Uighur, and
Khotanese. And there were paintings on
paper and hemp, paintings on silk, and
silken banners—in "a transparent gauze
of remarkable fineness"—some of which

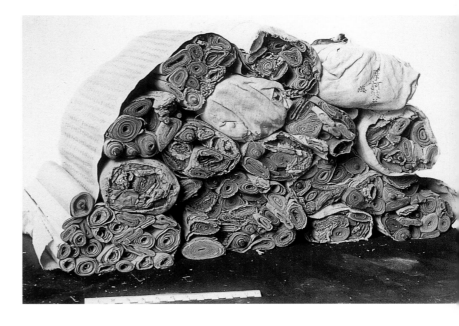

*Pile of ancient scrolls
obtained by Stein
from the Library Cave
in 1907.*
By permission of The British
Library, Stein photo 17747

1987 Establishment of Dunhuang
Academy (formerly called
Dunhuang Research Institute);
Mogao inscribed on Unesco list
of World Heritage sites.

1988 Getty Conservation
Institute begins collabora-
tion with Dunhuang
Academy at Mogao.

1993 International confer-
ence held at Dunhuang on
conservation of Mogao
caves and other ancient Silk
Road sites.

2000 International confer-
ence at Dunhuang marks
centenary of discovery of
Library Cave.

In addition to thousands of ancient manuscripts, the Library Cave yielded an abundance of silk embroideries and paintings. The brilliant coloring and excellent state of preservation of this painting on silk, obtained by Paul Pelliot, is due to its being still quite new when it was stored away in the early eleventh century. The influence of Tantric Buddhism is evident in the geometrical arrangement of the deities around the central figure, Amoghapasha, an important deity. Donor portraits can be seen at bottom. Northern Song dynasty.

Musée des arts asiatiques-Guimet, Paris. © Photo RMN

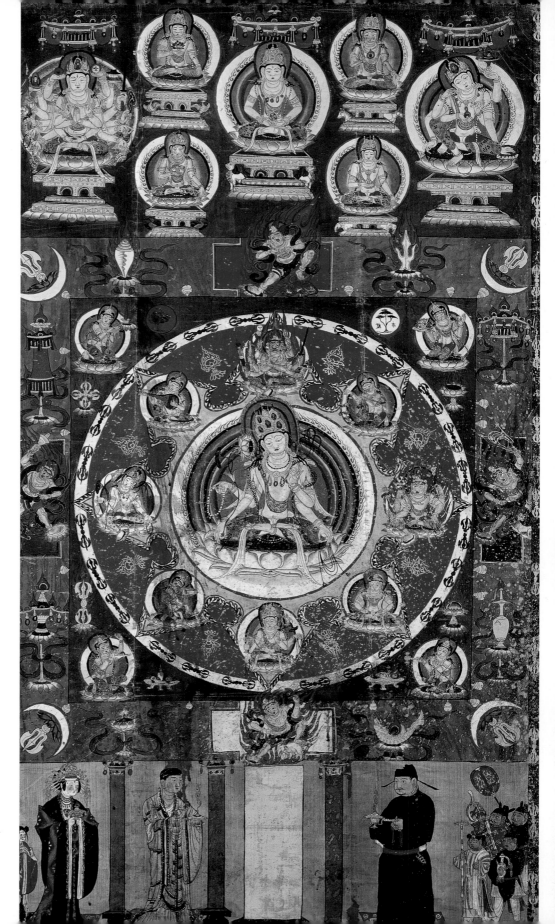

were so long that they could only have
been intended to hang from the Mogao
cliffs. The cave, in short, contained an
unprecedented record of the medieval
Chinese world.

This small chamber, which once had
been dedicated to Hongbian, Zhang Yichao's
chief of monks in the ninth century, had
been closed up sometime around the year
1000. Just why is a mystery, but there was
no doubt that this sealed cave in an arid
desert provided the perfect hiding place.
Not a single document had been lost to rot.

Soon, however, the documents would
disappear in other ways. Stein and the
abbot had to continue their dance for a
while longer, and Wang Yuanlu was still
afraid the authorities would find out about
their dealings. Eventually, however, the
abbot decided that *this* foreigner *could* be
trusted; in all he sold Stein seven thousand
complete manuscripts and six thousand
fragments, as well as several cases loaded
with paintings, embroideries, and other
artifacts. (Wang was motivated not by per-
sonal greed but by the desire to fund
restoration work at the caves.) All of this,
as Stein was proud to record, cost the
British taxpayer the sum total of £130.

The next Western visitor to Mogao
would be Paul Pelliot, a Frenchman eager
to redress his country's tardy entry into
the hunt for Silk Road treasures. Pelliot was
a meteor on the horizon of French sinology
whose brashness and brilliance would, over
the years, create for him many enemies as
well as admirers. His memory, for example,
was so phenomenal that he could quote
passages verbatim years later without refer-
ence to the actual text, but those who
refused to credit this accused him of exag-
geration. He was only twenty-two when he
was appointed professor of Chinese at the
prestigious Ecole Française de l'Extrême
Orient in Hanoi, younger than that when

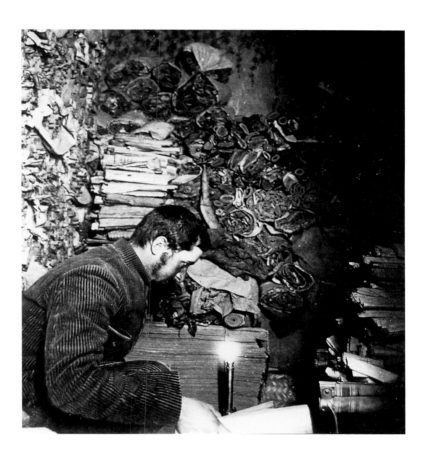

*During his stay at
Mogao in 1908, the
French linguist and
explorer Paul Pelliot,
who was fluent in
Chinese, examined
thousands of manu-
scripts by candlelight,
to select the most
important for
removal to Paris.*

Pelliot Collection, 9992/93,
Musée des arts asiatiques-
Guimet, Paris. © Photo RMN

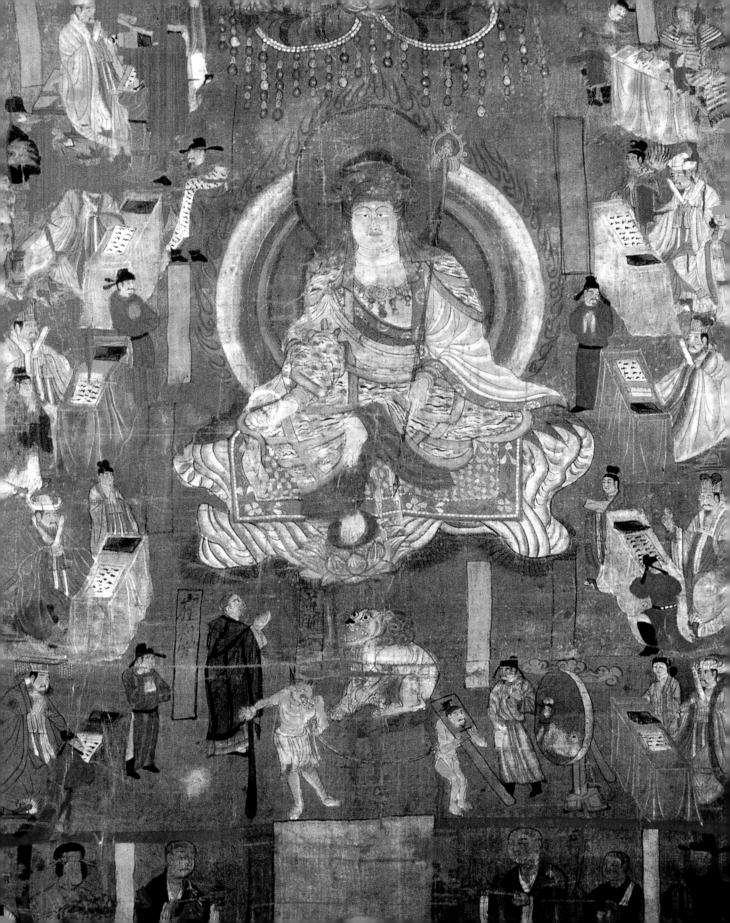

he began to criticize his older colleagues, and twenty-seven when he was sent to central Asia as head of the French expedition. Stein got there before him, but Pelliot knew Chinese, and that made all the difference. The British Library has five hundred copies of the Diamond Sutra and over a thousand Lotus Sutras, largely because Stein did not realize what he was taking away from Dunhuang. Pelliot knew.

While Stein had been waiting for Wang to return, Pelliot had been stuck in Tashkent, waiting for his luggage to arrive. (He passed the time by learning Uighur, the principal language of the region.) Pelliot arrived in Dunhuang in 1908, after overseeing various archaeological finds in Tumshuq, Kucha, and Urumqi; he, like Stein, was staggered when he entered Cave 17. His triumph was facilitated by Stein's discretion, because Abbot Wang was finding it easier now to trust his European visitors. Despite Stein's haul, Pelliot estimated that between fifteen thousand and twenty thousand documents still remained —and, remarkably, he spent the next three weeks examining them, one at a time, by candlelight.

Pelliot estimated that over a period of fifteen days he examined almost one thousand documents a day. Unlike Stein, he was able to decipher on the spot what valuables he held and then to determine which were most likely to prove of scholarly or historical importance. Like Stein, however, he was a very good bargainer: French taxpayers paid the equivalent of £90 for the thousands of documents that he shipped to the Musée Guimet and the Bibliothèque nationale de France in Paris. On his way back to France, Pelliot passed through Beijing, where he showed some of his finds to scholars. In 1909 the Chinese government ordered the removal of all that remained of Cave 17 to the Ministry of Education

in Beijing, and today these documents are in the National Library of China in Beijing.

Abbot Wang, however, did not render quite everything that was his, secreting various texts in the statues he was so laboriously restoring and perhaps hiding others in other caves. In 1911 he had enough left over to sell six hundred documents to a Japanese expedition, headed by an archaeologist who claimed to represent the Kyoto monastery of a certain Count Kozui Otani, the leader of the Japanese Pure Land sect. According to one account, British and Russian intelligence agents in the region, who had his expedition shadowed, believed that he was a spy.[8] The priest sold two hundred more documents to a Russian expedition in 1914. Stein returned in 1914 and bought five more cases of material, though he did not see Cave 17 again.

In the 1920s the American art historian Langdon Warner made the trek to Dunhuang to see the wall paintings for himself. He had read the accounts published by Stein and Pelliot, but on arriving at the Caves of the Thousand Buddhas, he would later write, "there was nothing to do but to gasp. . . . For the holy men of fourteen centuries ago had left their gods in splendor on these walls."[9] He acquired twelve sections of wall paintings and a small sculpture for the Fogg Museum of Harvard University, in Cambridge, Massachusetts, but he was conscious of being watched.

By then, in fact, the Chinese were reacting with ever-deepening outrage to what they perceived as the pillaging of their cultural treasures. Some expeditions would even be sabotaged, including the second of Langdon Warner and the last—the fourth— of Aurel Stein. Soon the doors slammed shut, and by the end of the 1920s, the great race for Silk Road antiquities was over.

Nevertheless, the final numbers are breathtaking. Central Asia had yielded

Opposite: One of the silk paintings removed by Aurel Stein. The figures who surround the bodhisattva Ksitigarbha are the ten kings of the underworld, shown behind desks and appareled as Chinese magistrates, just as they appear in illustrated copies of the Sutra of the Ten Kings. The monk Daoming—who descended to hell and returned to tell of his visions there—can be seen along with a lion.

© Copyright The British Museum, OA 1919.1-1.023 (Ch. 0021)

Among the thousands of manuscripts taken from the Library Cave is this tenth-century copy of the Sutra of the Ten Kings; each king sits at a desk *and judges the good and bad deeds of the deceased as they enter into the afterlife.*

Pelliot chinois 2003-12. Courtesy Bibliothèque nationale de France, Paris

hundreds of thousands of artifacts. In addition to manuscripts in Chinese, many thousands of manuscripts in other regional languages, such as Turkic, Mongolian, and Sanskrit, have been found at other ancient sites west of Dunhuang. The many remarkable and fragile textiles found preserved in this arid climate, meanwhile, reveal immensely complex weaves and patterns, with influences from Persian, Chinese, and

given such damages, "in twenty years this place won't be worth a visit."

More Silk Road treasures were destroyed in seven nights of Allied bombing of Berlin during World War II, however, than all of the above had managed in seven centuries. Others mysteriously disappeared when the Russians occupied the city. Much of the Japanese collection of the enigmatic Count Otani was also dispersed.

Not surprisingly, China particularly resents the loss of the Cave 17 library to mainly Western institutions. Although most of the scrolls have long been available on microfilm, Chinese scholars have been hampered by lack of access to the material, and most of the research has been done elsewhere. In the past few decades, however, Dunhuang research groups have been established at most leading Chinese universities, and their scholars have published hundreds of articles and monographs about the Mogao caves. Excellent historical, art-historical, and conservation research is carried out by members of the Dunhuang Academy. The widespread diaspora of the Dunhuang material, meanwhile, has given rise to a vibrant field of international scholarship, with scholars from China, Japan, and the West working to preserve the once-lost treasures of the Silk Road. As for the wall paintings in the Mogao cave temples, the art gallery in the desert remains essentially and marvelously intact.

NOTES

1. Peter Hopkirk, *Foreign Devils on the Silk Road* (Amherst: University of Massachusetts Press, 1980), 122–46. This book offers a captivating account of the hunt for Silk Road antiquities.
2. M. Aurel Stein, *Ruins of Desert Cathay* (1912; reprint, New York: Dover Publications, 1987), 2:20.
3. Ibid., 22–23.
4. Ibid., 24.
5. Ibid., 31.
6. Ibid., 169.
7. Ibid., 172–76.
8. Hopkirk, *Foreign Devils on the Silk Road*, 190–206.
9. Langdon Warner, *The Long Old Road in China* (New York: Doubleday, Page & Company, 1926), 138.

Opposite: Mural at Mogao showing two of the gaps left when the American art historian Langdon Warner removed about a dozen fragments of wall paintings in the 1920s. Cave 320, High Tang dynasty.

Photo by Lois Conner, 1995

Above: The head of an attendant bodhisattva—the fragment missing from the space at the far left of the mural opposite.

Photo by Rick Stafford; courtesy of the Arthur M. Sackler Museum, Harvard University Art Museums, First Fogg Expedition to China, 1923. © President and Fellows of Harvard College, Harvard University

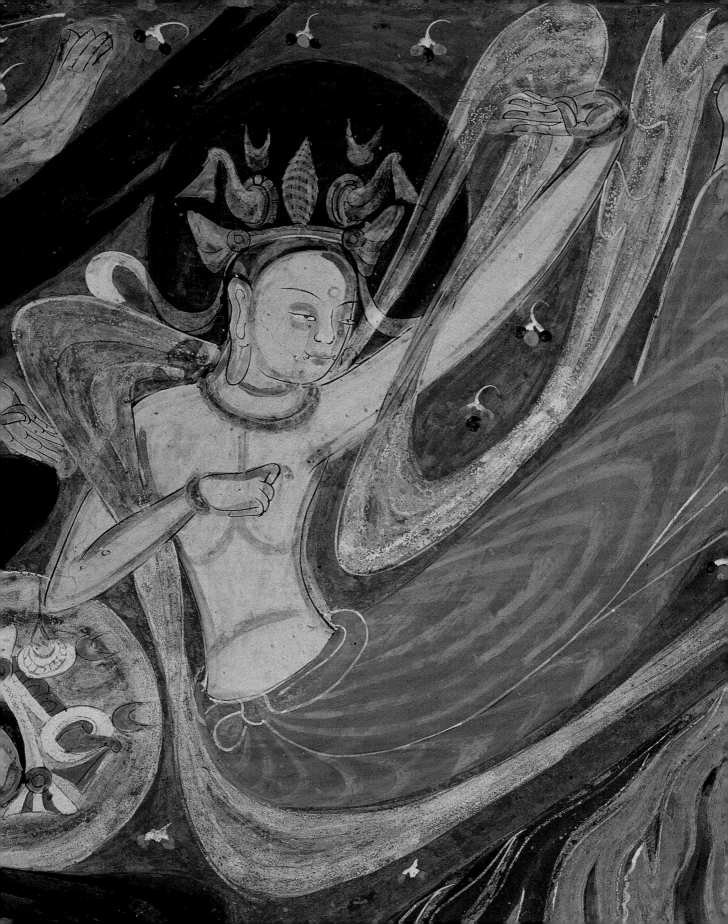

The Peerless Caves

In the late fourth century, when the monks Yuezun and Faliang are said to have carved the first caves in the cliff at Mogao, this remote desert valley was a narrow band of green in the surrounding desert. A grove of elm trees flourished along the stream at the base of the cliff, and across the valley floor rose a range of rugged mountains. Perhaps the only sounds were the singing of birds and the hissing of sand blowing over the cliff from the dunes above. Within two centuries, however, Mogao would evolve from the isolated haunt of a few hardy hermits into a vibrant center of Buddhist culture and art whose renown would extend from the Chinese capitals to the far western kingdoms of the Silk Road.

An apsarasa, or
flying celestial being.
Cave 285, Western
Wei dynasty.
Photo by Wu Jian, 1999

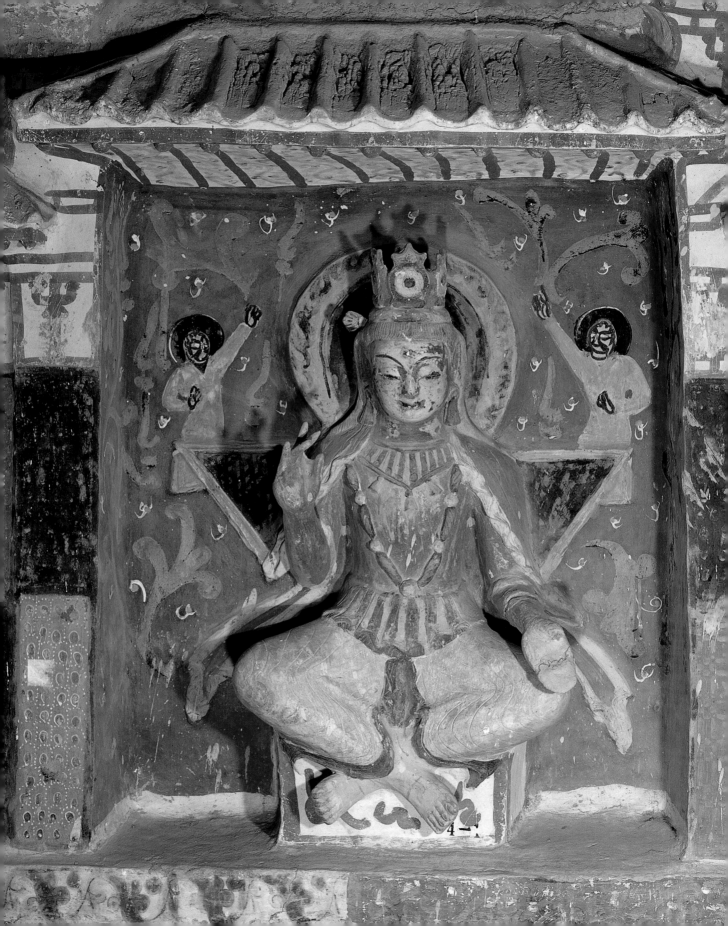

Over the course of a millennium, the Mogao grottoes, or Peerless Caves, would be slowly fashioned by monks and merchants, artists and city officials, gentry and common laborers. While the caves appear to have developed in an almost haphazard fashion, in some ways, at least, they were carefully planned, with changes in dynasties marked by new beginnings in a different part of the cliff. Like the great Gothic cathedrals of Europe, which were often constructed over centuries, different sections of the complex display different styles, according to the historical circumstances and artistic influences that held sway at the time of their construction. Some are merely niches, with enough room for only a solitary hermit to sit in meditation. Many, of medium size, were probably frequented only by relatively small numbers of monks. The largest have lofty ceilings and space enough for processions of one hundred or more worshipers. Evident from the very earliest caves is the lack of a clearly defined distinction among architecture, sculpture, and mural painting; rather, these art forms were fused in these remarkable shrines where the heavenly beings of Buddhism were said to dwell.

The caves of Yuezun and other early monks were little more than meditation niches. Although their caves have not survived, three early grottoes (Caves 268, 272, and 275) do remain, situated in the same part of the cliff face. They date to the time of the Northern Liang dynasty—between 419 C.E. and the conquest of Dunhuang by the Northern Wei in 439. Some contain meditation cells, indicating that by the early fifth century there was already a small community of monks—not just individual hermits—residing at Mogao. The caves of the first few centuries generally reflect influences from China as well as from

Opposite: Statue of Maitreya, the Future Buddha, in his divine abode, known as Tusita Heaven. He is depicted wearing a crown and jewelry; his legs, aristocratically crossed at the ankles, suggest the fashion adopted by the kings of the ancient Kushan empire. Small figures on the back of his throne point upward, an allusion to a phrase in the Maitreya Sutra, which says that those who recite it will be reborn in Tusita Heaven—where they will progress toward enlightenment "as fast as a strong man can raise his arm."
Photo by Lois Conner, 1995

Above: Celestial beings point heavenward. Cave 275, Northern Liang dynasty.
Photo by Lois Conner, 1995

der the Great four centuries earlier. Greek traditions thereby influenced the way the Buddha was represented. Gandharan art was distinctively Greco-Buddhist, and this influence, too, traveled east along the Silk Road to Dunhuang.

When Buddhism first reached China, by the first century at the latest, the first images to be brought there were no doubt small and portable; by the fourth and fifth centuries, however, cave temples were being created all along the Chinese end of the caravan routes. These shrines had first been made at such northern Indian sites as Ajanta, where both Buddhist and Hindu grottoes, adorned with bas-reliefs and sculpture, date back at least to the first century B.C.E. New caves were carved into cliffs at Bamiyan, in present-day Afghanistan; at Yungang, in China, under the patronage of the Northern Wei rulers; at Longmen, near the second Wei capital; and, of course, in the area around Dunhuang.

For Mahayana Buddhists — laypeople and clergy alike — making images of the Buddha or copying the sutras were works of religious devotion, through which devotees hoped to escape from the cycle of suffering and rebirth. The images could be colossal, like the two great Buddha statues at Bamiyan. They could also be very small — a few inches in height and repeated over and over, as on the walls and ceilings at Mogao. The merit to be obtained by making an image was thereby within the reach of the poorest, as well as the richest, believer.

Buddhist Art

The art of Buddhism accompanied the religion from India across central Asia to China. At the very earliest sites in India and Afghanistan, dating from the second and first centuries B.C.E., the Buddha himself was not portrayed in human form but was represented by a series of symbols, each of which referred to an event and a specific place. The *bodhi* tree symbolized the Buddha's enlightenment, which took place at Bodhgaya in northern India; a wheel symbolized

the preaching of his first sermon in the Deer Garden at Sarnath; and a stupa (a monument containing relics of the Buddha's body) stood for the Buddha's nirvana or final transcendence, in a grove of sal trees at Kusinagara. Sometimes the presence of the Buddha was simply indicated by his footprints.

From the first century C.E., however, images of the Buddha began to be produced in India and Gandhara (present-day Pakistan). Gandhara was also rich in Western influences because of the presence of Alexan-

central Asia, which absorbed the artistic influences percolating out of India, where the first great Buddhist cave shrines had been created in the first century B.C.E. For example, some architectural flourishes, such as the design of niches that hold statues, are modeled on the Kizil Caves, west of Dunhuang on the northern Silk Road, while others are clearly modeled on Chinese architecture.

Cave 275, a rectangle three meters wide by five meters deep, gives a fair idea of the world of Buddhism that by then was becoming entrenched along the Silk Road. In a spirit of millennial foreboding, the fifth century—some thousand years after the death of the historical Buddha—was felt to be an age of moral and spiritual decay, known as *mofa* (Decline of the Law). Throughout eastern and central Asia, the lives of the people were beset by constant hardship. Two sutras foretold the birth of the bodhisattva Maitreya, first in his divine abode—known as the Tusita (Joyful) Heaven—and eventually on earth, where he would end all suffering. He was therefore worshiped as the Buddha of the Future. The cave is dominated by a large statue of Maitreya, with several smaller images lining the walls. He is shown wearing the clothing of a Kushan king; the building in which he is seated, however, represents Tusita Heaven. Its design—a fortified city gateway with flanking brick-faced watchtowers, wooden bracketing, and a tiled roof—is typical of traditional Han architecture, as if to promise a Chinese future for Buddhism itself.

By 439 the Dunhuang area had become part of the Northern Wei dynasty, which established its authority throughout northern China. The Northern Wei and the other reigns to follow — the Eastern and Western Wei, Northern Qi, and Northern Zhou—were all peoples of non-Chinese origin. Under the Northern Wei, Buddhism

Two scenes in a mural illustrating a jataka tale, a story of the Buddha's earlier incarnations, in which the compassionate nature of the future Shakyamuni is tested. Opposite, he is shown as a king—the seated figure with a halo—holding in his hand a dove that has taken refuge with him. An attendant carves flesh from the king's leg to pay the dove's ransom. In return for placing his body on a scale, above, the king will be restored to wholeness. Cave 275, Northern Liang dynasty.

Photos by Lois Conner, 1995

In this jataka narrative illustrating the laws of karma, the story's episodes are separated by landscape elements—the blue river on the lower left and the rows of triangular hills. At left, a young man kneels in allegiance to the deer, who has saved him from drowning. Above, the deer sleeps. In scenes not shown here, the young man reveals the deer's hiding place to a ruler seeking medicine—obtainable only from a dead deer—for his wife. At right, the ruler arrives on horseback. The deer tells him how he had saved the young man, only to be betrayed; moved by this creature's magnanimity, the ruler abolishes deer hunting in his kingdom. The young man, however, will suffer a disfiguring disease in return for his disloyalty. Cave 257, Northern Wei dynasty.

Photo by Lois Conner, 1995

gained a privileged position in the state. At Dunhuang, grotto shrines would soon be sponsored not only by monks but also by local governors, with contributions from various elements of the populace. Accordingly, the shrines became larger, more complex, and more richly decorated.

The caves of the Northern dynasties generally featured a short corridor leading from the entrance hall to a transverse chamber with a simulated gabled roof. Opposite the entrance, the principal Buddha image was placed against a central pillar. This

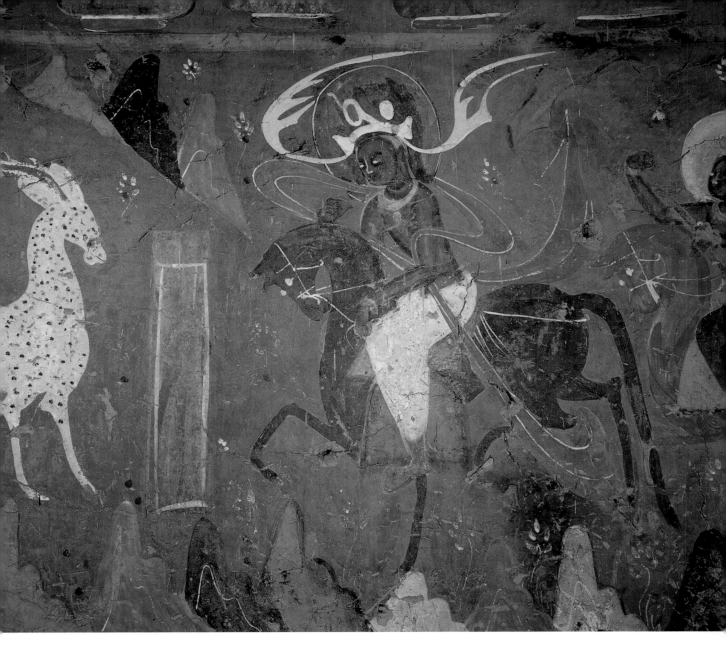

arrangement allowed worshipers to walk in homage around the sculptural images, probably in a clockwise direction, keeping the statue groupings on their right. Sculptures were also set on the other faces of the central pillar and along the sidewalls. They were generally modeled on Indian or central Asian prototypes; some were influenced by the Greco-Indian style of Gandhara; others followed the style prevalent at Mathura in India.

The walls were adorned by the Thousand Buddha motif—depictions of the Buddhas of the past, present, and future ages. In their midst were often set panels depicting the Buddha with attendant bodhisattvas—enlightened beings who have vowed to help all sentient beings reach enlightenment—and flying deities, or apsarasas, above. The most prominent wall spaces were reserved for larger panels depicting the Buddha's enlightenment and first sermon. More extensive narratives might appear on the walls or ceiling, arranged in narrow horizontal bands, in which a succession of scenes, often

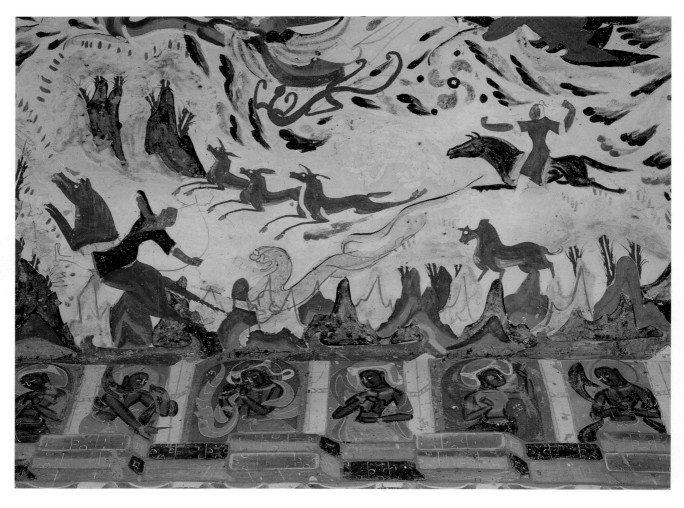

separated by landscapes—mountains, rivers, trees—would tell Buddhist stories. Different narrative paintings were to be read in different ways—some left to right, some right to left, some top to bottom, and so on. Many illustrate the jatakas, while others illustrate the sutras, or Buddhist scriptures.

By the sixth century, the Mogao shrines had come to serve as a focus for the aspirations not only of local devotees, such as monks from the Dunhuang monasteries, but also of many others, including merchants and government officials, as well as pilgrim monks, who journeyed to Mogao

Above: In this ceiling mural, the action is framed by a row of triangular mountains in which riders hunt deer, as well as a large tiger and a white lion, which is almost invisible against the white background. Heavenly musicians are shown along the top of the walls. Cave 249, Western Wei dynasty.

Photo by Lois Conner, 1995

Opposite: This seated Buddha, powdered by desert dust and showing the damage wrought over fifteen hundred years, displays the childlike serenity and sweetness characteristic of the Buddha image in the fifth century. Cave 259, Northern Wei dynasty.

Photo by Lois Conner, 1995

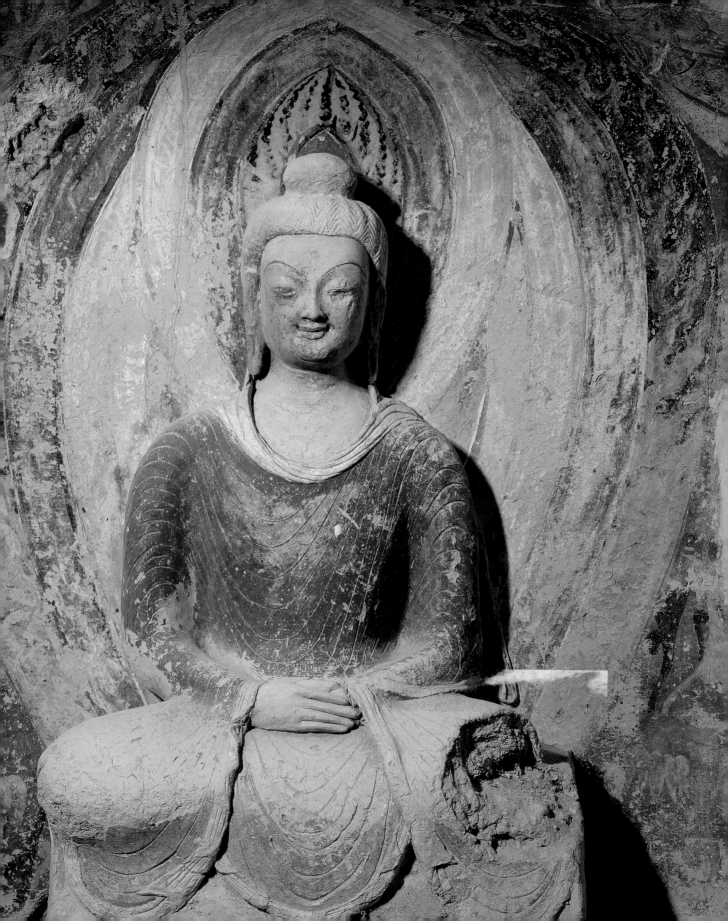

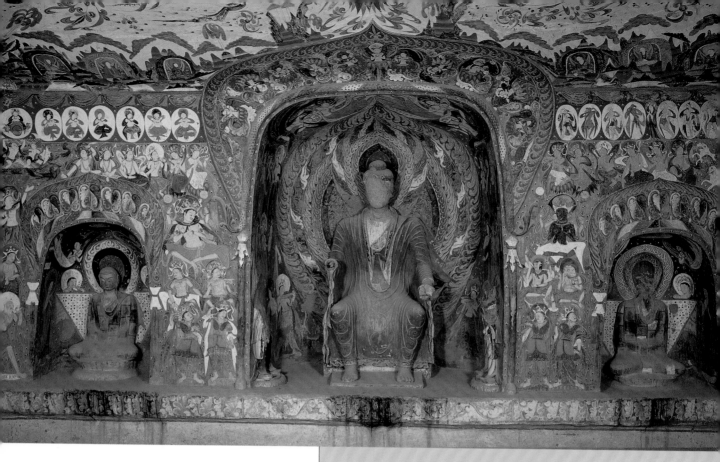

from central China and from various kingdoms along the Silk Road. By the second quarter of the sixth century, Dunhuang was important enough to have a member of the imperial Northern Wei house as governor. Under his patronage, two new, sumptuously decorated caves were cut in a previously untouched part of the cliff.

The construction of Cave 285, completed in 539, reveals that by this time the Mogao caves had become an important shrine for the faithful—and the powerful—throughout the region. The sidewalls are lined by niches for monks to sit in and meditate, inspired by the statues and paintings around them. The art and iconography of this cave afford a fascinating glimpse into the world of Dunhuang in the sixth century—a world of both opulence and peril, where both Indian Hindu gods and the ancient mythical deities of China were enlisted in the service of the newer religion of Buddhism;

Cave 285

Cave 285 was sponsored by a number of wealthy donors, led by Prince Dong Yang, a member of the Wei imperial house who was dispatched to Dunhuang in 523 and who would rule for some fifteen years as a local governor. Its sumptuous decoration reflects its aristocratic patronage. A sculpture of the Buddha dominates the main wall, flanked by figures of meditating monks, perhaps as an example for the living monks who meditated there. At the base of the ceiling, other hermits are shown sitting in cells among mountain landscapes. Flying spirits and divinities—many derived from traditional Chinese legends, others from Buddhist belief—cavort in the tumultuous heavens above.

Opposite: Statues of the Buddha and of monks.

Above left: A temple guardian.

Above: A celestial musician.

Left: The ancient Chinese deity Nuwa, father of the cosmos.

Photos by Wu Jian, 1999

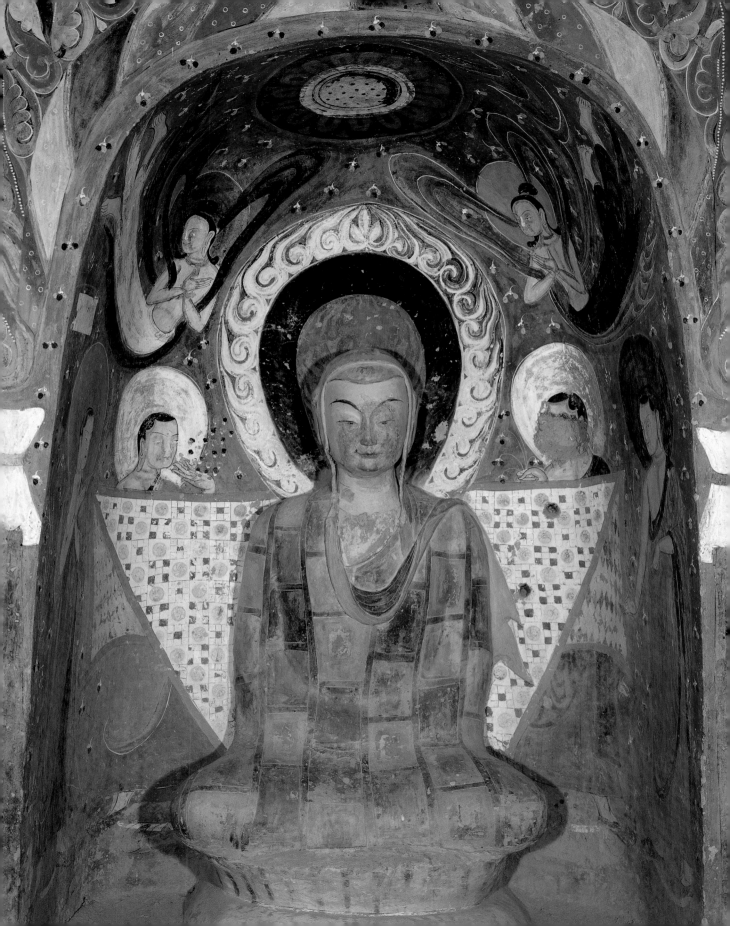

in short, the world of a frontier town on the Silk Road.

During the brief period when the Northern Zhou dynasty ruled northern China, Buddhism underwent a decline, as a Daoist monk persuaded the Zhou emperor Wu (r. 561–77) to proscribe the religion. The emperor needed little encouragement; although he was not Chinese by birth, he wished to appear Chinese, and he regarded Buddhism as foreign to Chinese traditions. The persecution in 574 caused widespread destruction of Buddhist institutions in central China. In Dunhuang, however, while two monasteries were destroyed, the Mogao caves apparently escaped serious damage.

The largest of the Northern dynasty caves, Cave 428, was, like Cave 285, also the creation of a governor of Dunhuang, a relative of the Northern Zhou imperial house. Unlike Emperor Wu, however, the Dunhuang governor favored Buddhism. This very large cave in fact represents the joint efforts of Buddhist devotees throughout the region, many of whom are pictured in donor portraits along the walls.

Another fresh start was made in the late sixth century, when China, after centuries of division into northern and southern empires, was unified once more. In 581 Yang Jian took the throne from the Northern Zhou and proclaimed himself Emperor Wen of the Sui dynasty. By almost superhuman effort, northern and southern China were united under a single ruler, largely because the first two Sui emperors were—or claimed to be—devout Buddhists. An imperial decree in 583, for example, authorized the repair of monasteries damaged or destroyed under the Northern Zhou; another in 593 ordered the replacement of images that had been destroyed. Monasteries were erected by imperial decree at the foot of the sacred mountains in every district. Well over a

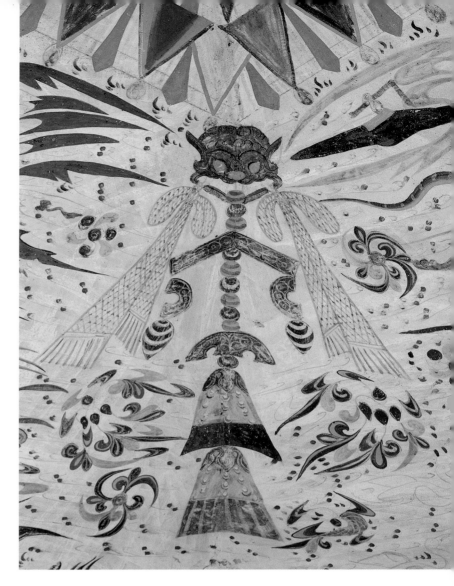

Opposite: This statue wears the traditional monk's robe, or kasaya, *made from patches of discarded cloth. The monks painted on the walls behind and beside him illustrate stages on the spiritual path. The monk on the right grasps flowers, whose stems are already wilting, as if to reproach his attachment to material things. The monk on the left, conscious of his material desires, vainly seeks to push away with his open palm the petals that nevertheless persist in attaching themselves to his person. The monks on the niche's sidewalls appear to have reached a higher stage of enlightenment: the flowers strewn by the heavenly beings above float down harmlessly, indicating the monks' freedom from attachment to material things. Cave 285, Western Wei dynasty.*

Photo by Lois Conner, 1995

Above: Monster mask with pendants in the shape of ancient Chinese jades. Cave 285, Western Wei dynasty.

Photo by Lois Conner, 1995

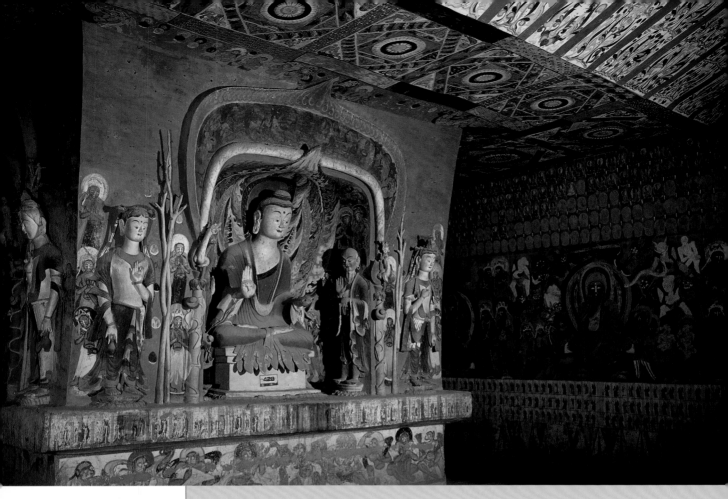

Cave 428

Cave 428 was commissioned by Prince Jianping, a relative of northern China's ruling Zhou dynasty, who was governor of the region from 565 to 576. The residents of Dunhuang alone could not have afforded such a cave, which was one of the most sumptuous of the early temple shrines at Mogao and which was sponsored by people throughout the region. The four niches of the central pillar each feature statues of Shakyamuni, the historical Buddha, flanked by bodhisattvas. The ceiling is decorated with vivid floral motifs and painted red rafters. The walls are adorned with preaching scenes of Shakyamuni; above are Thousand Buddha images, molded in shallow relief, some of which have fallen off; below are small portraits of the some thousand donors who sponsored the cave, including monks, nuns, and government officials.

Photos by Wu Jian, 1999

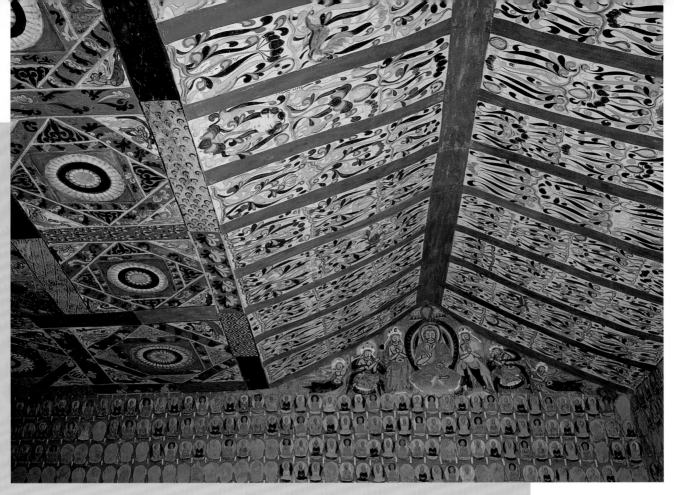

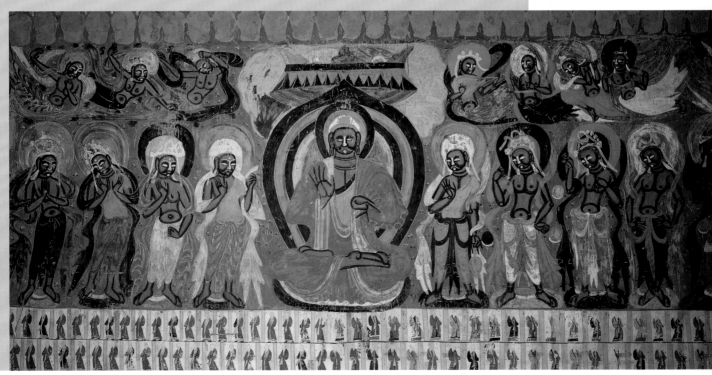

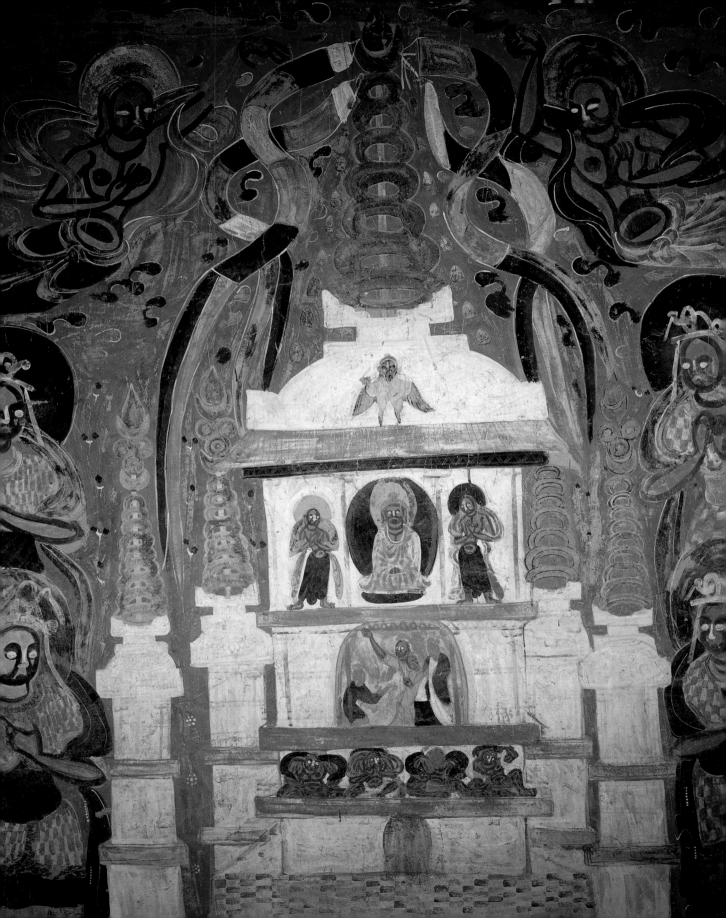

hundred stupas or pagodas were built, including one in the Dunhuang region, probably at Mogao.[1]

The Sui emperors used Buddhism as a major instrument of their rule, and, although it was far from the capital, Dunhuang was profoundly affected by their policies. One cave at Mogao was commissioned by an imperial envoy who was sent to Dunhuang in the years following the founding of the new dynasty; and, at about this time, a new lecture hall was constructed at the Mogao caves. Imperial patronage of Buddhism is apparent in the luxuriant style of images and in the tempo of cave construction, which accelerated to the point where almost two caves a year were being cut and decorated. In the mere four decades of the Sui dynasty, more than eighty new caves were fashioned. Sui imperial patronage is also evident in the large size of the Buddhas and bodhisattvas in several of the Sui caves.

Many of the most beautiful caves built during the Sui dynasty are extremely well preserved, and their decoration often reflects a remarkable aesthetic unity. The mural paintings and stucco images in the main niche of Cave 419, for example, blend beautifully together. The colors still appear brilliant after some thirteen centuries. Sculptors and painters worked closely together to achieve a harmonious effect, matching the fielded pattern of the *kasaya*, or monk's patched robe, to the subtly modeled lines of the drapery, and echoing the sculpted figures in the painted ones on the wall behind them. The high aesthetic standards of this period reflect the styles of images then being created in the Sui capital.

Ultimately, the sheer grace and delicacy of gesture of the Sui style at Mogao suggests that what we see there reflects the vanished masterpieces of temples long

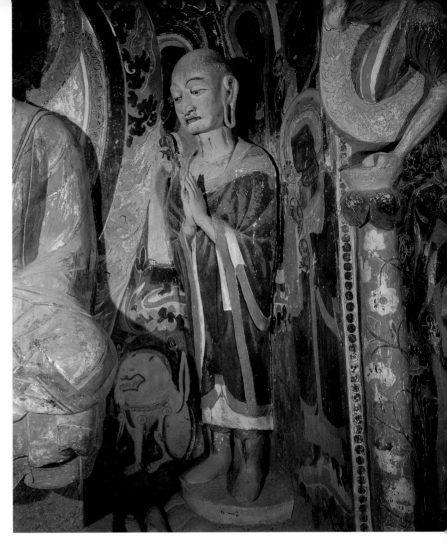

Opposite: This painting of a large stupa depicts the Buddha's life on earth and the relics he left behind. In the center is an arch with a scene of Shakyamuni being born; above, the Buddha sits in meditation. The stupa rests on the shoulders of four Atlas figures, an arrangement also found in Gandhara, where such figures appear to have been introduced from the Greek classical world. Cave 428, Northern Zhou dynasty.

Photo by Lois Conner, 1995

Above: Statue of the disciple Kashyapa. Other disciples and a Buddhist lion are painted on the wall. Cave 427, Sui dynasty.

Photo by Lois Conner, 1995

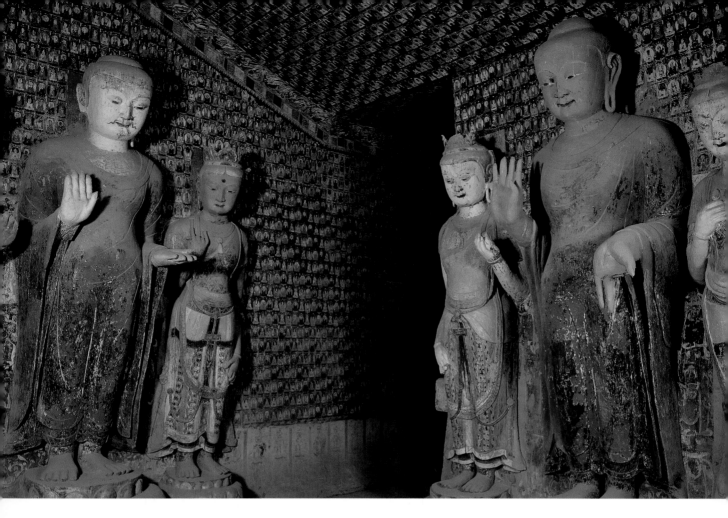

In Cave 427, probably the first and certainly the largest of the Sui dynasty grottoes, the main chamber is dominated by three groups of towering figures (above), each consisting of a Buddha and two bodhisattvas. The main Buddha figures are over five meters high. They correspond to the Buddhas of the past, present, and future, but it is easy to see in them a reflection of imperial portraiture and patronage. Other figures (right) astonish in their rich color and gilding and in their elaborate drapery patterns, which represent not only Chinese but also Sasanian silk weavings from Persia, which by this date were being freely traded along the Silk Road. Cave 427, Sui dynasty.

Above: Photo by Wu Jian, 1999

Right: Photo by Lois Conner, 1995

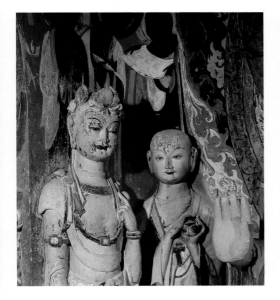

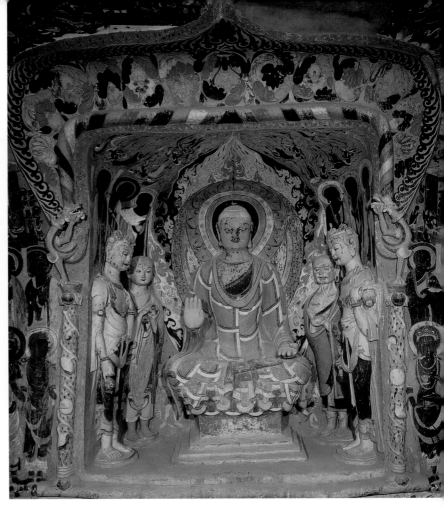

since destroyed in the Sui capital and other cities in central China. This marks Mogao's great importance, showing that it had become much more than a religious and artistic mecca for the vast, if sparsely populated, region west of the Yellow River. By the late sixth century, in fact, the "wonderful cliff" that the first solitary hermits had found so suitable for their lonely meditation cells had developed into a richly adorned showcase of Chinese imperial power.

NOTES

1. Dunhuang Research Academy, *Chugoku Sekkutsu: Tonko Bakkokutsu* (Chinese cave temples: Mogao caves of Dunhuang) (Beijing: Wenwu Publishing, 1987), 2:182 n.15.

This Buddha grouping exemplifies the harmonious integration of mural painting and stucco sculpture characteristic of the grandest cave shrines at Mogao. The graceful central Buddha figure reflects the style propagated throughout the empire on the instructions of the first Sui emperor.

The attendant stucco figures of disciples and bodhisattvas have an almost childlike innocence; those painted on the walls behind them are reading Buddhist texts. Flying celestials adorn the ceiling of the niche. Cave 419, Sui dynasty.

Photos by Lois Conner, 1995

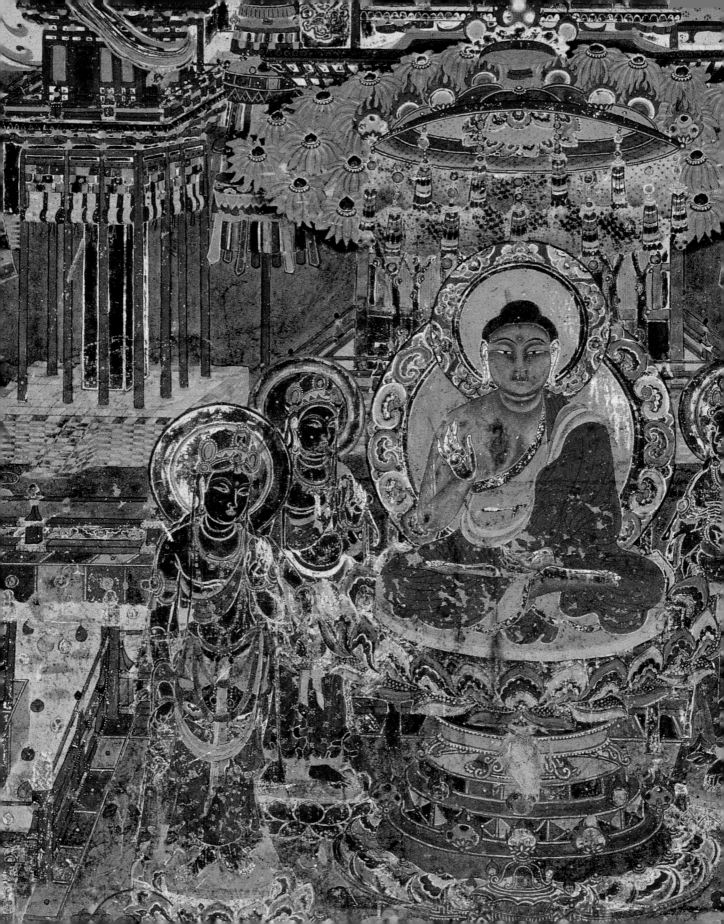

Temples of the Pure Lands

During the Tang dynasty (618–907), the Chinese empire, which had been united under the Sui (589–618), reached its vastest extension, spreading from the Pacific Ocean in the east across central Asia to far western outposts in Khotan, Karashahr, and Kashgar. Chinese civilization also reached its apogee. The capital of Chang'an, with its spacious avenues, was the world's largest and most cosmopolitan city, absorbing myriad foreign influences and consuming many exotic luxuries imported along the Silk Road. Chinese Mahayana Buddhism reached the summit of its popularity, and Chinese art became increasingly sophisticated and refined.

During the Tang dynasty, Pure Land paintings became increasingly popular at Mogao. Transcendent Buddhas, such as Amitabha, are portrayed ruling over their divine abodes.

Here Amitabha is flanked by bodhisattvas in the Pure Land of the West, which is adorned by elaborate celestial architecture. Cave 217, High Tang dynasty.
Photo by Wu Jian, 1999

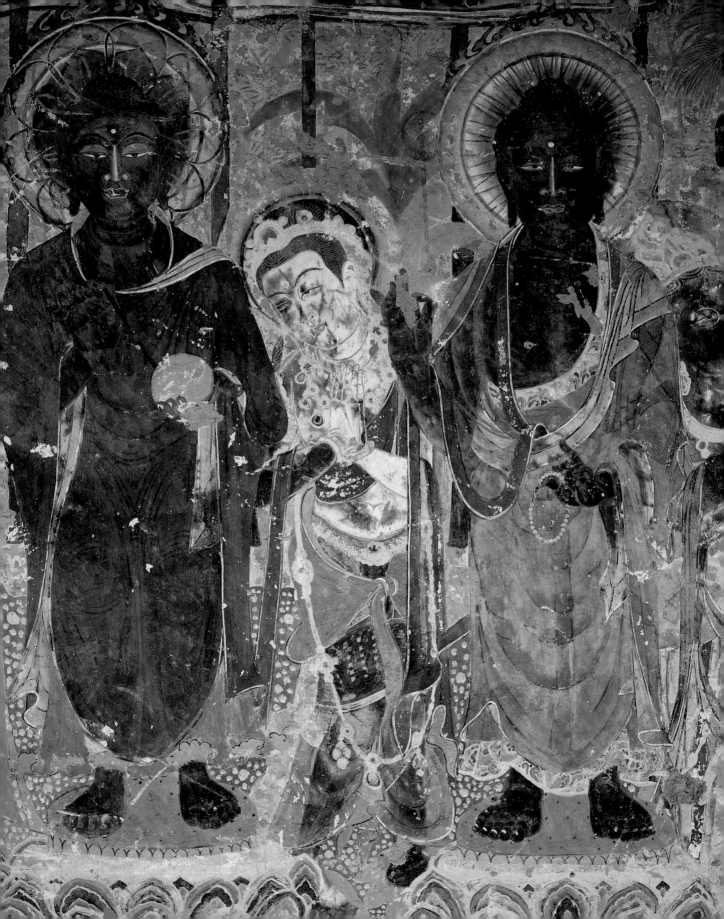

The remarkable vitality of Tang culture, along with the imperial ambitions of the Chinese nation, ensured the diffusion of Tang influence. It is possible, for example, to see similar styles in art in places as far apart as Mogao, on the western borders of the empire, and Nara, far to the east in Japan.

Although Mogao was remote from Chang'an, its art was strongly influenced by styles set in the capital. From 618 onward, during the Early and High Tang periods, until Dunhuang was conquered by Tibet in 781, the area was under Chinese rule. The art of the Mogao caves reached new heights of elegance and sophistication, reflecting the cultural vitality and political power of the Tang empire and the increasing importance of Buddhism in Chinese culture. The splendor of the Tang period at Mogao is reflected in the sheer number of caves hewn from the cliff and in their sumptuous ornamentation. The groups of Buddhas, bodhisattvas, and other figures, both in the mural paintings and in the statue groupings, grow ever more colorful and magnificent. These preaching scenes and assemblies evoke the splendor of the Buddhist paradises, offering to all believers, through the intermediary of the great bodhisattvas, the hope of rebirth in the Pure Lands.

Although there were hundreds of large monasteries in Chang'an, none have survived, and the wall paintings they contained perished with them. At Mogao, however, scores of large wall paintings and virtually complete cycles of decoration remain; with their rich coloring and inventive compositions, they are reflections of lost masterpieces from the metropolitan monasteries. Tang art at Mogao, therefore, affords invaluable insight not only into the art of this region but also into the art of the Chinese capital.

The early years of the Tang dynasty saw the completion of some caves begun under the Sui, but it was not until 642 that a new wave of artistic influence reached the site. That year marks the completion of Cave 220, also known as the Cave of the Cui Family, generations of whom inherited the responsibility for its upkeep and were still looking after it when it was refurbished almost three centuries later. The cave's wall paintings reflect the latest fashions in coloring, style, and iconography depicted on the walls of the capital's great monasteries by the most famous painters of the time. Contemporary writings tell us of the exploits of these masters, but little of their work survives—only imperial and princely tombs with extensive sequences of wall paintings that are almost exclusively secular in nature, such as hunting, polo, and garden scenes. The testimony from Dunhuang is thus all the more precious. The murals in Cave 220 suggest that these artists were being influenced by new images from India, before their own creations were brought halfway back again to Dunhuang. This freedom of artistic influence and invention characterizes the nature of cultural contacts along the Silk Road from the mid-seventh to the mid-eighth century—the most glorious period of the Tang dynasty.

Even the location of Cave 220, some 140 meters south of the nearest earlier cave, indicates that a new start was being made. The interior also marked a new departure, for instead of the usual arrangement, in which a central panel of a preaching scene

Opposite: The Medicine Buddha Bhaishajyaguru was said to look after the spiritual and physical needs of all sentient beings. Devotees believed he could heal the sick. The left-hand figure holds a medicine bowl. The dark skin tones are the result of pigment oxidation. Cave 220, Early Tang dynasty.

Photo by Lois Conner, 1995

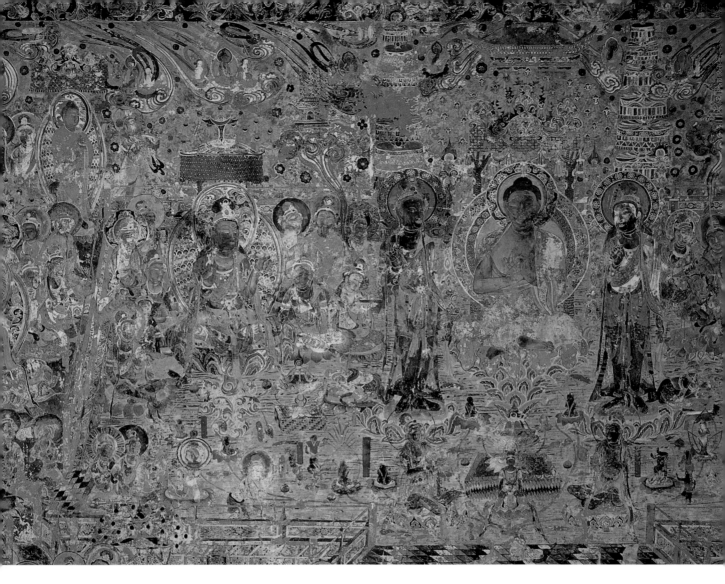

The Buddha Amitabha sits on a lotus blossom in the Pure Land of the West, flanked by two bodhisattvas and their heavenly retinues. Infants, representing the souls of those recently reborn into this paradise, dance joyously or kneel in reverence. Other souls, not yet ready for rebirth, are enclosed inside transparent—but still unopened—lotus buds. Cave 220, Early Tang dynasty.

Photo by Lois Conner, 1995

was set among depictions of the Thousand Buddhas, each sidewall is devoted to a single large painting much more elaborate than any earlier works. These murals reflect the growing popularity in China of the Pure Land school of Mahayana Buddhism, with its emphasis on rebirth in paradises ruled by transcendent Buddhas, who, assisted by saintly bodhisattvas, could offer solace to suffering humanity.

On the left, or southern, wall is a representation of the Pure Land of the West, the domain of Amitabha, the Buddha of Boundless Radiance. In conformity with a Chinese belief that the next world was actually located in the west, his Pure Land would become the most popular and would serve

as the model for the paradises of other Buddhas. Such Pure Land paintings are one of the central features of Tang art at Mogao and of the Pure Land faith. Devotees, through their devotion and meritorious deeds—such as calling on Amitabha's name, reciting his sutra, or having it copied—would aspire to be reborn in the Pure Lands after their death, instead of returning to a new cycle of birth and life as a human being, or, worse, as an animal, as a hungry ghost, or in hell.

The right, or northern, wall of Cave 220 features seven standing images of Bhaishajyaguru, or the Medicine Buddha, standing side by side on lotus pedestals on a jeweled platform. According to the

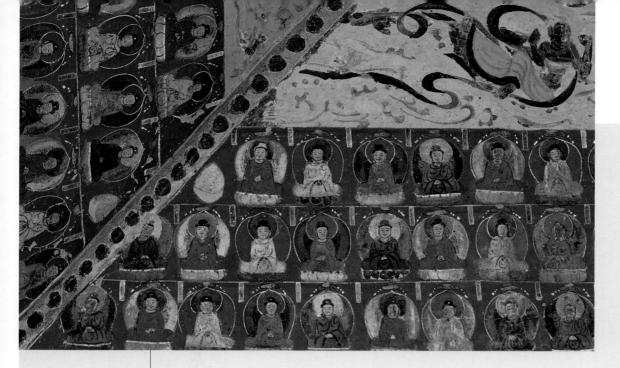

Making and Painting the Peerless Caves

During the Tang dynasty, the Thousand Buddha motif, which symbolized the omnipresence of Buddha-nature in the universe, often adorned the soaring ceilings of the cave shrines. The ceiling shown in detail, above, and in full on pages 76–77 is among the most lavish. In the centerpiece, lotus flowers and flying celestial beings also can be seen. Cave 329, Early Tang dynasty.

Photo by Wu Jian, 1999

The construction and decoration of the cave shrines at Mogao involved a wide range of the local populace. First a cave would be commissioned — by officials, monks, governors, merchants, or, often, a combination of these. One might serve as a master patron, who would make a substantial contribution as well as solicit funds from a number of additional donors. The responsibility for the cave's upkeep was often passed on to the master patron's descendants, and it could stay in the same family for generations.

The caves were excavated by a team of *lianggong* (good workmen), who chiseled out the ceiling and walls, which were then plastered with clay tempered with chopped straw and finished with a thin layer of plaster. In return for their labor, the workers might have received meals in the monastery on the valley floor. The paintings would have already been commissioned. They were executed by *qiaojiang* (skilled workmen) under the direction of a senior Buddhist monk. The overall scheme of the wall decoration was carefully planned. The most important paintings were accorded the most space; smaller narratives and scenes flanked them. A master painter might do a freehand sketch of the figures' outlines, and other painters would then add detail and color. The master artists enjoyed considerable reputations, often coming to Mogao from afar; they were paid by the painting, while lesser local artisans were generally paid on a time basis.

For the Thousand Buddha motif often used on walls and ceilings, pounces — perforated patterns, or stencils —were used. The outline of the Buddha image was drawn in ink on squares of thick local paper and then pricked through with a needle. Next, the artist would fill a cloth bag with finely powdered dry pigment, such as charcoal. With one hand holding the pounce in place, the artist would bang the powder bag against it so that powder would leak through onto the wall behind, leaving a faint dotted outline. This outline would then be painted in.

The work in progress was periodically inspected by monks from the monastery, as well as by officials and various donors. Statues were usually modeled on-site and then painted; decorative elements such as halos were sometimes modeled in low relief on the wall behind the sculpted figures. The construction of a large cave under the direction of a distinguished monk served to commemorate his achievements and mark the glory of his family. As for the painters, while much of their work remains, their names have long been forgotten.

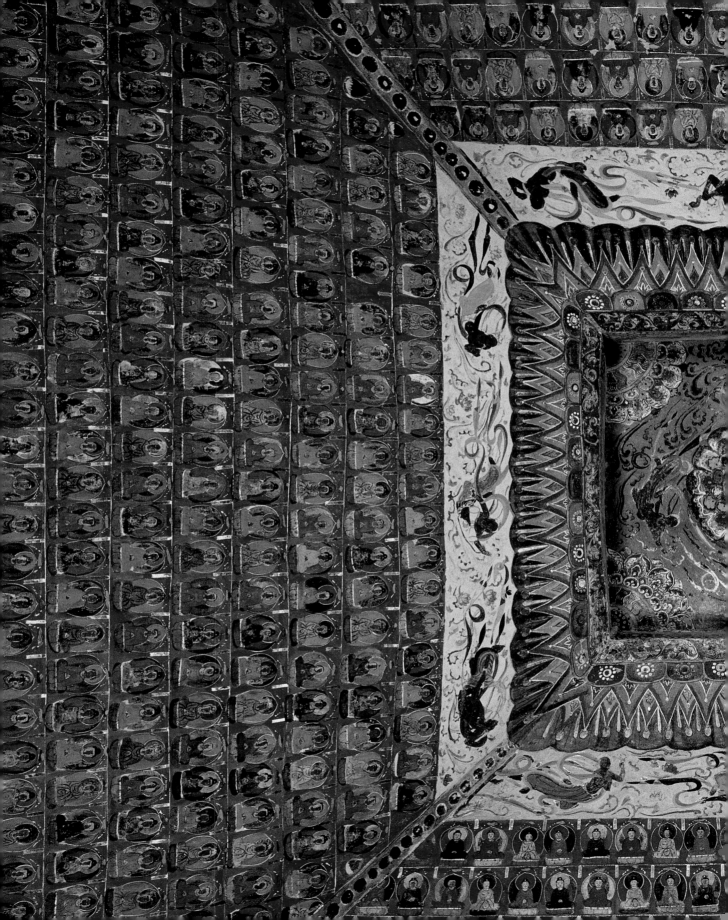

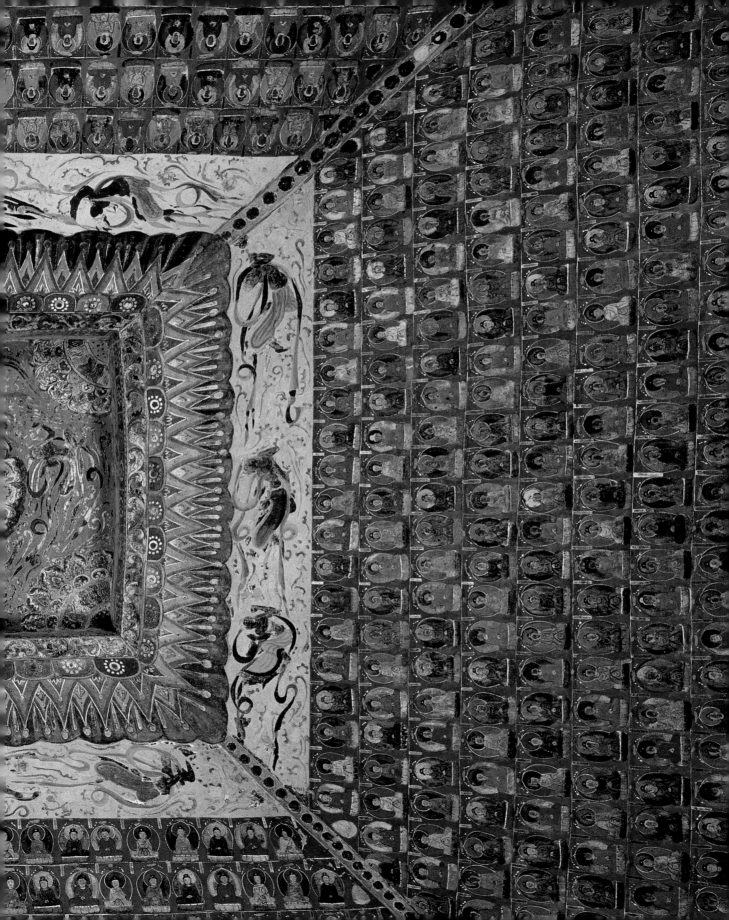

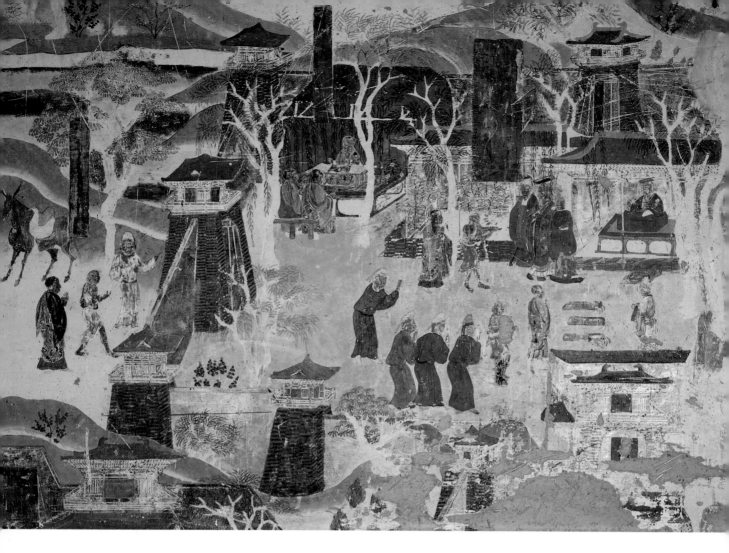

This narrative painting uses details of daily life to illustrate the Parable of the Conjured City from the Lotus Sutra. It depicts a city conjured up as a place of rest by the leader of pilgrims who are in danger of abandoning their difficult journey. In the upper center, a senior monk offers instruction to two novices. In the center, a figure who may be the emperor receives a gift of a scroll. On the upper right, an official, seated on a dais, hears petitions from a line of supplicants, or perhaps he is registering the tribute gifts laid out before him. *Cave 217, High Tang dynasty.*

Photo by Lois Conner, 1995

sutra dedicated to him, Bhaishajyaguru had vowed to provide for the bodily and the spiritual needs of sentient beings. Reading the Bhaishajyaguru Sutra, lighting lamps on seven-tiered candelabra, and hanging forty-nine-foot banners were the prescribed forms of worship. In the version of his sutra recently translated by the monk Xuanzang, devotees had been instructed to make seven images of this Buddha. Two of the seven standing images on this wall are shown on page 72. A composition of seven standing images was never repeated, whereas the composition of Amitabha's Pure Land would be developed, with the addition of more elaborate architecture, and repeated hundreds of times (see pp. 70–71).

The close links between the Tang capital and Dunhuang are also evident in

a large painting on the cave's east wall depicting a famous debate described in the Vimalakirti Sutra between the rich layman Vimalakirti and Manjushri, the Bodhisattva of Wisdom. In the earliest depictions of the debate, which are generally quite small, those listening consist simply of rows of monks or bodhisattvas. Here, the scene is depicted on a large scale, and the audience includes the Chinese emperor and his entourage, as well as various foreign rulers. The emperor, preceded by two standard-bearers, is the largest figure: he wears a mortarboard crown, and his ample robes are adorned by a slender white dragon and the imperial symbols of the sun and moon. This is exactly the way in which the great figure painter at court, Yan Liben (d. 673), portrayed an entire series of emperors in a magnificent hand scroll on silk, now in the collection of the Museum of Fine Arts, Boston. The resemblance confirms that the new, whole-wall compositions seen at Dunhuang in the very first Tang cave were inspired by the masterpieces of artists in the Tang capital. They may even have been executed by painters sent from the Chinese court.

Indeed, the Tang murals at Dunhuang afford a variety of insights into manners and mores in the great metropolis of Chang'an. Vignettes drawn from life in the capital enlivened many depictions of sutra tales, especially the parables found in the immensely popular Lotus Sutra, which by the Sui and Tang dynasties had assumed a position of foremost prominence in the Buddhist canon. This can be seen in Cave 217, which was built in the eighth century by a later generation of the same family that had played a prominent role in the construction of Cave 285 in 538 C.E. The paradise scenes are surrounded by renderings of stories from the Lotus Sutra, notably the Parable of the Conjured City. With their

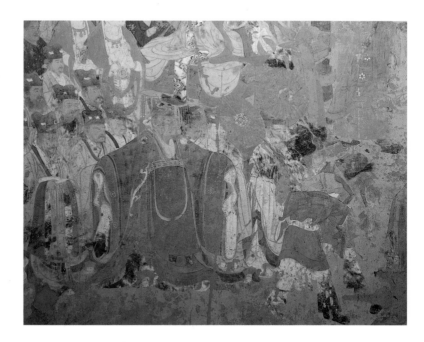

depiction of fine detail, such scenes serve as windows on daily life in Tang China.

By the late seventh and early eighth century, Chinese Buddhism had reached its apogee, and thus it was possible to devote virtually the whole of the wall space in a fairly large cave, such as Cave 323, to illustrating important events, both historical and legendary, relating to the history of the religion in China. This cave, in fact, could be said to represent a kind of illustrated history of Chinese Buddhism (see pp. 17–18). It was cut and decorated in the reign of the Empress Wu Zetian, who gained the throne and declared herself the first woman emperor in 690. From then until her death in 705, she invited a succession of notable Indian monks to the capital and sponsored their translations; she herself even wrote the preface to the longest of these, the Garland Sutra.

The growing popularity of the Pure Land school during the Tang dynasty, and the consequent proliferation of large paintings depicting Amitabha and other

In this fine example of Tang figure painting, the Chinese emperor listens to a debate of Buddhist doctrine. Cave 220, Early Tang dynasty.

Photo by Lois Conner, 1995

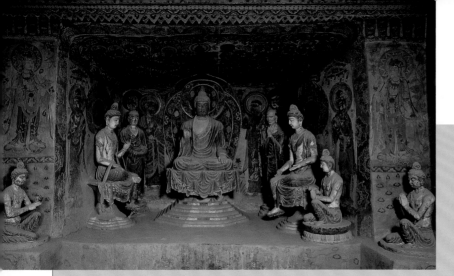

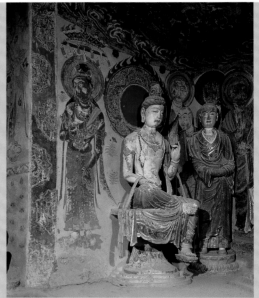

Cave 328

Cave 328 was created between 683 and 704, during the reign of Empress Wu Zetian, China's only female ruler. Its entrance wall was repainted in the eleventh century, but the deep niche in the west wall has survived for some thirteen hundred years in virtually its original state. Particularly striking is the group of stucco sculptures: a large seated Buddha, probably Amitabha, who reigned over the Pure Land of the West, flanked by his disciples and two great seated bodhisattvas; three smaller bodhisattvas also can be seen. Sculptural technique had become quite sophisticated by the Tang dynasty, and for dramatic effect and vivid coloring and gilding, these figures are truly remarkable. The demure appearance of earlier sculptures, with their simple robes often inherited from the Greco-Indian art of Gandhara, have here given way to lively poses and expressions and richly modeled draperies. Some figures, like the bodhisattvas, nearly naked above the waist save for jewelry, and with clinging robes of shimmering silk below, reflect Indian influences; other features, like the richly painted floral designs, seem to be inspired by the sumptuous fashions and embroideries of the Chinese capital. Gorgeous, flaming halos of the two seated bodhisattvas, along with much rich ornament, are painted on the wall behind.

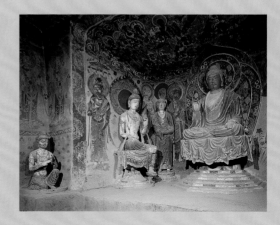

Upper left:
Photo by Wu Jian, 1999

Above and opposite:
Photos by Lois Conner, 1995

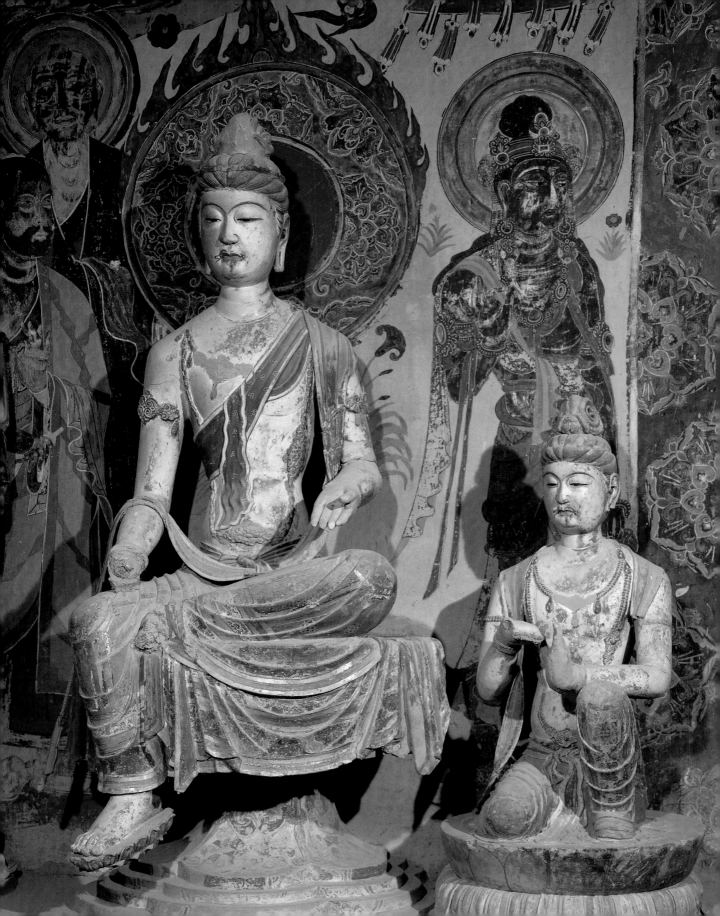

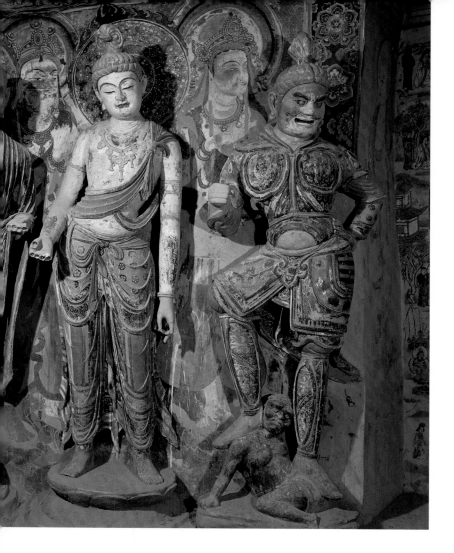

The graceful and serene bodhisattva on the left is accompanied by a heavenly king arrayed in armor. Cave 45, High Tang dynasty.

Photo by Lois Conner, 1995

Buddhas in their divine abodes, meant that older Buddhist stories, such as the jataka tales telling of Shakyamuni's virtuous deeds in his earlier existences, which once had dominated the walls, would eventually be allotted less space. In Cave 72, for example, the tigress jataka is relegated to a small panel inside the west niche.

Following the An Lushan rebellion in 755, the great flowering of Tang court culture came to an end. China withdrew its troops from the Western Regions, and by 781 the Tibetans controlled Dunhuang, where they ushered in a new period in the art of Mogao. This period of Tibetan occupation (781–848) is known as the Middle Tang, even though Dunhuang was no longer under Chinese control. Recent converts to Buddhism, the Tibetans were enthusiastic in their devotion, bringing a new zest to the opening and decoration of cave temples, forty-eight of which can be dated to this period of just seven decades. The Tibetan caves continue the High Tang tradition of Pure Land scenes, but the need to accommodate the ever-growing repertory of sutras, as the Buddhist canon continued to expand, meant that as many as three of these might have to be depicted on a single wall, each image measured exactly and framed with floral borders. This regimented display ensures a very different atmosphere, with new subject matter and ornamental features.

The influence of Tibetan Buddhism continued after the end of Tibetan rule. The new school of Esoteric, or Tantric, Buddhism emphasized fierce deities and complex diagrams of their cosmic relationships. In Mahayana Buddhism, all sentient beings, through the agency of the compassionate bodhisattvas, had the possibility of rebirth in the Pure Lands, there to encounter the most favorable conditions for attaining enlightenment. In theory, all

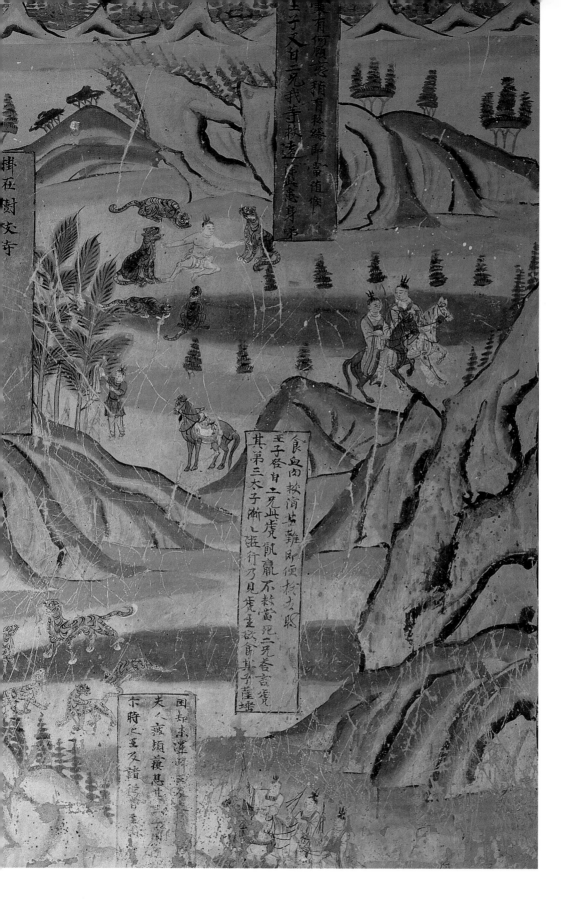

This jataka narrative, recounting an episode from a previous life of the historical Buddha, reads from bottom to top: Riding through the forest with his two brothers, the Buddha-to-be comes upon a starving tigress and her cubs, whom he compassionately resolves to feed with his own flesh. As his brothers ride off, he hangs his clothes on a tree. Finally, he sits among the beasts, who appear playful rather than ravenous. Cave 72, Song dynasty.

Photo by Lois Conner, 1995

Lady Song, wife of the Dunhuang general Zhang Yichao, is shown in this ceremonial procession from a series of panoramic paintings honoring her husband's victory over the Tibetans in 848 (see pp. 26–27). The luxurious accoutrements of the general's lady speak both of his military power and of his social prestige. Cave 156, Late Tang dynasty.

Photo by Wu Jian, 1999

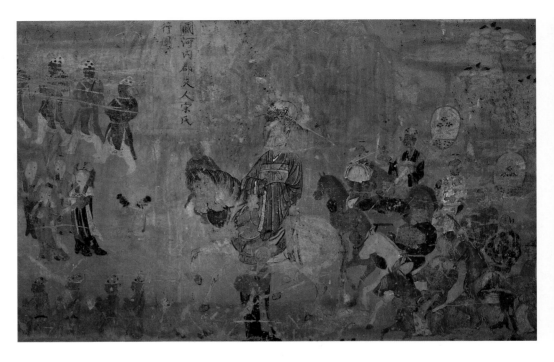

beings could eventually become Buddhas and achieve nirvana. In Esoteric practice, the process was speeded up, with the direct and secret transmission of spiritual knowledge from teacher to pupil. Together with the recitation of mantras or secret spells, Esoteric Buddhism offered the possibility of attaining enlightenment within a single lifetime.

The victory in 848 of the local general Zhang Yichao, who led the inhabitants of Dunhuang in expelling the Tibetans, ushered in a period of increased political autonomy for Dunhuang. Thenceforth, although the area remained nominally under Chinese rule, Zhang Yichao and his descendants exercised power. The Mogao art of this period, from 848 until the final collapse of the Tang ruling house in 907, is known as Late Tang.

Zhang was a major patron of the cave temples, and several large caves were fashioned under his rule. While in the earlier Tang period Mogao art had been

strongly influenced by the Chinese capital, following the Tibetan conquest relatively little artistic inspiration made its way to Dunhuang from metropolitan China. The Late Tang period, however, did see an infusion of fresh subject matter. This is evident in the murals in Cave 156, completed in 865 to celebrate the end of Tibetan rule. The donor portraits along the two sidewalls are quite different from those of any earlier cave; they show Zhang's victory parade and, on the opposite wall, a similar procession led by his wife, Lady Song. Guards, musicians, dancers, riders, and huntsmen celebrate the return to power in a way that reflects imperial ceremony and aristocratic pursuits of the time. In this mural, Zhang, not content with merely showing his devotion to the Buddha, has depicted both his military power and his social prestige. The treatment of such worldly concerns would become an important thematic and stylistic feature of murals in the later caves.

Another large Late Tang cave is Cave 16, fashioned under the direction of the monk Hongbian, who, as Zhang Yichao's religious counterpart, was the chief of monks in the entire Hexi region. Here, as in a number of the large caves built on the initiative of the secular rulers of Dunhuang, a small memorial chapel opens off the entrance corridor, honoring the monk who had been responsible for the execution of the enterprise. Cave 17, where Abbot Wang found the manuscripts later collected by Stein, Pelliot, and others, was originally a memorial chapel honoring Hongbian. The statue, removed to an adjacent cave in the eleventh century to make room for the cache of old manuscripts, has now been put back in place. In 851 an imperial decree had granted Hongbian, as Zhang Yichao's religious associate, several titles and the honorary right to wear purple silk, fragments of which were found sealed inside the statue's torso.

During the Late Tang period, Mogao painters used a reduced palette of colors, probably owing to disruptions of trade on the Silk Road; these colors could nonetheless be put to effective use. In Cave 14, where two colors predominate, the panels on the sidewalls display the iconography of Esoteric Buddhism, first introduced under the Tibetans. Bodhisattvas such as Avalokiteshvara and Manjushri are portrayed with a thousand arms, the better to save all sentient beings.

After the collapse of the Tang ruling house in 907, Dunhuang was governed by the Zhangs until about 920, when the military command passed to the Cao family, five generations of which continued to rule the region for more than one hundred twenty years. The period from 907 to 960 in China is known as the Five Dynasties. The House of Cao established its own painting academy, which gathered together

Hongbian, the chief monk in the Dunhuang region, sits in meditation, hands concealed beneath his monastic robe, his water bottle and pilgrim's satchel painted on the wall behind him. His expression radiates authority and power. Cave 17, Late Tang dynasty.
Photo by Lois Conner, 1995

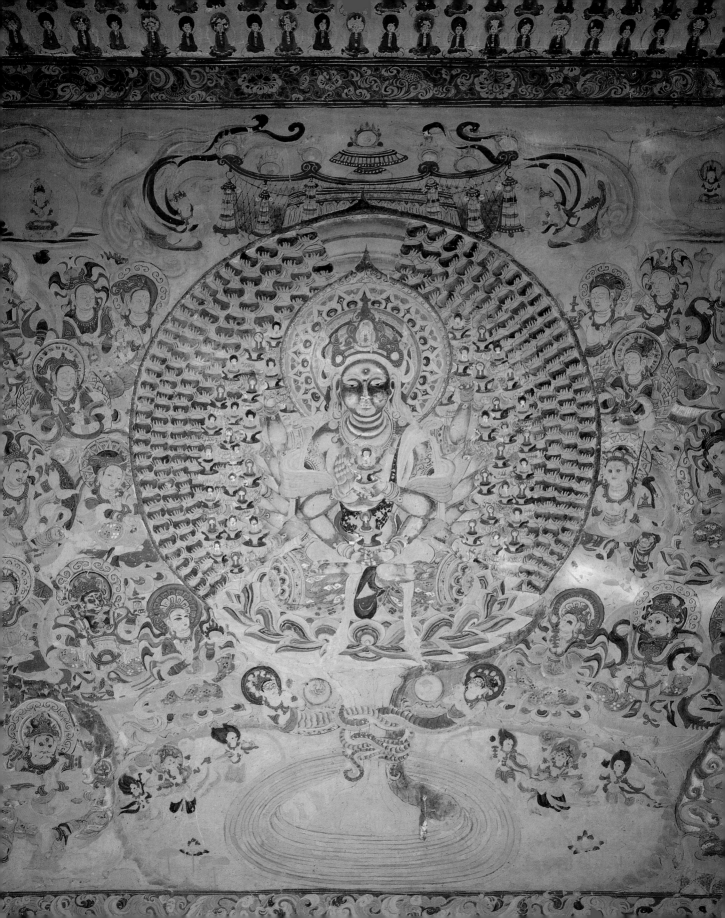

many leading regional artists. During this time, some twenty-six new caves were cut, and more than three hundred were renovated, as the new rulers were careful to restore—and, at times, refashion in their own image—the artistic heritage of Dunhuang. Some of the largest caves were cut under their rule, sometimes swallowing up four or more early caves in the process.

Cave 98 was begun in 920 by Cao Yijin, soon after he assumed his post as the new ruler of Dunhuang. He and his successors followed Zhang Yichao's example in using the caves as the place where they and their families advertised themselves and the sources of their power, with mural portraits sometimes reaching life size. Of particular importance, after the portraits of the rulers themselves, generally placed in the entrance corridor, are those of their wives and daughters, each labeled with a cartouche giving name and place of birth. As with earlier donor portraits, the inscriptions indicate which of the donors were still living and which were already deceased at the time the cave was constructed.

In Cave 61, as in many of the later caves, devotional and religious themes coexist with more worldly concerns. Constructed between 947 and 951, it is dedicated to the Bodhisattva of Wisdom, Manjushri, and is dominated by an immense panorama of Mount Wutai, in present-day Shanxi Province, held to be Manjushri's abode on earth. The chamber's other main walls feature long processions of donors, some life size, testifying to the prestige of the Zhang and Cao clans. The serried ranks of female devotees include many from distant regions such as Khotan, brought in as brides for members of the ruling families. In this way, the bridal portraits commemorated political alliances made with neighboring states. Their costumes feature elaborate embroidered decoration, much of central Asian

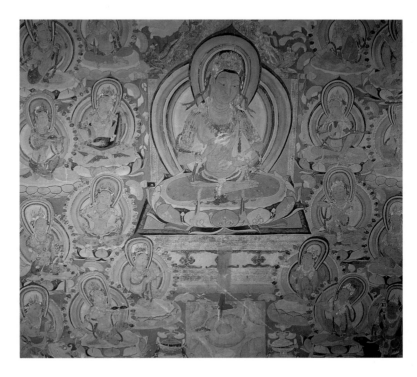

Opposite: This ethereal depiction of Manjushri, the Bodhisattva of Wisdom, shows the influence of Esoteric Buddhism. He is seated on a lotus throne atop Mount Sumeru, which rises from the midst of a sea. The coiling snake refers to an Indian myth in which the cosmic ocean is churned by the gods. The deity's many hands hold alms bowls, some of which contain seated Buddhas. This imagery symbolizes an infinity of universes as innumerable as the grains of sands in the Ganges. Cave 14, Late Tang Dynasty.

Photo by Lois Conner, 1995

Above: This Tantric bodhisattva of female aspect, named Vajrasattva for the vajra, or diamond club, she holds in each hand, personifies the indestructibility of wisdom. Cave 14, Late Tang Dynasty.

Photo by Lois Conner, 1995

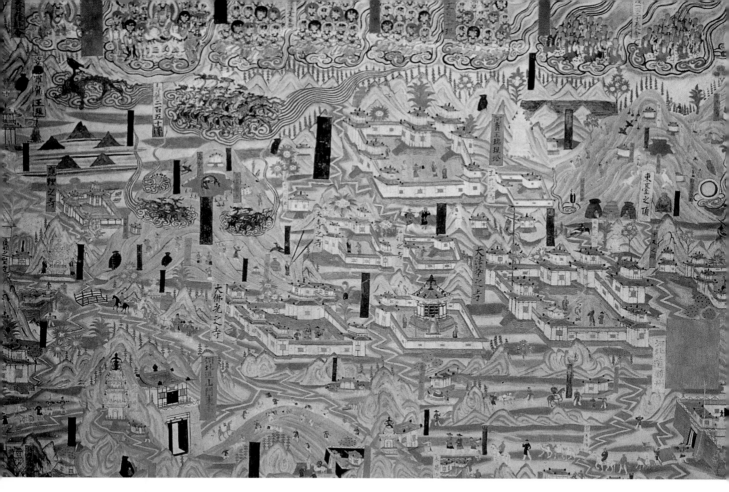

This panoramic view of Mount Wutai, said to be the worldly abode of the Bodhisattva of Wisdom, Manjushri, is a grandiose depiction of both landscape and architecture. Various monasteries and vignettes are portrayed in remarkable detail (see also page 122). Cave 61, Five Dynasties.

Photos by Wu Jian, 1999

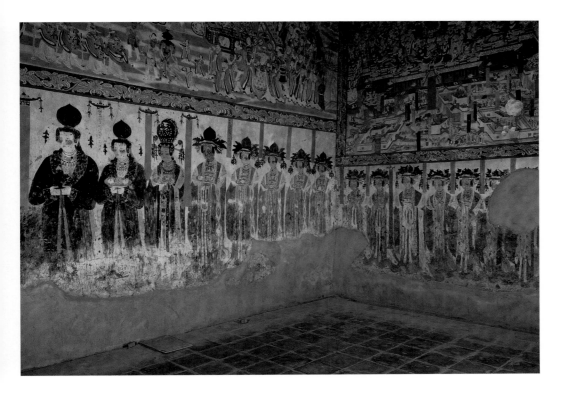

After the expulsion of the Tibetan occupiers in the mid-ninth century, many new caves advertised the political power of the Dunhuang rulers. Seen here are donor portraits of women related by marriage to the rulers of Dunhuang.

Left: Cave 61, Five Dynasties.
Photo by Wu Jian, 1999

Below: Cave 98, Five Dynasties.
Photo by Lois Conner, 1995

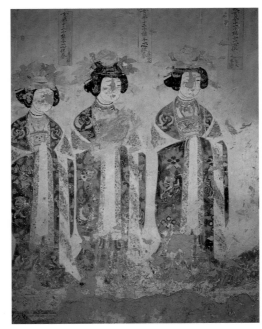

rather than Chinese origin, with motifs such as phoenixes and floral scrolls or, in the case of a Uighur khan, dragon medallions. Such alliances helped to strengthen the power of the Cao family in their dealings with neighboring peoples.

After being absorbed into the Uighur empire, probably in the early eleventh century, Dunhuang became part of the empire of the Western Xia around 1072. They would rule Dunhuang until the Mongol conquest in 1227. Under Western Xia rule, some eighty caves were built or restored. Although the late large caves provided space for more and bigger sutra illustrations, they seem to have as their main themes the subjects of worldly circumstance and the advertisement of favorable marriage alliances with both neighboring and distant peoples. The pious refurbishing of earlier caves was often accompanied by the narrowing of the cave entrances, which

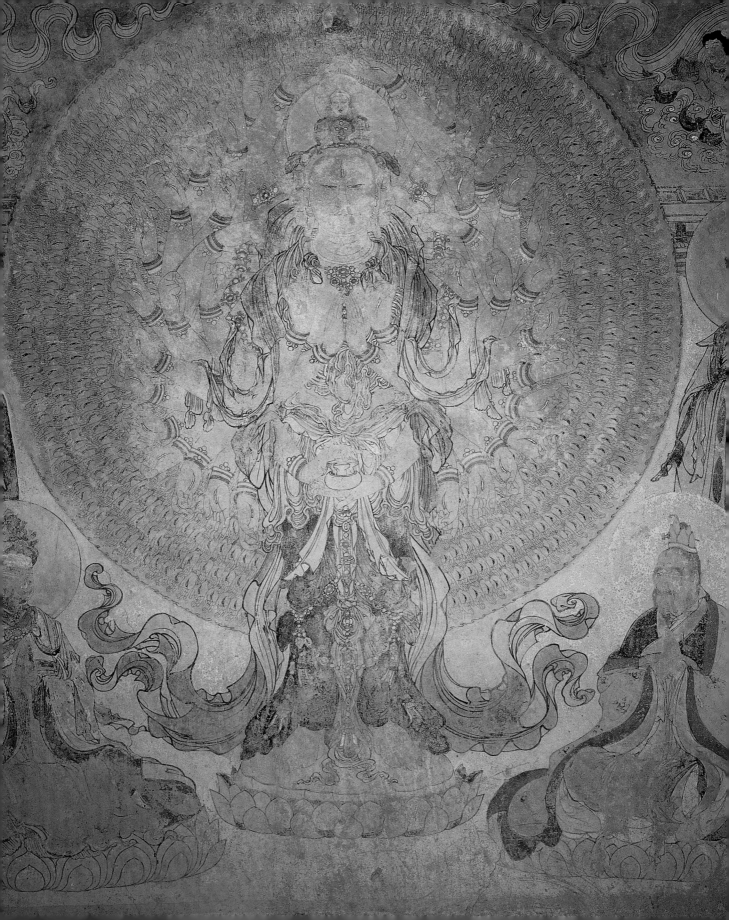

has helped to protect the caves and their art from the sun. However, while such redecoration may have been bright and colorful, it is often fairly repetitive and lacks the variety and artistic quality of earlier periods.

Nevertheless, construction of these caves did not mark the conclusion of activity at the site. During the Yuan dynasty of the Mongols, several additional cave temples were dug and decorated—the last to be made at Mogao. In addition to a small cave featuring the water moon and Thousand Arm Avalokiteshvara, one more large shrine was made under the Mongols in the fourteenth century. In both style and subject matter, the decoration of this cave is quite distinct from all that had gone before; it shows the Mongol preference for Tantric Buddhism from Tibet, with which both Genghis Khan and Kublai Khan maintained frequent relations. To judge from its position at the far northern end of the cliff face, it was intended as the first in a whole new series of caves. However, by the 1350s, almost exactly one thousand years after the first caves had been fashioned by a few wandering monks, artistic activity at the Caves of the Thousand Buddhas was finally ending. The Yuan dynasty fell a few years later. Although both the Ming and the Qing courts continued to have exchanges with the Tibetan hierarchs, these exchanges took place in the Chinese capital. With the closing of the Silk Road, the vitality had gone from the region, and no more grotto shrines would be opened at Mogao.

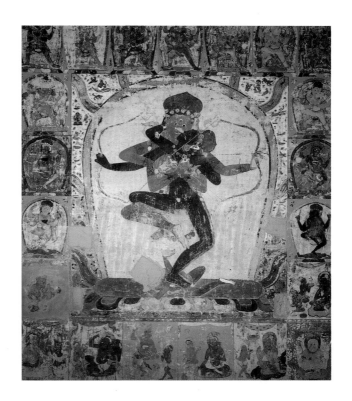

This Tantric image shows a deity and his consort, who personifies wisdom and the deity's female energy. Cave 465, Yuan dynasty.

Photo by Lois Conner, 1995

The caves opened after the Mongol conquest reflect the influence of Tibetan Tantric Buddhism, which was popular at the Mongol court. Here the bodhisattva Avalokiteshvara, known in Chinese as Guanyin, is depicted in Tantric form with one thousand arms, the better to save all beings. Cave 3, Yuan dynasty.

Photo by Lois Conner, 1995

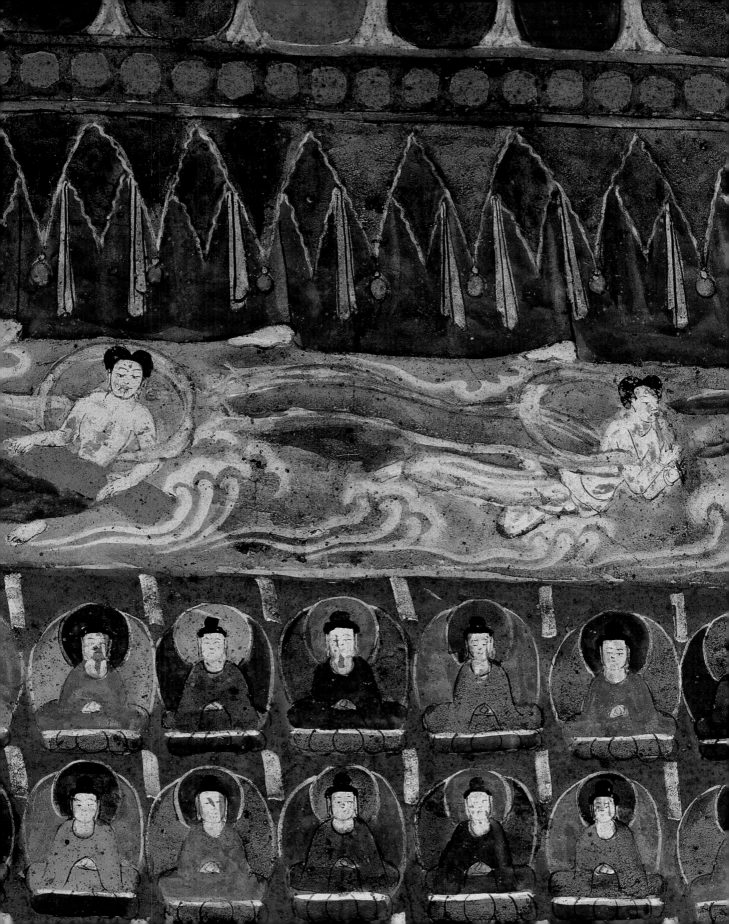

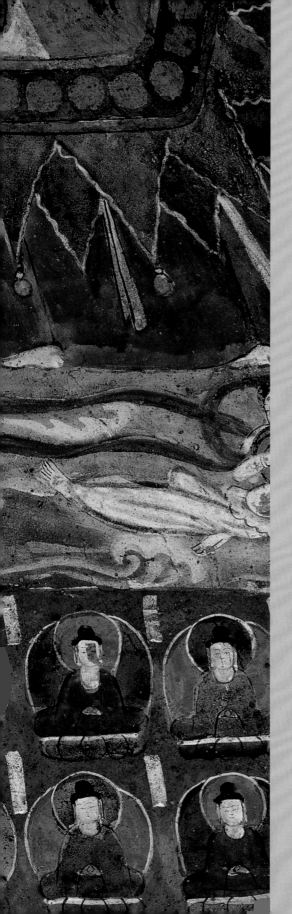

A Millennium of Murals

The forty-five-thousand square meters of wall paintings in the Mogao cave temples, fashioned over the course of nearly one thousand years, provide an unequaled overview of mural art between the fifth and the four-teenth centuries. Primarily Chinese in style, they also reflect central Asian, Indian, and Tibetan influences, all of which were carried along the Silk Road to Dunhuang. Buddhist imagery predominates, but many other subjects are treated as well. Rich in color, incident, and ornamentation, the murals of Mogao are among the great treasures of world art.

Apsarasas playing music adorn this section of a Thousand Buddha ceiling. Cave 322, Early Tang dynasty.
Photo by Wu Jian, 1999

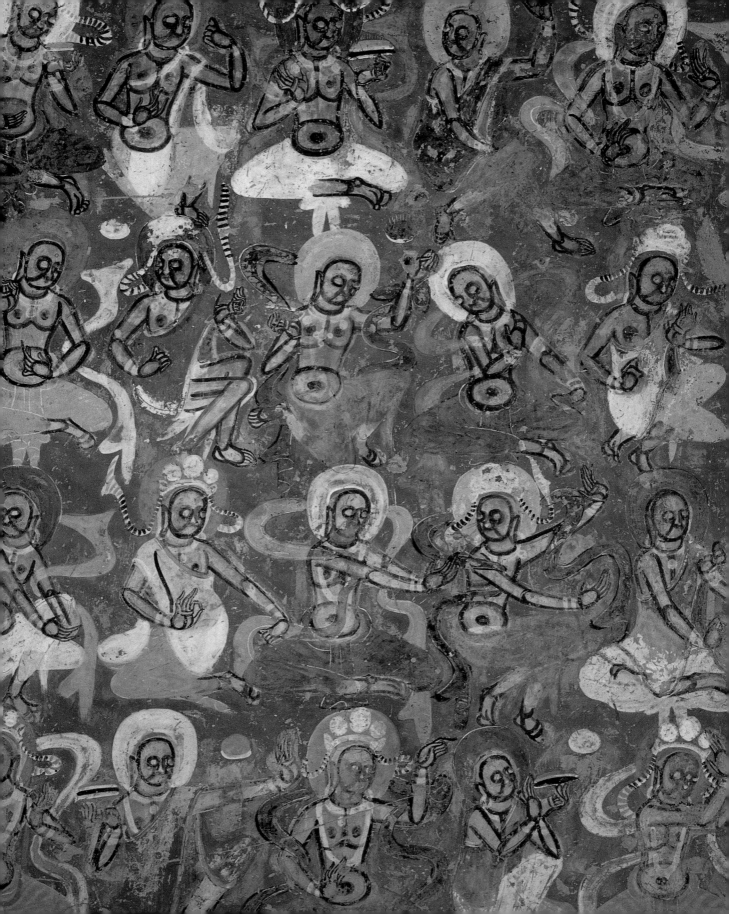

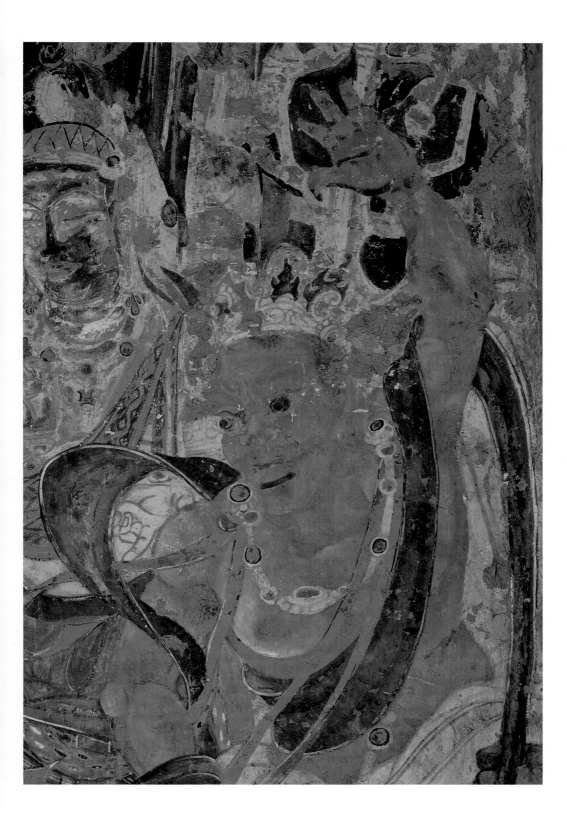

Opposite: Devas—beings who inhabit the heavenly realms but are nonetheless subject to rebirth. Cave 272, Northern Liang dynasty.

Photo by Wu Jian, 1999

Left: A vajrapani, who in this cave serves as a guardian of the Pure Land of the East. Cave 220, Early Tang dynasty.

Photo by Wu Jian, 1999

Pages 96–97: Cosmological Buddha, flanked by bodhisattvas, with apsarasas flying above. On the Buddha's coat are scenes symbolizing the forms of existence, including heavenly beings, the human world, and, at bottom, ghostly figures and demons. Cave 428, Northern Zhou dynasty.

Photo by Wu Jian, 1999

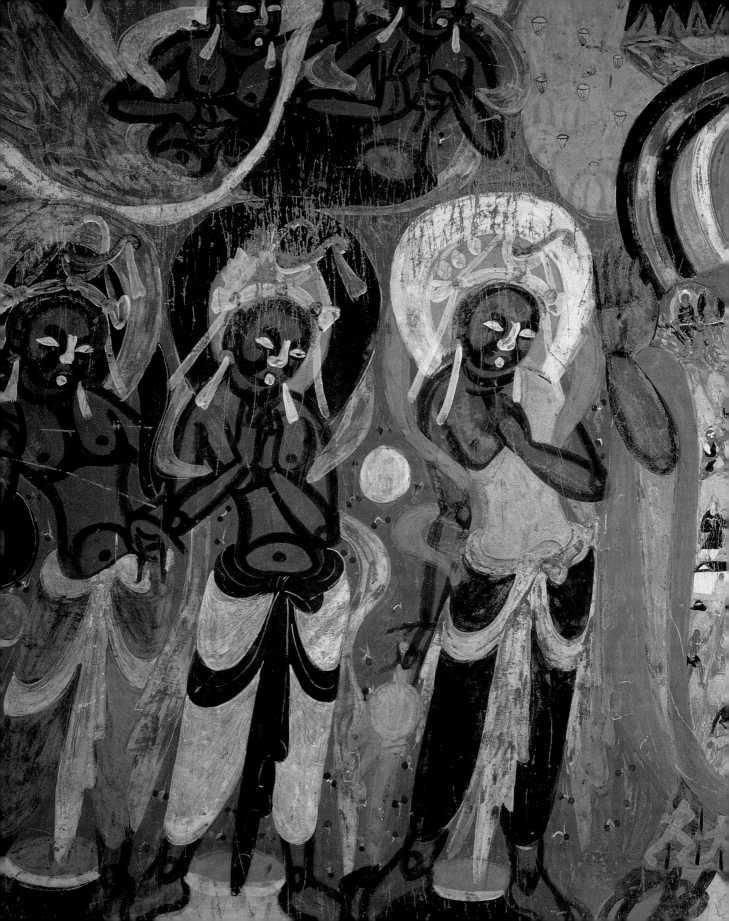

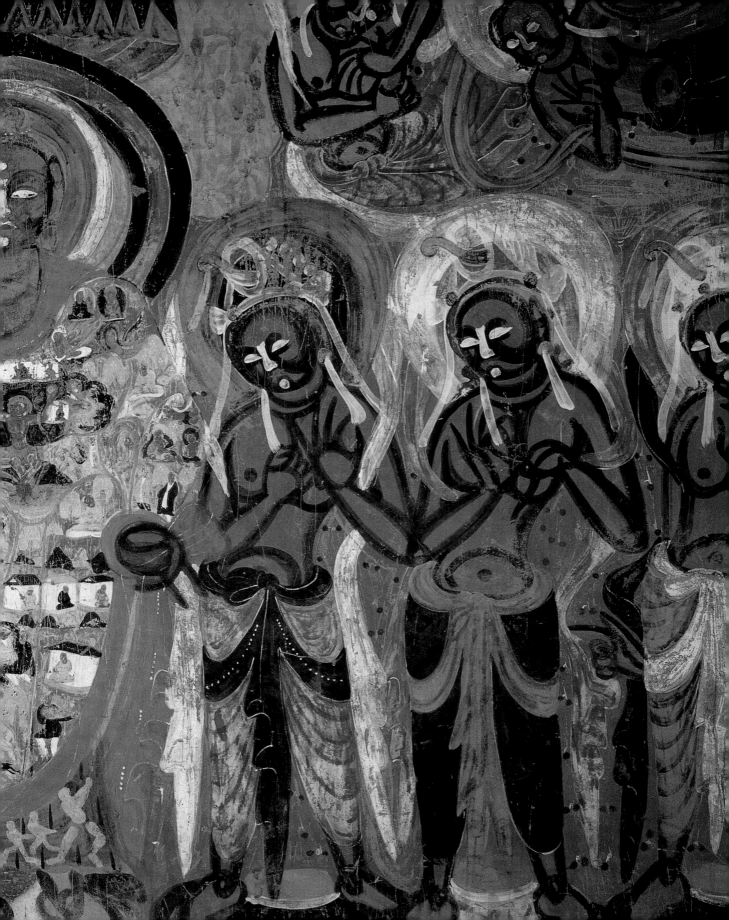

Scenes from daily life.
Photos by Wu Jian, 1999

A yaksha, a divine
being that often serves
as a temple guardian.
*Cave 290, Northern
Zhou dynasty.*

*Opposite: Ceiling
adorned with the
Thousand Buddha
motif. Cave 390,
Sui dynasty.*
Photos by Wu Jian, 1999

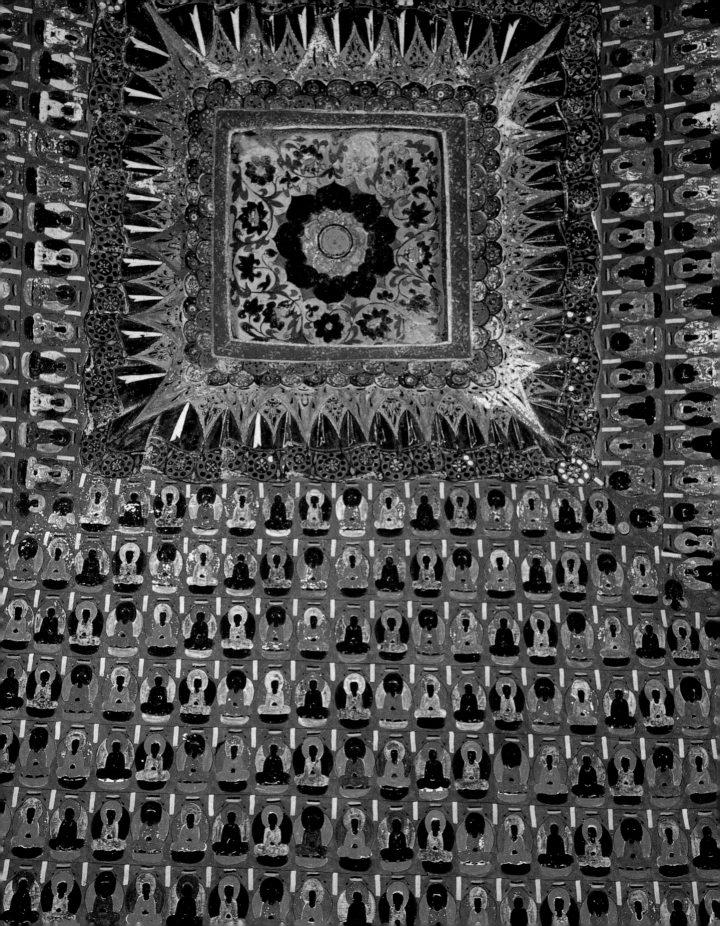

Left: Celestial musicians at play. Cave 420, Sui dynasty.
Photo by Wu Jian, 1999

Pages 102–103:
Ceiling mural depicting the Buddha Akshobhya, the imperturbable, the subduer of passions. He reigns over the eastern paradise Abhirati. The style of this painting reflects the dominant influence of Tibetan Buddhism during the Mongol period. Cave 465, Yuan dynasty.
Photo by Lois Conner, 1995

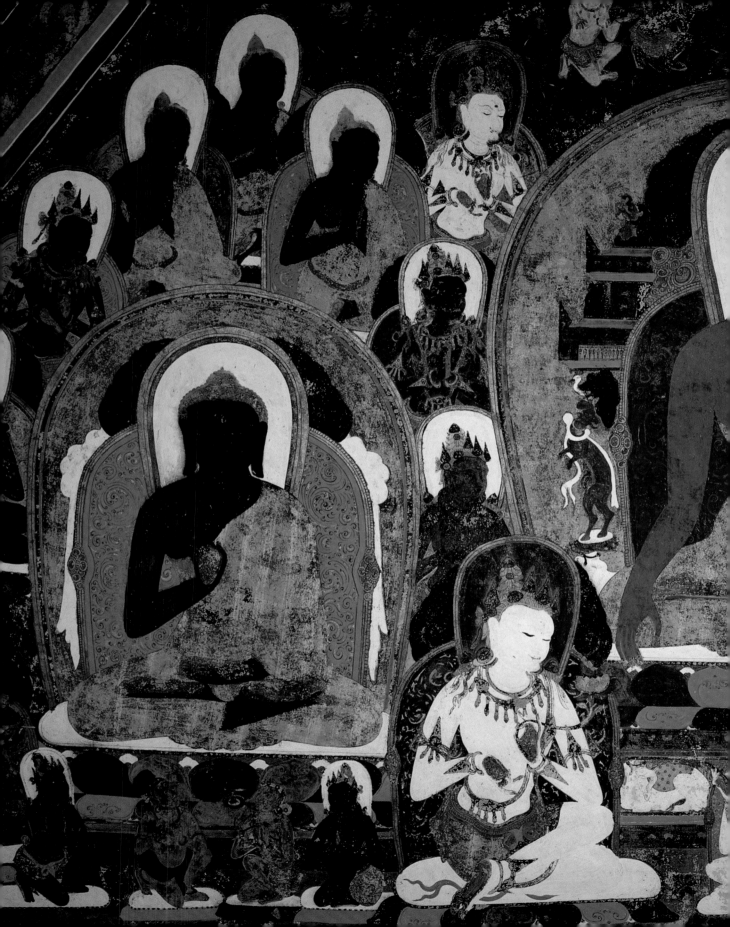

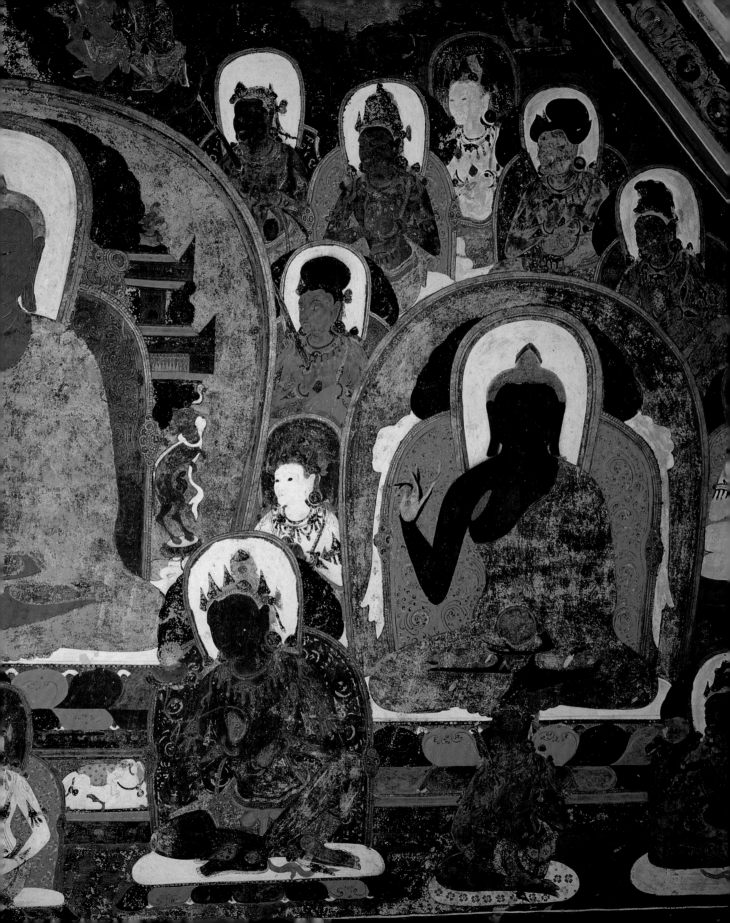

Conserving the Heritage of Mogao

Mogao spoke directly to the heart of a young man who came to the site from the south of China at the end of World War II. "On the eve of the Mid-Autumn Festival in 1946," wrote Duan Wenjie, "we arrived at the Mogao grottoes, which we had eagerly looked forward to reaching for so long. We tried to enter the caves soon after we alighted from the truck. Dilapidated scenes appeared before us. The murals were exposed to sunlight and sandstorms. There were no entrances or gates. The only opening was dug at the expense of the murals, and one route cut through over a dozen caves. Yet the murals, even with faded colors, looked brilliant and charming, providing a feast for the eyes. Like a hungry ox breaking into a vegetable farm, I was much satisfied spiritually. From then on, the Mogao grottoes became my Pure Land paradise of art."[1]

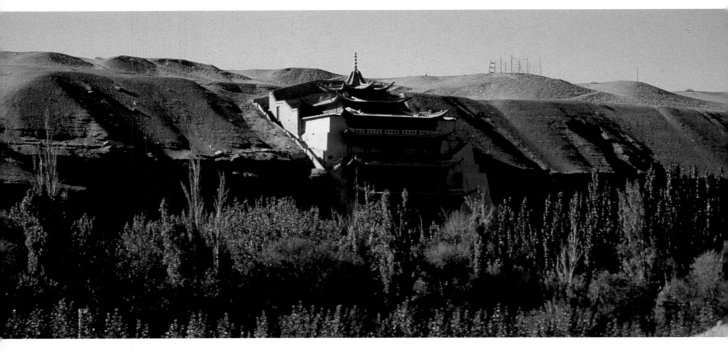

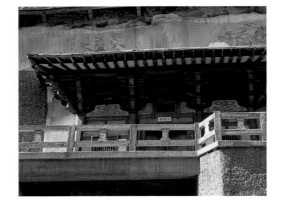

Above: The cliff face at Mogao and the nine-story pagoda, seen from across the Daquan River.
Photo by Guillermo Aldana, 1991

Right: Several of Mogao's wooden temple facades date to the Song dynasty (tenth century); they are rare examples of early Chinese architecture.
Photo by Guillermo Aldana, 1991

Pages 104–105: Conservators at work on the wall paintings in Cave 85.
Photo by Neville Agnew, 2000

Duan Wenjie would stay on for more than half a century, first as an artist copying the murals, and he would eventually rise to become director of the Dunhuang Academy. His impassioned description of his arrival captures the two issues that are the essence of heritage conservation: On the one hand, he found dilapidation, decay, and destruction; on the other, he was moved with force and immediacy. It was the beauty and antiquity of the art, not a desire to begin the daunting yet urgent task of clearing sand and protecting the caves, that held him at Mogao and provided the motivation for what would become his life's work.

While many people think of heritage conservation as "fixing" valuable things that are broken or as restoring artworks that have been damaged, at its deepest level, heritage conservation seeks to preserve the meaning and values of a place or an object by saving the physical fabric that embodies them. The skills and patience of the conser-

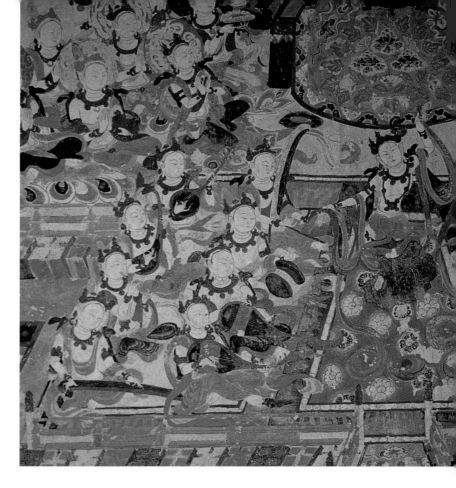

vator, essential though they are, in fact represent only the more apparent facets of what today has become an increasingly complex and sophisticated undertaking. Conservation lies at a crossroads of the arts and sciences; the cultural heritage calls upon many different disciplines, including the methods and materials of science and technology, for its preservation.

In approaching the conservation of a site such as Mogao, with its many historical and artistic dimensions, the conservation team—for no single person has all the necessary expertise—needs to understand the full range of its values: its history, its art, the various elements of the physical site itself, its uses past and present, its significance as a place of meaning to people, and so on. Those who conserve and manage Mogao must conceive of it as a whole. Among its principal elements, of course, is the ancient Buddhist art—wall paintings, sculpture, and manuscripts. Also important is the site's historical and symbolic significance as a mecca on the Silk Road. However, there are many other values as well. One is the incomparable desertscape itself—the towering sand dunes to the west, the jumble of the iron-hard Sanwei Mountains to the east, the soft rustle of the breeze in the poplars planted by Abbot Wang at the foot of the cliff. Another is the architecture of the cave temples, which combines with the sculpture and the magnificent painted walls to create spaces of remarkable aesthetic harmony. The floor plan, the ornate ceilings, the murals depicting Buddhist parables, the inscriptions and illustrations of sutras on the walls, the portraits of the donors in the entranceway—all fuse into creations of sublime art that are invested with a broad range of religious, historical, and aesthetic meanings. In truth, few places can match the sense of history and time that Mogao evokes.[2]

In addition to being masterpieces of religious art, the wall paintings are important sources of historical information, which but for the remoteness and aridity of the Gobi Desert would have long since been lost. The cave walls are a pictorial encyclopedia. Musicians are depicted in over two hundred caves, performing on some forty different kinds of instruments, many of which no longer exist today; these paintings document the development of music over one thousand years. Mogao also serves as a "museum" of dance, with many murals depicting various folk dances, as well as those of the aristocracy. In ancient China there was no word for sport as we know it, but wrestling akin to the sumo wrestling of Japan appears in the paintings, as do the martial arts, polo, archery, and "elephant lifting"—though the rules of that activity are not apparent, and indeed, the idea stretches the imagination.

Wall paintings depict forty kinds of musical instruments, many of which no longer exist. Some of these have been re-created and, with the aid of information from the musical manuscripts found in Cave 17, have been used in performances of ancient Chinese music. Cave 85, Late Tang dynasty.

Photo by Sun Hongcai, 1999

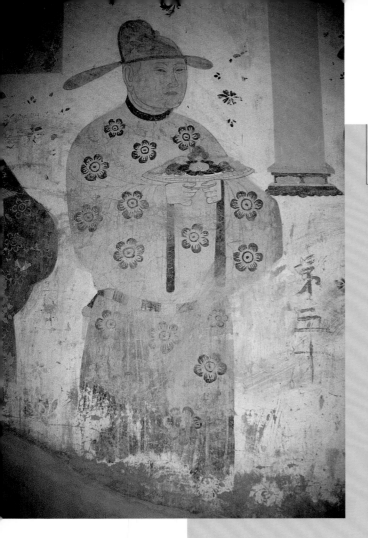

Portrait of one of the cave's donors; damage from flooding is visible at the bottom.

Photo by Francesca Piqué, 1997

Cave 85
A Model for the Future

Recently a model program was set up by the Dunhuang Academy and the Getty Conservation Institute to conserve Cave 85, a large Tang dynasty grotto. The shrine was commissioned in 862 by Zhai Farong, the powerful head of a family in the Dunhuang region, and completed some five years later. It is splendidly decorated: donor portraits with attendants, life size and in reverent procession, appear in the entrance corridor, and in the main chamber large paintings illustrate themes from the Buddhist canon.

Over the centuries, however, Cave 85 has been considerably damaged. Like other caves at ground level, its floor was flooded in the past when the Daquan River overflowed. Consequently, all the paintings up to a height of about a meter from the floor were lost. The floodwater, rich in soluble salts and minerals, left behind a deposit of these harmful substances, which continue to wreak their damage. And over the centuries, pernicious salts have leached from the bedrock through the layer of mud plaster on which the paintings were executed, causing the paint layer to flake and peel. This problem accelerates when the ambient humidity rises above a critical level and the salts absorb moisture, particularly after summer rainfall. The cave's rear wall has deteriorated severely; sections of the painted ceiling have fallen, too, where the clay mud layer has detached from the underlying rock.

These problems need for their solution the full gamut of conservation experience and scientific skill. The Cave 85 team is interdisciplinary, comprising conservators, scientists, art historians, technical photographers, and draftspersons. The team's approach is to study the deterioration rigorously and to document and diagnose the present situation in the cave. Conservators monitor the microclimate, both in the chamber and in the rock, to determine whether capillary moisture from the ground and the conglomerate is affecting the wall paintings. They then develop and test procedures and materials for conservation treatment. Finally, they treat the paintings. As elsewhere at Mogao, the wall paintings are being conserved, not restored. The conservation of Cave 85 will take four to five years of intensive research and hands-on conservation that require the patience and skills of a surgeon. The methods and techniques of wall paintings conservation that are developed here will be applied to other grottoes at Mogao and, eventually, to other Buddhist cave temple sites along the Silk Road.

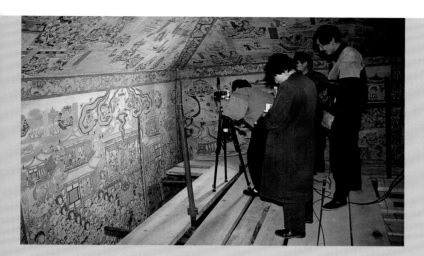

Left: Photographic documentation of the cave walls in progress. The record before, during, and after treatment allows conservators to diagnose problems and develop effective solutions. In Cave 85, prior to any treatment, some five hundred photographs were taken, showing where further deterioration has occurred over the past twenty years.

Photo by Leslie Rainer, 1998

Above: This conservator is taking samples of paint for laboratory analysis; when conservators know exactly what pigments and binding medium were used, they can design effective treatments.

Photo by Leslie Rainer, 1998

Right: Using digital technology, images of the paintings may be overlaid and manipulated to quantify loss. This digital representation indicates where deterioration and loss have occurred. While time-consuming and expensive, such documentation is an investment in the future, because the visual record will be available when needed, should deterioration begin again.

Drawing documentation: Francesca Piqué and Zheng Jun

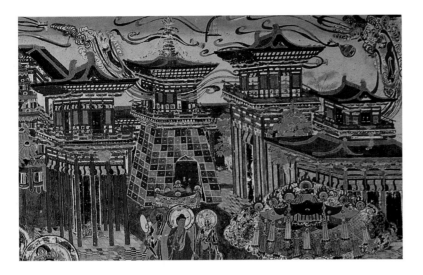

In Tang dynasty paintings of the Western Paradise of Amitabha, detailed depictions of pagodas, temples, and pavilions provide a rich source of information for historians of early Chinese architecture. Cave 217, High Tang dynasty.

Photo by Wu Jian, 1999

New information on a multitude of other subjects has come to light as well: a new type of plow, the use of stirrups, lunar calendars, classical herbal medicine (though not acupuncture), celestial maps, printing, and distilling. In 1943 the foremost Western scholar of Chinese science and technology, Joseph Needham, visited Mogao to obtain information for his classic work *Science and Civilization in China*. The world's oldest picture of a cannon comes from Mogao, in a painted silk banner of the mid-tenth century, now in the Musée Guimet, Paris. Many murals provide invaluable information for architectural historians. Mogao also affords insights into political history; an inscription from Cave 17, for example, reveals that the second Tang emperor staged a coup, an event that was, of course, not recorded in official histories written at the time.

The manuscripts found in the Library Cave contain a comparable abundance of information, discussed later in this volume. While most illuminate Chinese Buddhism, other documents, especially from the seventh to the tenth century, are literary. There are essays, stories, and poems. There are also songs, some of which suggest that

song played an important function in the propagation of Buddhism in China and in the transition from earlier classical Chinese to a vernacular language. Also important is calligraphy, in China the most esteemed of the arts. The calligraphy of the Mogao documents and the many inscriptions on the walls, dating from the fourth to the tenth century, have been the focus of intense scholarship. Between thirty thousand and forty thousand examples have been studied and many distinct calligraphic styles identified.

Mogao has yielded a wealth of information for archaeologists as well. Bowls containing pigments, for example, were found in the Northern Wei Cave 487, from the fifth or sixth century, indicating that during the Tang dynasty the cave's function had changed from temple shrine to artists' workshop.

From the record of Mogao's many cultural values, the immense significance of the site is clear. All of the elements that embody these values—including the environment and the beauty of the landscape itself—should be preserved intact. The achievement of this challenging task, however, requires a broad range of expertise, guided by a comprehensive, detailed overall plan for the management and preservation of the site. This master plan should take all the site's values into account. It should also be developed in consultation with all interested parties, for surprises often emerge when values are fully assessed. Different groups of people may ascribe different kinds of significance to a site; what is of consuming passion to one group may be of little or no value to another. At Mogao, where economic benefit has become a significant value in its own right, the use of the site has emerged as an important issue. With more and more visitors arriving at the expanded Dunhuang airport, bringing

*Scenes from a series
of woodcuts illustrating
traditional Chinese
papermaking.*

*By permission of
The British Library*

Conserving Ancient Manuscripts

The conservation of paper docu-
ments in Cave 17 was best man-
aged during the eight hundred
years that the documents were
sealed in the dark, dry cave,
untouched and undisturbed. Of
the nearly fifty thousand paper
documents and fragments from
the Library Cave, those that have
not been conserved are still in fine
condition, just as they were over a
thousand years ago. The sheer
volume of items — up to fourteen
thousand in such institutions as
the British Library and the Biblio-
thèque nationale in Paris—has
prevented the conservation treat-
ment of all but a few of the pieces
during the century since they left
the cave.

However, the more outstand-
ing items received well-meaning
conservation attention in the first
years after their acquisition. The
commonly used treatment was
mounting—pasting the paper of
the original onto a robust backing.
In China and Japan, mounting has
been the traditional method of
conserving paintings on silk and
paper for over a thousand years.
Nevertheless, it is a destructive
treatment for many reasons. First,
even when backing is performed
with the greatest skill, it is difficult
to avoid stiffening the whole; and
when the scroll is rolled up, the
backing must stretch farther than
the original paper, often resulting
in cracking. Second, mounting can
conceal text on scrolls with writ-
ing on both sides, a common
occurrence at Dunhuang, since
good paper was at times scarce,
especially during the Tibetan era,
and paper was often reused.
Finally, mounting involves the
application of twentieth-century
pastes and papers to eighth- and
ninth-century (or earlier) items,
making it impossible to discover
or reconstruct the chemical con-
stituents of the originals and hid-
ing from future researchers often
important aspects of paper, text,
and printing history.

All institutions holding material
from Cave 17 now admit that most
of their conservation work today
consists in undoing treatments
carried out in their own studios in
the years after the arrival of the
documents. Conservators mini-
mize their interventions, loosen-
ing patches or backings with the

smallest possible amount of water.
During the last decade, scrolls that
require some support have been
mounted only along the edges,
with the papers joined with a light
starched paste rather than an
adhesive. Conservators may sand-
wich small fragments between
glass or very stable plastic, in a
safe environment where they can
be handled without being touched.

Hand in hand with minimal con-
servation goes scientific research.
Buddhist sutras were almost invari-
ably written (or printed) on fine
yellow paper. The yellow dye from
the Amur oak tree, known as
huangbo in China, is soluble in
water, making the conservator's
task very difficult, since water is
generally the preferred solution
for dissolving the paste that affixes
the early, destructive mountings.
We know from Chinese texts that
Buddhists considered yellow to be
auspicious (it is the color of monks'
robes). The dye, which was insecti-
cidal and water repellent, pro-
tected the precious texts from
damage by bookworms or mois-
ture. Scientific analysis of the vari-
ous dyes used in these papers will
not only contribute to the field of
conservation but also enhance
knowledge of paper history.

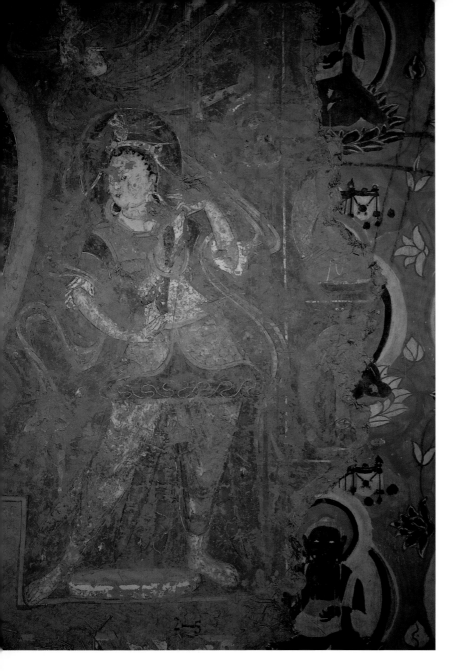

Early murals were at times plastered over and repainted centuries later. As a result, the underlying mural was protected from the effects of light and the atmosphere, preserving flesh tones that in other paintings have been oxidized to black. Here unknown visitors have removed sections of the later painting; remaining sections, in turquoise, can be seen on the right. Also evident is the original layer of mud mixed with chopped straw. Cave 263, Northern Wei dynasty.

Photo by Lois Conner, 1995

prosperity to the city, great pressure will build to accept more tourists into the caves. As at cultural tourism sites elsewhere in the world, the right balance must be struck at Mogao, or, in the end, the values it embodies will be degraded. Bringing to light, understanding, and (where possible) resolving conflicts between competing values—even before turning to the technical challenges of scientific conservation—are part and parcel of conserving and managing the cultural heritage.

In the migration of Buddhism eastward along the Silk Road, it was in the wall paintings at Mogao that the most thorough sinicization of Indian Buddhist art took place. Parables and tales were depicted with Chinese characters, clothing, and customs, creating a hybrid that completely transformed the art of the Indian progenitor. No other site offers a comparable survey of one thousand years of Chinese and central Asian painting. Mogao's forty-five-thousand square meters of murals are the equivalent of a wall five meters high and nearly nine kilometers long. These wall paintings are the site's most important element. Given the small number of trained conservators and the limited financial resources available, the conservation of the wall paintings is the most exacting task facing the Dunhuang Academy today.

Think of the problem of conservation of wall paintings like this: The glorious paintings, the art and record of one thousand years, an unsurpassed document of medieval Chinese life, are in reality no more than the thinnest tissue of paint—thinner, indeed, than the paper on which these words are printed. The paintings are literally the interface between two hostile environments—the solid rock of the cliff lying behind and supporting them on an inch of dried mud, and the ambient atmosphere in which they are constantly bathed.

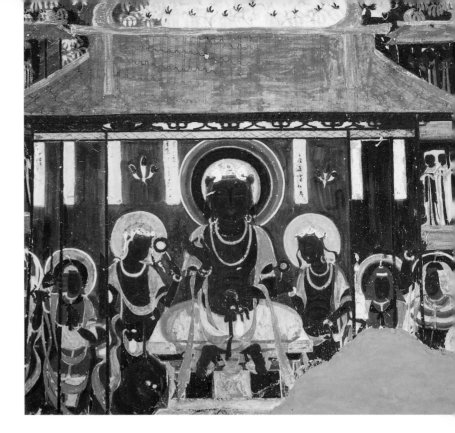

From the rock come mineral salts (mainly sodium chloride, common table salt), which slowly and inexorably migrate to the surface, there to crystallize and disrupt the paint, making it flake and powder. Salt plays a fatal role in detaching painted plaster from the rock body, eventually causing it to fall and shatter. The atmosphere, meanwhile, brings humidity, dust, pollutants, microbiological attack, and insects. Adhered to the wall by the merest amount of binding medium—the glue that holds the pigments—the paintings have led a precarious existence for more than a millennium; the miracle is that any have survived at all. The documents from the Library Cave have been removed to controlled environments—whatever the ethics of Stein, Pelliot, and others may have been, and however their activities may be viewed today. The demons of deterioration that assail the wall paintings, however, must be confronted where they occur: the preservation battlefield is the mural itself.

The Chinese word for chemistry, *hua xue,* literally means the "study of change." Apropos of artworks and cultural heritage sites, change, like time's arrow, has only one direction, and that is forward, with ever-increasing accumulation of damage. Yet chemistry—indeed, science in general—harnessed to resist change is a powerful tool of conservation. We must study the deterioration of the cave paintings if we are to understand the processes and intervene effectively to slow them. While we understand deterioration much better today than in the past and possess an ever-expanding arsenal of instruments, materials, and so on, we do not yet fully understand the processes of chemical and physical deterioration at the microscopic and molecular levels. Similarly, treatment methods and materials in wall paintings conservation have not been fully developed. In this

Above: The area of loss of painted plaster at the lower right has been filled in with plaster. Exposure to light and the atmosphere has darkened the mural's original bright colors. Cave 419, Sui dynasty.

Photo by Lois Conner, 1995

Above: A conservator inserts a probe to monitor the moisture level in the rock ceiling. Right: Soot from fires lit in some caves has blackened the paintings. Here the Thousand Buddha decorations that were molded onto the ceiling have fallen off. Attempts have been made in the past to remove the soot on the lower walls.

Photos by Neville Agnew, 2000 (above) and 1997 (right)

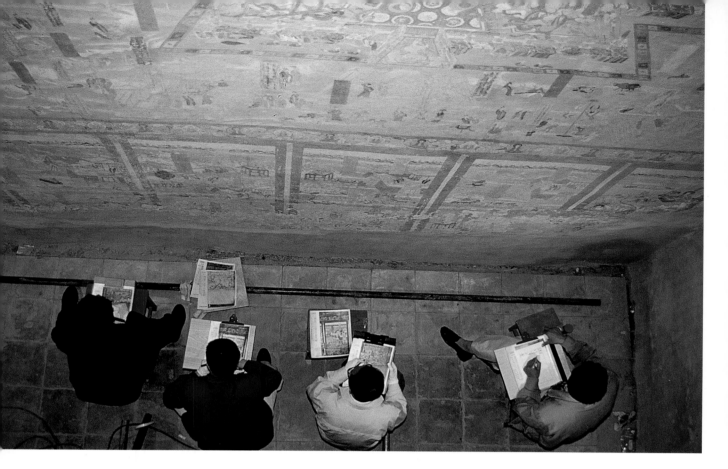

Before beginning treatment, conservators carefully document the condition of the murals by making both detailed drawings—such as here—and photographs.

Photo by Leslie Rainer, 1999

respect, the field of conservation science is still in a kind of infancy.

"First do no harm"—this classic medical adage also applies to heritage conservation, for many examples exist of earlier inappropriate treatments that may have meant well but were often quite damaging (see sidebar on manuscript conservation, p. 111). Fortunately, such missteps are less common nowadays. All treatments should be compatible with— and yet, at least on close examination, distinguishable from—the original. Ideally they should also be reversible, that is, capable of being undone, although this in reality is only an ideal. More realistically, prior treatments should not interfere with subsequent ones. Authenticity of the original must be respected at all costs, which is why a distinction is drawn between conservation, which seeks to preserve works and prevent further deterioration, and restoration, which seeks to return them to their original state—an intention that

today is frowned upon. All interventions, however, have the potential for compromising authenticity. Faced with this conundrum, conservators must intervene as little as possible while aiming to slow the inevitable deterioration, for nothing is truly forever.

It is remarkable to realize that the brilliant painted walls are rendered on humble river mud. Untold generations of monks and artists labored to carve the temples, and with devotion and deft hand, they took wet mud from the Daquan River at the foot of the cliff, mixed it with chopped straw, and spread and smoothed it on the caves' coarse rock walls to create the canvas for these marvelous works. Next came a fine layer of mud, followed by a ground for the painting—usually a thin layer of white pigment to prepare the surface for the outline drawings, which were then painted in. Sometimes, centuries later, new murals were painted over early ones.

Various pigments were used in painting the murals. From documents in Cave 17, we know that thorough records of costs were kept. Expensive pigments were doled out carefully. White pigments were calcite and talc; red layers have been identified as hematite; and copper-based pigments like azurite, malachite, and atacamite were used for blues and greens. Lead-based pigments were common, and many have changed color over time, a subject of intense scientific investigation. The orange lead pigment minium, for example, used for flesh-colored tones in depictions of faces, has in many instances been oxidized in the presence of light and humidity into a different mineral, black plattnerite; the black color in such murals today is an artifact of time and does not reflect the artists' original intent. Black, when needed as a pigment, was usually soot from oil lamps. Certain rare pigments, such as yellow orpiment and vermilion cinnabar, containing arsenic and mercury, respectively, also may have been used on occasion.

The painting technique used at Mogao is quite different from the fresco technique of Europe. There, paint is applied to wet lime plaster, and on drying it fuses with the wall. Paintings at Mogao, applied to a dry surface and susceptible to peeling, flaking, and the destructive effects of soluble mineral salts leached over centuries from the mother rock of the cliff, are much more fragile.

As a first step, conservators need to document the condition of the wall paintings. This is done photographically and graphically and by describing the pathologies observed—flaking, detachment, loss, and so on. Next, emergency stabilization is often done to secure the flakes until an appropriate final treatment methodology and materials have been developed and tested. For this treatment, special tissue

Analyzing Ancient Paint

While the pigments used in the Mogao wall paintings have been well studied, the binding medium of the paintings — the glue that holds the pigment together and to the ground layer—has proved notoriously difficult to identify. Ideally the conservator wants to know all the original raw materials of the painting, along with any later additions, in order to design a compatible treatment. Previously, it was surmised that local peach gum was the binding medium, although other binders such as animal glue were also used. Recently, however, from an almost microscopic sample of wall painting from the Tang dynasty Cave 85, Getty Conservation Institute and Dunhuang Academy conservation scientists have identified the binding medium as gum tragacanth, a natural product from a shrub of the genus *Astragalus*, the traditional species of which is found in Persia and other parts of western Asia. Many species of this plant exist, and it is not yet known whether the traditional tragacanth was the source or whether some local species was used. It is tempting to imagine — if impossible to prove — that, together with some of the rare and precious pigments demanded by the patrons and artists for their paintings, tragacanth gum was also carried eastward in caravans along the Silk Road.

paper from the mulberry tree is used. Little paper "Band-Aids" are applied, one by one, over the detaching flakes, which are eased back flat onto the wall using minimal moisture or sometimes the least possible amount of reversible adhesive. This holding situation is reversed and the tissue removed as the final treatment begins; each flake is then again secured, but this time with the particular consolidant that has been selected, either synthetic resin or a natural product such as a plant gum. When the treatment is complete—which may take months or years, depending on the severity of deterioration—the condition of the wall is again documented to complete the record. Thereafter, regular inspection monitors the condition of the wall paintings. Sophisticated color monitoring is carried out, to track any further change in the pigment.

"Lying on the floors of many alcoves and chapels, awaiting repair, were many plaster statuettes," wrote the American Irene Vongehr Vincent, who as a young woman visited Mogao in 1948. "I was

Photomicrograph of a wall painting cross section. The thin, reddish line at top is the paint layer; below lie thicker layers of ground and fine mud plaster. The scale bar is fifty microns (fifty-thousandths of a millimeter).

Photo by Michael Schilling, 1999

To stabilize flaking paint, little paper "Band-Aids" are applied as an emergency treatment until the final treatment is carried out.

Photo by Sun Hongcai, 1999

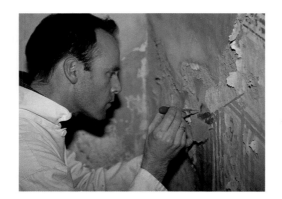

Color monitoring is carried out at selected points in a cave to see whether pigments are still undergoing color change. Such measurement provides data to help determine whether artificial lighting would be safe. At present, visitors view the dark interiors by flashlight. Questions of light intensity, color temperature, and duration of exposure must be carefully considered.

Photo by R. Tseng, 1989

strongly tempted to carry off a pretty little bodhisattva, but each visitor of the Tun Huang Institute must now promise not to damage or remove anything from the chapels."[3] Would that others had been as sensitive. Often portable and always fragile, the sculptures have suffered serious damage when people have tried to carry them away. Indeed, such attempts have usually resulted only in destruction.

Today, some twenty-four hundred clay sculptures survive at Mogao, ranging from the colossal to the miniature. Constructed on a frame—or "skeleton"—of wood bulked with reeds, then modeled with clay and painted in brilliant pigments, the figures are one of the glories of Mogao. In the Tang period particularly, the art of

sculpture reached its pinnacle. Now, however, many of these exquisite works are headless or otherwise vandalized. Restorations of the sculpture, as well as some new figures, were commissioned by the well-meaning Abbot Wang at the beginning of the twentieth century. He did this to replace sculptures that had been lost. Regrettably, these are often a garish travesty of the original, and apart from some now-historical interest in their own right, they detract from the beauty of the art in the caves.

Conservation of the polychrome clay sculpture presents many of the same problems as conservation of the wall paintings, as might be expected, because the materials are the same. But fortunately, the problem of moisture and soluble salts from the bedrock of the cliff that so bedevils the wall paintings is largely absent. This is because the sculpture is isolated physically from the conglomerate, except, of course, at the base, and here little influence is found, since the sculpture is invariably mounted on a platform. Being freestanding, however, the sculpture is susceptible to overturning, particularly in earthquakes. Again, no restoration is being done. For now, conservation of sculpture at Mogao is focused on stabilizing and preventing further mechanical damage to sculptures that are leaning or loose on their bases.

An important part of conservation at Mogao is concerned with the site itself, which faces a number of perils. Among the most devastating are earthquakes. The cliff face, weakened by often-invisible cracks and fissures in the rock body, is poised to collapse when the next shudder of the earth happens—as it has so often, most recently in the 1920s and 1930s. Where cracks are accessible, their width is measured and recorded to monitor the stability of the cliff face. At some sites, Yulin being

one, a technique known as geotechnical rock bolting has been used to pin fractured slabs of rock and thereby provide a measure of resistance to the inevitable next temblor—for we are always "between two earthquakes," as the title of a book on cultural heritage in seismic areas aptly points out. At Mogao, however, the cliff was so honeycombed by assiduous monks in their creation of the cave temples that too little rock body remains for the bolts to hold securely. This problem has been the subject of some ingenious proposals, but each has to face up to the reality that no damage or risk of damage to the art is permissible. Heavy engineering interventions such as drilling and rock bolting pose too high a risk.

Today the southern section of the long cliff face is buttressed by a modern concrete facade. This facade and the aluminum cave entrance doors installed in the 1980s make for a very different scene from the gaily bedecked pagodas that stood at the entrances a thousand and more years ago, with fluttering silk banners hanging from the eaves and the temple bells tinkling as pilgrims approached across the desert. These wooden foretemples have almost all disappeared, consumed by fire, rot, windblown sand, and the earthquakes that brought down whole sections of the cliff. Although archaeological excavations have yielded evidence of many others, today only five remain. At least two have been dated, to 976 and 980, in the Song period, when Dunhuang was ruled by the Cao family. The ancient facades, which represent a departure from the Indian model of Buddhist grotto art, are rare examples of early Chinese architecture.[4]

Sandstorms and windblown sand from the Gobi are still a threat to the site, as they must have also been in ancient times. In fact, the name Shazhou, or City

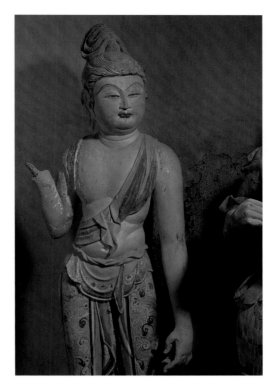

Sculptures were modeled in clay stucco on a wooden frame.
Photo by Wu Jian, 1999

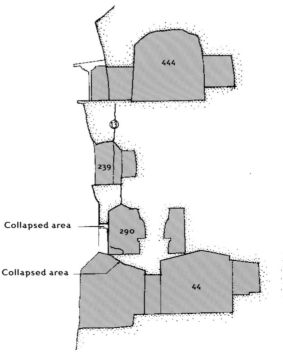

Vertical cross section of part of the cliff face, showing the relationship among caves, existing cracks in the rock, and areas where collapse has occurred in the past.
Courtesy Dunhuang Academy

Collapsed area

Collapsed area

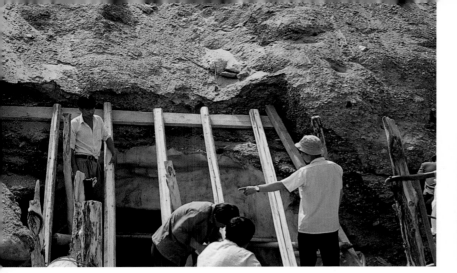

Ceilings of some of the upper-level caves have collapsed inward. A lightweight composite panel has been developed to seal existing holes or, in cases where collapse is imminent, to strengthen the cave's rock roof. The result has an aesthetically acceptable appearance. Such work requires exquisite care, to prevent damage to other caves only a few meters below.

Photos by Po-Ming Lin, 1993

of Sands, as Dunhuang was known after the Tang period, is still used on occasion. It is appropriate, for on leaving Dunhuang by road for Mogao, the transition from green, cultivated oasis to lifeless, bare desert is as abrupt as though one were transported to another planet. On either side of the road lies a stony plain, dotted with small mounds and prayer flags of recent burials, rising in the distance to the huge sand dunes that loom over the plateau behind Mogao. These, since antiquity, have fed the sands blown over the cliff face, abrading the soft rock to the extent that some of the upper-level grottoes have paper-thin ceilings, while not a few have collapsed. The sand piles down on the walkways and cave entrances below; the impalpably fine dust from the cascade billows into the caves and settles in the still air, coating the sculpture with an obscuring layer.

Sand has always threatened to engulf the site, as it has so many other ancient towns and cities on the Silk Road. Over the

centuries, some caves at Mogao were completely filled with drift sand. Between two and three thousand cubic meters of sand needed to be removed by hand every year. Various attempts to solve the problem had failed, and new approaches were needed. With environmental data collected over several years by the Getty Conservation Institute's solar-powered meteorological station on the cliff top, GCI and Dunhuang Academy scientists, working with specialists from the Chinese Desert Research Institute in Lanzhou, designed a synthetic textile wind fence about four kilometers long. It reduces wind speed by half, causing the wind to drop its load of sand. The result has been dramatic. The amount of sand blown over the edge of the cliff was reduced by more than 60 percent. Fabric filters on the modern aluminum louver doors at cave entrances have further reduced intrusion of the finest dust.

The textile fence is a passive device, however, and cannot serve as a permanent solution to the problem. The synthetic fabric has an expected life of about twenty years—perhaps less in the intense desert light, which degrades plastics; in addition, sand buildup at the fence has been inevi-

table, although by taking advantage of seasonal changes in wind direction, it has been possible to minimize this. A better answer was needed, and this has been found in a living fence of desert-adapted plants, all indigenous to the central Asian deserts, which have been extensively planted between the dunes and the cliff edge, a distance of several kilometers. Sustained by a drip irrigation system with water from the Daquan River, the initial plantings are now being extended greatly with funding from the Chinese government. The wind fences are being studied by scientists to implement in desert reclamation projects elsewhere in China.

NOTES

1. Quoted in Luo Qingzhi, *Bainian Dunhuang: Duan Wenjie yu Mogaoku* (One hundred years of Dunhuang: Duan Wenjie and the Mogao grottoes) (Lanzhou: Dunhuang Wenyi Chubayshe, 1997), 27.
2. See Neville Agnew, ed., *Conservation of Ancient Sites on the Silk Road* (Los Angeles: Getty Conservation Institute, 1997).
3. Irene Vongehr Vincent, *The Sacred Oasis: Caves of the Thousand Buddhas, Tun Huang* (Chicago: University of Chicago Press, 1953), 100.
4. See Ma Shichang, "Buddhist Cave Temples and the Cao Family at Mogao Ku, Dunhuang," *World Archaeology* 27, no. 2 (1995): 303–17.

The wind fence (top) has substantially reduced the amount of sand drifting into the caves (right). Eventually it will be replaced by a living fence of desert plants fed by a drip irrigation system (above).

Top and above: Photos by Lois Conner, 1995
Right: Photo by Guillermo Aldana, 1991

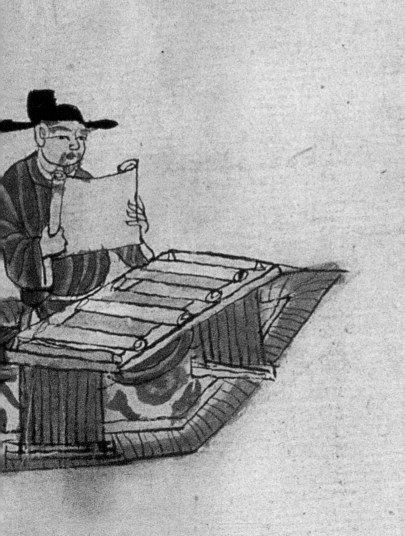

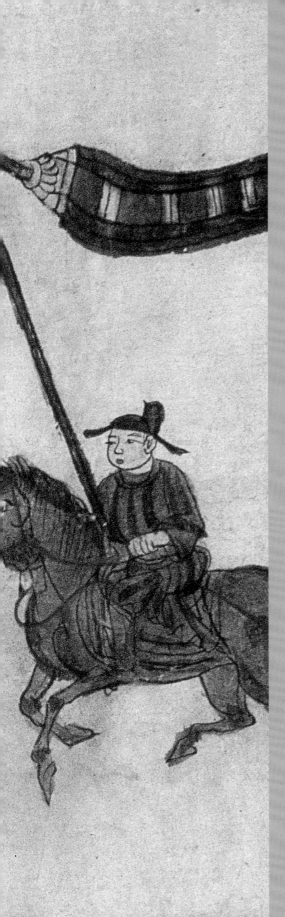

Monasteries, Monks, and Manuscripts

Upon his first encounter with the manuscript cache in the Library Cave, Aurel Stein immediately realized the remarkable importance of his find. Initial examination revealed the antiquity of the manuscripts, which had been sealed away in the early eleventh century, and suggested the light they could cast on the development of monasteries and other aspects of early Buddhist culture, as brought from India along the Silk Road into China. "With . . . evidence clearly showing the connection which once existed between these religious establishments and Buddhist learning as transplanted to the Tarim Basin," Stein wrote, "my hopes rose greatly for finds of direct importance to Indian and western research."[1]

An official seated behind a desk at the entrance to one of the hells described in the Sutra of the Ten Kings is checking names in a scroll. A messenger from the living approaches on horseback. Third illustration to the Sutra of the Ten Kings, early tenth century.

Pelliot chinois 4523-2. Courtesy Bibliothèque nationale de France, Paris

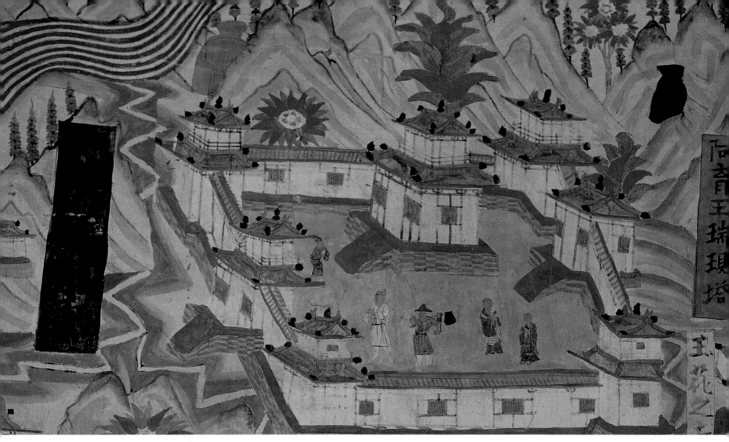

The cache of manuscripts, which came from a number of Buddhist monasteries in the Dunhuang region, indeed proved to be one of the most important finds in the history of archaeology, opening a window onto the religious, intellectual, and secular worlds of medieval China and the kingdoms of the Silk Road. Of the some fifty thousand items, the majority were Buddhist scriptures, but there were also many other texts, ranging from popular ballads and lyric poems to nonliterary secular documents of considerable historical significance. Most were handwritten in Chinese, but there were a few painted items, including the world's oldest dated printed book. Tibetan and Uighur documents were also found, reflecting the region's tumultuous history.

The presence of such a hoard of manuscripts reveals that Dunhuang was clearly a major center of Buddhist scholarship and learning. Even though it was geographically isolated, Dunhuang was part of a great network of monasteries under official

Chinese control during the Tang dynasty. The monastery complex at Mogao itself included the caves—both the undecorated cells used for the monks' living quarters in the northern part of the site and the larger, devotional temples—as well as a series of buildings on the valley floor, probably enclosed by a wall. There were prayer halls, refectories, living quarters for the abbot and monks, and other public rooms. And, perhaps most important, there was a library.

In medieval China, as in Europe, monastery libraries served as important repositories of knowledge. Documents from the Library Cave mention more than fifteen local monasteries and nunneries. The library at Mogao, like those of other Buddhist monasteries, consisted largely of the three categories of texts that made up the Buddhist canon, or *Tripitaka* (from a Sanskrit word meaning "three baskets"): the sutras, the *abhidharma* or *sastra*, and the *vinaya*. Sutras are the sermons of the historical Buddha, which were transcribed in Sanskrit or Pali, languages local to northern India, probably several centuries after his death. They usually begin with a description of where and when the Buddha was preaching and contain parables designed to enlighten the listener. Abhidharma are philosophical and psychological discussions of doctrine—interpretations and elucidations by monks and scholars of the Buddha's words. The vinaya set forth the rules and regulations of monastic life—proper dress, eating habits, and so on, including offenses for which a monk or nun could be defrocked, ranging from murder to excessive pride in one's own sanctity.

It was important for a monastery's library to be as complete and as accurate as possible. Along with other high-ranking monks, the librarian—sometimes referred to as the keeper of sutras—was charged with developing the collection. During the

first millennium this was not an easy task, as the Chinese Buddhist canon was continually expanding, with previously unknown sutras being discovered; brought from India by traveling monks, merchants, and others; and translated from Sanskrit or Pali into Chinese. Some exist in several different translations. In other cases, because the originals no longer exist, the Chinese version is the earliest record. Apocryphal sutras—some of which were invented by Chinese monks and scholars—also found their way into the tradition.

New sutras considered to be canonical works were carefully translated in the Chinese capital. These manuscripts, deemed official translations, can be recognized by their long tabulated colophons—notes written at the end of the scroll giving details of the translation and copying process, which in Chinese Buddhist culture was remarkably elaborate. One, for example, dated to 693, describes the process of translation employed at the Wild Goose Pagoda, which had been established by the Chinese emperor for the monk Xuanzang, after the adventurous pilgrim's return from India in 645. Two Indian monks, one a royal envoy from central India, first expounded the

Tabulated colophon at the end of a manuscript copy of the Lotus Sutra. These colophons give details of the copying process and provide insight into the care with which the translation and copying of sutras was undertaken. High Tang dynasty, dated 762.

By permission of The British Library, Or.8210/s.2181 (end section)

Fragment from a manuscript copy of the Lotus Sutra—a central text of Mahayana Buddhism—with gold lettering on deep blue paper.

Pelliot chinois 4512. Courtesy Bibliothèque nationale de France, Paris

lated, wrapped in paper or cloth, and stored; a silk or ivory tag was sewn on the wrapper to identify its contents and the monastery to which it belonged. When monks or nuns wished to borrow these sutras—for chanting, study, or copying—a record would be kept, to ensure that the sutras would be returned.

Among the most popular texts in the Dunhuang region was the Lotus Sutra, a central text of Chinese Mahayana Buddhism, which emphasizes the importance of the compassionate bodhisattvas. Well over a thousand copies were found at Mogao in several different translations, ranging in date from the fifth to the late tenth or early eleventh century. Most date to the Tang dynasty of the seventh and eighth centuries, including a group of official copies from the 670s. These used the finest paper, made from pounded mulberry or hemp fibers at renowned centers in central China. The colophons give the name of the copyist—usually a lay scholar, sometimes affiliated with the College of Literature and chosen for his calligraphic skills—as well as the paper dyer, checkers, revisers (most texts went through three revisions), assessor, and overall supervisor. One of the chief revisers was a monk named Huili, the biographer of the famous pilgrim Xuanzang. Most of the copies found at Dunhuang, although over nine meters long, contain only one or two chapters of this lengthy sutra. One of the most popular chapters itself became known as the Guanyin Sutra, from the Chinese name for the bodhisattva Avalokiteshvara, a principal assistant to the Amitabha Buddha, who presides over the Pure Land of the West.

Other sutras found at Mogao illustrate various features characteristic of Chinese Buddhism. The Sutra of the Ten Kings, for example, copies of which are among the

Sanskrit text. Four monks interpreted into Chinese and verified the Sanskrit as it was being explained, two others transcribed the lectures, two more compiled the texts, and a further nine checked the final text for accuracy. Perhaps ten other scholars and monks would also be involved, including specialists on manuscripts and on composition, as well as a supervisor to oversee the work.

Once the translation was perfected, copies were distributed to monasteries throughout the empire. To supplement the official copies received from the capital, provincial monasteries sent monks in quest of sutras; from Dunhuang they journeyed east to the capital of Chang'an and west to other Silk Road kingdoms, with some traveling all the way to India. Sutras also were acquired through imperial donation, as well as from prominent local families. Manuscripts were read for accuracy, col-

Ink drawing found in the Library Cave, showing a traveling monk and his few possessions: shoes, a water bottle, a leather satchel, and a string of beads. Tang Dynasty.

© Copyright The British Museum, OA 1919.1-1.0163 (Ch. 00145)

The Translator Monks

The spread of Buddhism from India into central Asia and China is one of history's great examples of the migration of a cultural legacy. In the beginning, Buddhist scholar-monks journeyed north from India into such Silk Road kingdoms as Gandhara and Khotan, and from there on to China; later, Chinese monks headed west in pilgrimages back to Buddhism's birthplace. Many passed through Dunhuang. Over the course of a thousand years, more than fourteen hundred texts were carried back and translated into Chinese. In one modern edition, this body of work comprises fifty-five volumes of about one thousand pages each.

The four greatest Chinese translator monks, Kumarajiva, Paramartha, Xuanzang, and Bu Kong, lived between the fifth and eighth centuries.[2] However, there were many others as well. Dharmaraksa, born in Dunhuang in about 250, translated the Lotus Sutra;[3] he is sometimes known as the Dunhuang Bodhisattva. Another was Zhu Shixing, who in about 250 was one of the first Chinese to enter the Buddhist priesthood. When he was nearly eighty years old, he undertook the trek west to Khotan to procure a copy of the Prajna Sutra, which he gave to his disciples to take back to China, a return trip Zhu was now too weak to make. He died in the Western Regions.

Along with Xuanzang, perhaps the greatest of the translator monks was Kumarajiva, who was born into an aristocratic family of Indian descent in the Silk Road state of Kucha in the late fourth century. At the age of nine this child prodigy traveled with his mother throughout India, studying with Buddhist masters and gaining renown for his brilliance in debate. He was said to be able to memorize thirty thousand words of sutra text per day; by the time he was a young man, he had committed much of the Buddhist canon to memory.

In about 401, Kumarajiva journeyed to China, probably passing through Dunhuang. He spent twelve years in Chang'an, where he is said to have translated some fifty works running to more than three hundred volumes. His elegant translation of the Lotus Sutra was fashioned in the summer of 406 at a great congress attended by more than two thousand monks. Over the last fifteen hundred years, it has been read by more people than any other translation of this important text; and, like many of his translations, it remains unsurpassed.

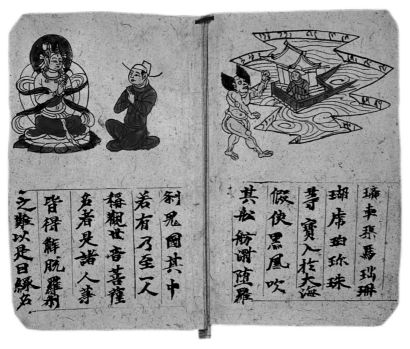

Pages from a tenth-century booklet of the Guanyin Sutra, with illustrations helpful to those who were illiterate or semiliterate. The booklet form made this sutra easier than a scroll to carry and consult.

By permission of The British Library, Or.8210/s.6983

most vividly illustrated manuscripts from the Library Cave, shows the incorporation of indigenous Chinese beliefs—such as the belief in hells—into the Buddhist worldview. The text was not included in the official Chinese Buddhist canon, but it was nevertheless quite popular in Late Tang China. There are over thirty copies dating from the tenth century among the Dunhuang manuscripts; many contain dedicatory prayers revealing the importance of this text to the local population.

Another important feature of Chinese Buddhism, the popularity of schools and sects that did not require their acolytes to become monks or to adopt rigorous lifestyles, is exemplified by the Vimalakirti Sutra. This text became popular in China largely because the protagonist is a learned layman more proficient in debate than even the most important bodhisattvas. It was first translated into Chinese in the early third century; another five translations—including two by perhaps the most famous translators in China, the Kuchean monk

Kumarajiva and Xuanzang—had appeared by the middle of the seventh century. Other translators included Indo-Scythians, a sinicized Indian, and a relative of the Kuchean ruling house.

While many of the scrolls found at Dunhuang were made in the Chinese capital, others were copied locally. It was common, for example, to pay for the copying of a sutra on the death of a close relative. Sometimes this is simply stated in the colophon, as in the case of the assistant commissioner of the military post at the nearby Jade Gate, who gives his name and official titles and reports that the sutra was copied in 759 "on behalf of his deceased wife, Madame Shang." Others use the opportunity to offer more general prayers, on behalf of all their ancestors or even for "all living beings in the whole universe." In other instances, the sutra is copied for the ill or otherwise afflicted. And sometimes it is offered as thanks—as in the case of a soldier based at a frontier garrison who had part of the Lotus Sutra copied in 880 "in fulfillment of a vow made while on military service in the heart of Tibet."

Monasteries, however, were much more than centers of worship and scholarship. In Dunhuang, as in the rest of medieval China, they played a central role in the life of the community. For example, they apparently formed clubs for lay believers, including some for women, whose activities included organizing discussions of sutras. Extant circulars not only record the date, time, and place of their meetings but also specify a penalty (usually a jug of wine or a bowl of grain) to be paid by latecomers. These clubs also provided insurance: Members would make regular payments of grain or other commodities and in return would call upon the club in times of hardship. Sometimes a club would even supply a funeral fund.

Monasteries also acted as inns for travelers and offered grain from their stocks to the poor. And on special days they would hold fairs, with stalls selling copies of sutras, prayer sheets, and various charms. Prayer sheets were also written on request for individuals, like the sixty-four-year-old woman who asked the god Rahu for protection against misfortunes, "which appear as fast as lightning."

The thousands of secular documents found in the Library Cave are practically the only primary sources for this period in Chinese history. Extensive historical records kept by Chinese officials were distilled into officially written histories that have become the main source for scholars. (The initial records were usually destroyed.) This process was dominated by the educated elite—court-centered literati—who recorded the material, selected what to use, and compiled the final versions. Consequently, the official dynastic histories afford a view into the very select world of official court life. Moreover, the picture presented in these histories—of a China inhabited by scholar-officials, valiant generals, and wise if flawed emperors—is largely a secular world, as well as one practically devoid of women.

The documents from Dunhuang, however, present a totally different picture, offering a glimpse into the lives of ordinary people. They show a people concerned with the basics of everyday life—the price of a donkey, how to write a letter to a bereaved friend, women's clubs, the weather—as well as a people concerned with what may be beyond life. They show both the mundane and the transcendent. And they show a China pervaded by religion—by monks and nuns, monasteries, and private and public religious ceremonies. Since the protagonists come from all walks of life, including officialdom and the educated

Embroidered fragment of a silk patchwork, probably a kasaya, or monk's robe, found in the Library Cave.

© Copyright The British Museum, BM MAS 856

The tenth-century Sutra of the Ten Kings tells the story of King Yama and the nine other lords of the underworld who judge the dead. It teaches the ritual ceremonies necessary for the devout to reach the Pure Land of Amitabha and describes the tortures meted out in the afterlife to those who have not acted in accordance with Buddhist tenets. Four bodhisattvas grace a section of text. These manuscripts were probably read and chanted, as well as shown to the faithful to inspire piety.

Pelliot chinois 2003-2. Courtesy Bibliothèque nationale de France, Paris

The Oldest Dated Printed Book in the World

Frontispiece and first section of the Diamond Sutra.

By permission of The British Library, Or. 8210/p.2

Among the manuscripts in Cave 17 were a small number of printed items. One of the earliest uses for paper, which according to the official Chinese annals was invented in 103 C.E., was for rubbings of the Confucian classics, which had been engraved in stone in order to provide official and unalterable versions of the texts. A further step was the creation of stamps, similar to the rubber stamps of today, which were used to print sheets filled with small Buddha images. Stencils were also used for this purpose. The repetition of Buddha images and Buddhist texts was a sacred act for believers, who paid monks to copy sutras and painters to produce banners or wall paintings—a practice also reflected in the murals at Mogao. Such practice may have inspired the printing of multiple copies of Buddhist sutras—and, perhaps, inspired the invention of printing itself.

The most celebrated printed item found at Mogao is a ninth-century copy of the Diamond Sutra, one of the central texts of Mahayana Buddhism. Though small examples of printing, such as repeated rows of tiny Buddha figures, survive from a slightly earlier period, this, the first known complete scroll printed by the woodblock method, is the world's first dated printed book. A text was first written in a good hand on thin paper, with brush and ink. The text was then pasted, face down, on a block of hard, fine-grained wood, and the plain parts of the paper, along with the wood, were cut away, leaving the reversed text in relief. The block was inked, and sheets of fine paper were pressed against it to take the ink impression. Then the sheets were pasted together to form a scroll more than eight meters long.

The Diamond Sutra of Dunhuang is one of the world's great treasures. The beautiful frontispiece depicts the Buddha, surrounded by saints and attendants, with apsarasas flying over his head,

a table of silver altar vessels in front of him, and two small lions at his feet. In a corner of the illustration, an elderly monk named Subhuti is shown sitting on a prayer mat; his black cloth shoes are placed neatly beside him. The sutra relates Subhuti's questions to the Buddha about the significance of existence and recounts the Buddha's answers concerning the illusory nature of life: "This fleeting world is like a star at dawn, a bubble in a stream, a flash of lightning in a summer cloud, a flickering lamp, a phantom, and a dream." Remarkably, the world's first printed book was to be given away: The last few lines of the colophon read, "Reverently made for universal free distribution, on behalf of his two parents, by Wang Jie on the fifteenth day of the fourth month of the ninth year of the Xiantong reign"—or May 11, 868.

Chinese elite, the manuscripts point to Buddhism's infiltration of all levels of society, including those previously thought to have remained Confucian.

The Dunhuang documents, however, also suggest that Buddhist theory and practice often diverged. Whereas vinaya texts representing official Buddhism state that monks and nuns could not own property, for example, one manuscript notes that a novice has borrowed a large amount of money from an ordained monk, promising to repay interest at 10 percent per month, with principal and interest repayable on demand. If the novice does not make his payments, his property will be seized. Many nuns and monks were quite poor, as shown by a contract drawn up in 803, in which a fifty-eight-year-old nun, "on account of her lack of food and her outstanding debts," agrees to exchange a black cow, "in perfect condition," for wheat and millet.

Other contracts give a wrenching idea of the basic subsistence level of many farmers, who at times had to turn to charity. Farmers, as well as clergy, are forced to borrow grain for sowing, presumably having used up the previous year's store. There are contracts for items as small as a cooking pot. There is even a funeral address for a donkey.

Slightly wealthier families could afford servants or laborers, as in the case of a Mr. Zhang, who, "lacking able-bodied young men in his own family," hired a Mr. Yin for the agricultural season, in return for a "suit of spring clothes with long sleeves and a pair of unlined leather shoes." Rolls of silk were common currency; a slave girl, for example, was passed from one family to another for three pieces of raw silk and two pieces of spun silk, in payment of an outstanding debt.

The Dunhuang manuscripts depict a world in which sickness and death were

Almanac dated 877 showing the animals of the Chinese "zodiac"; a feng shui, or geomantic diagram; and a lucky charm.

By permission of The British Library, Or.8210/p.6 (detail)

Prayer sheet depicting the god Rahu. Prayer sheets were produced for the faithful upon request, or they were sold at fairs held on monastery grounds. The popularity of Rahu—a deity not in the traditional Buddhist pantheon—illustrates the eclecticism of Chinese Buddhism.

By permission of The British Library, Or.8210/s.5666s

Yesterday, having drunk too much, I was so intoxicated as to pass all bounds; but none of the rude and coarse language I used was uttered in a conscious state. The next morning, after hearing others speak on the subject, I realized what had happened, whereupon I was overwhelmed with confusion and ready to sink into the earth with shame. It was due to a vessel of my small capacity, on that occasion, being filled too full. I humbly trust that you in your wise benevolence will not condemn me for my transgression. Soon I will come to apologize in person, but meanwhile I beg to send this written communication for your kind inspection. Leaving much unsaid, I am yours respectfully,

Model letter of apology to send to one's host after having drunk too much, ca. 1000.

tions the "fuel depot controller." Another recounts the retaking of the Dunhuang area by the Chinese in 848, following almost a century of Tibetan rule. And there are several reports on the precarious military situation in northern China at this time, reports that would have been seen by the emperor himself.

Among the printed items, in addition to the ninth-century copy of the Diamond Sutra, were copies commissioned a century later by the military governor of Dunhuang. He also commissioned printed prayer sheets, such as one from the year 947, whose inscription refers to the uncertainty and unrest that followed the collapse of the Tang dynasty forty years earlier: "The disciple Cao Yuanzhong, military governor of the Returning to Allegiance District,... and for the suppression of the Tibetans specially promoted, ordered this block to be carved for printing... so that the city god may enjoy peace and prosperity,... that evildoers north and south may be reformed,... that the sound of the war gong no longer be heard, and that pleasure attend both eye and ear."

Finally, nestled among the tens of thousands of manuscripts in the Library Cave were some eighty texts of popular literature—ballads, songs, chants, and lyric forms of poetry previously unknown to scholars. Storytellers would often recite ballads in public while holding up a sheet of paper that was illustrated on one side, for the audience to see, while they read from text on the other side. These manuscripts have greatly influenced the study of popular genres in Chinese literature, which may have originated from religious stories recounted by monks to convert people to Buddhism.

There remains the mystery as to why the cave was sealed during the early eleventh century. One possible answer is that these

always present. There are prayers and lamentations for the ill or deceased, letters to monasteries asking for services and prayers for the dead, wills, diagrams of tomb sites, official reports on local plagues, and medical texts. There are also model condolence letters that could be copied and sent to the bereaved.

Some letters, however, show the lighter side of life in this Silk Road oasis. One contains a model letter of apology that a transgressor could write to his host after having gotten drunk at a dinner party the night before.

Other manuscripts tell us about the line of watchtowers that guarded the frontier. One details the consumption of tamarisk wood at beacon stations and men-

This drawing of a lion is wholly Buddhist in character. The voice of Shakyamuni was likened to a lion's roar, and the lion's golden mane and coat were used as a metaphor for the omnipresence of Buddha-nature in the universe.

© *Copyright The British Museum, OA 1919.1–1.016 (Ch. 00147)*

Many manuscripts discovered at Mogao had Chinese text on one side and Tibetan on the reverse. The Tibetan text here combines historical narrative with lyrical chants that sing the praises of the Tibetan king under whose rule Dunhuang was conquered. The text reports that "law was excellent and the kingdom widespread. The incomparable religion of Buddhism had been established, and through faith, the devout were freed from birth and death."

Pelliot tibétain 1287. Courtesy Bibliothèque nationale de France, Paris

texts may have been old library copies of the sutras, which, as sacred texts, could not be destroyed but which, when new copies were obtained, would have been sent to storage. Recent scholarship has also suggested another possibility. In 1006, when Islamic forces from Kashgar conquered the Buddhist city-state of Khotan, an ally of Dunhuang, it must have seemed as if the age of Buddhism were finally coming to an end. These Islamic forces did not reach Dunhuang, which was absorbed a few decades later into the Buddhist Tangut empire. Following the Yuan dynasty of the Mongols, however, the area would eventually become Islamic in culture. Without the treasures of Cave 17, we would know far less about its Buddhist past; indeed, we would hardly believe that this remote site was once a cosmopolitan capital on the great Silk Road.

NOTES

1. *Ruins of Desert Cathay*, 2:176.
2. Daisaku Ikeda, *The Chinese Flower of Buddhism* (New York and Tokyo: Weatherhill, 1986), 24.
3. Ibid., 24.

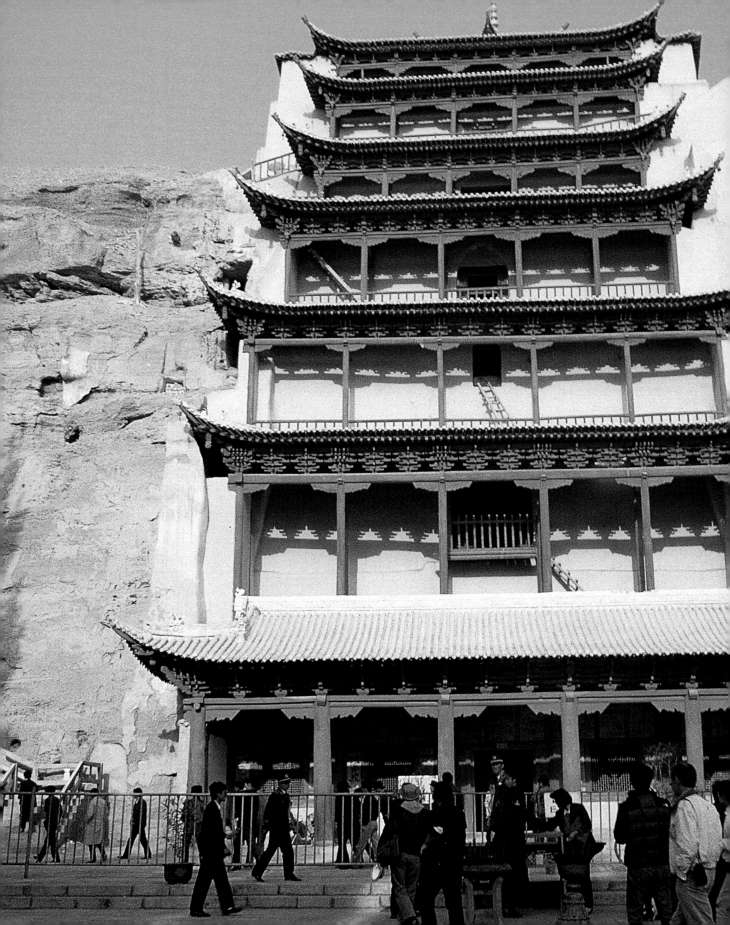

The Art Gallery in the Desert

The road south from Dunhuang to Mogao follows the course of the Daquan River, which flows past the grottoes before it is swallowed up by the Gobi Desert. After passing the section of the cliffside caves that was once used by resident monks as living quarters, the road ends. A walking bridge leads over the river through the main *pailou*, or traditional Chinese gate, to the precincts of the cave temples. This area is dominated by the nine-story pagoda that is the centerpiece of Mogao today.

The landmark nine-story pagoda encloses Cave 96, which houses a colossal Tang dynasty Buddha statue, some thirty-three meters high.
Photo by Guillermo Aldana, 1991

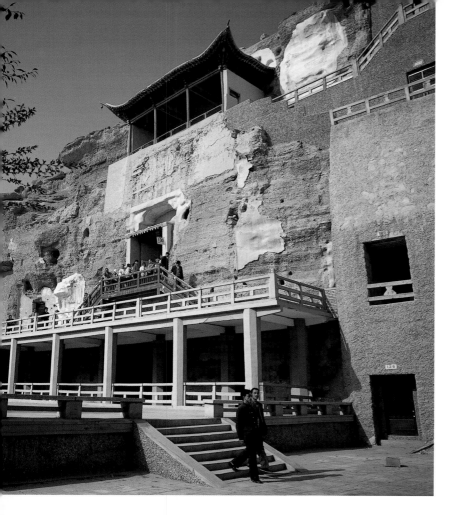

A group of visitors at the renovated entrance to Cave 130. Inside this multistory cave is the great Buddha statue shown on page 7.

Photo by Dusan Stulik, 1991

In caves that are open to the public, movable glass screens protect the wall paintings.

Photo by Neville Agnew, 1999

The setting under the cliff face offers an environment for quiet reflection. Large poplar trees—some planted by Abbot Wang in the early twentieth century—provide welcome shade for summer visitors. The Dunhuang Academy has undertaken extensive landscape work, as well as restoration of Abbot Wang's temple and dwelling, just a few paces from Cave 17. Abbot Wang died in 1931, and his memorial stupa, made out of dried mud from the Daquan River, is located near the main entrance, together with stupas of several of the monks who lived at Mogao long ago.

In recent years Mogao has become an increasingly popular tourist destination. The Dunhuang Academy is concerned about the impact this may have on the site, which is open eight hours daily throughout the year. The academy therefore strives to maintain a balance between visitation and protection. Access to the caves is carefully controlled, with guides conducting tours of the grottoes in groups of ten to twenty people. Each person carries a flashlight, and movable glass screens protect the wall paintings.

The academy's program of research, protection, and preservation began more than fifty years ago. During the 1940s, work was begun stabilizing caves on the verge of collapse and clearing sand that had accumulated over the centuries. Six previously unknown caves and some six hun-

dred scrolls were discovered at that time. The first site management department was established in the early 1950s. In the decades that followed, the present-day concrete facade was built on the southern section of the cliff face, where the decorated caves are situated. The academy has also carried out extensive documentation work and scientific research—the results of which have been published in more than one thousand scholarly articles and scores of books—and sponsored a number of international conferences.

To address the issue of increasing visitor numbers, the academy has erected an exhibition hall with ten full-scale, hand-painted replicas of important caves, including Cave 285, as well as caves from the Wei, Sui, and Tang dynasties. Since the actual grottoes are not artificially lit and visitors must examine the murals by flashlight, a well-lit, beautifully exact replica allows visitors to experience the total aesthetic of a cave, thereby enriching their experience of the real thing.

The copying of classic artworks has a venerable pedigree in China: it is an act of reverence, a way of becoming deeply imbued not only with the technique of the art but also with its spirit. At Mogao, the practice of copying wall paintings dates back to the 1940s. Today the replication section is one of the academy's important departments (the others include conservation, archives, visitor management, and art-historical research). Replica murals fashioned by the academy's artists have been shown in major exhibits throughout China, as well as in Japan, India, and Europe. A comprehensive exhibition, for example, was mounted in July 2000 at China's National History Museum, on Tiananmen Square in Beijing, to commemorate the centenary of the discovery of the Library Cave.

To a limited extent, Mogao is being used again as a site of veneration. The vestiges of the Buddhist historical record from the early imperial cities of Chang'an and Luoyang have been lost, and in this regard Mogao has acquired particular significance. Incense can be burned outside the great pagoda, and many visitors come from China and abroad, especially Japan, to seek the roots of their faith.

The Dunhuang Academy is responsible for the management of several smaller cave-temple sites in the Dunhuang region, as well as for the Yulin grottoes, about 170 kilometers to the east. Although smaller than Mogao, Yulin nonetheless contains a wealth of wall paintings, most of which date from the Tang and Song dynasties. While the Yulin murals are generally quite similar to those at Mogao, they contain some features that are extremely rare at the larger site, such as named self-portraits of

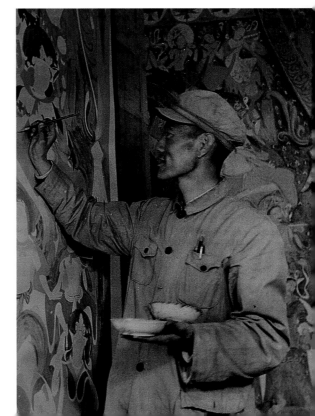

Duan Wenjie, former director of the Dunhuang Academy, painting a replica mural in the late 1940s, soon after his arrival at Mogao.
(Photographer unknown.) Courtesy Dunhuang Academy

This replica of the statue of the monk Hongbian, along with replicas of ten caves, can be visited in the exhibition hall. The gallery also contains silk and wooden artifacts, as well as the inscribed stone tablet recording the establishment of Mogao by wandering monks in the late fourth century.

Photo by Neville Agnew, 1999

Stupas mark the tombs of monks from centuries past who are buried at Mogao.

Photo by Neville Agnew, 1999

the artists. In addition, the academy provides conservation expertise to other ancient Buddhist sites far to the west, such as Kizil, where the devout also prayed long ago. Its work is enhanced by collaboration with such international organizations as the Getty Conservation Institute. The new methods of site conservation and management being developed at Mogao will thus find broader application, as they are carried both east and west through the region once traversed by the caravan routes known as the Silk Road. In various ways, the traditions of this ancient artery of knowledge and belief are being kept alive. The monks and pilgrims of ages past undoubtedly would have approved.

Suggested Reading

Books

Agnew, Neville, ed. *Conservation of Ancient Sites on the Silk Road.* Los Angeles: Getty Conservation Institute, 1997.

de Silva, Anil. *The Art of Chinese Landscape Painting in the Caves of Tun-huang.* New York: Crown Publishers, 1964.

Grousset, René. *Chinese Art and Culture.* Trans. Haakon Chevalier. New York: Orion Press, 1959.

Hopkirk, Peter. *Foreign Devils on the Silk Road.* Amherst: University of Massachusetts Press, 1980.

Mair, Victor H. *Tun-huang Popular Narratives.* Cambridge: Cambridge University Press, 1983.

Museum national d'histoire naturelle de Paris. *Chine: Fresques du désert de Gobi* (catalogue for exhibit of replica paintings). Paris: Editions du Centre national de la recherche scientifique, 1983.

Seckel, Dietrich. *Buddhist Art of East Asia.* Trans. Ulrich Mammitzsch. Bellingham: Western Washington University, 1989.

Stein, M. Aurel. *Ruins of Desert Cathay,* 2 vols. 1912; rpt., New York: Dover Publications, 1987.

Waley, Arthur, trans. *Ballads and Stories from Tun-huang: An Anthology.* New York: Macmillan Company, 1960.

Warner, Langdon. *The Long Old Road in China.* New York: Doubleday, Page & Company, 1926.

Whitfield, Roderick. *Dunhuang: Caves of the Singing Sands,* 2 vols. London: Textile and Art Publications, 1995.

Whitfield, Roderick, and Anne Farrer. *Caves of the Thousand Buddhas: Chinese Art from the Silk Route.* London: British Museum, 1990.

Whitfield, Susan. *Life along the Silk Road.* Berkeley: University of California Press, 2000.

Whitfield, Susan, ed. *Dunhuang Manuscript Forgeries.* London: The British Library, 1999.

Whitfield, Susan, and Frances Wood, eds. *Dunhuang and Turfan: Contents and Conservation of Ancient Documents from Central Asia.* London: The British Library, 1997.

Wriggins, Sally Hovey. *Xuanzang: A Buddhist Pilgrim on the Silk Road.* Boulder, Colo.: Westview Press, 1996.

Articles

Agnew, Neville, and Fan Jinshi. "China's Buddhist Treasures at Dunhuang." *Scientific American,* July 1997.

Brysac, Shareen Blair. "Last of the Foreign Devils." *Archaeology,* November/December 1997.

Caswell, James O. "Legacy of Dunhuang: Appreciating a Millennium of Art at the End of the Silk Road." *Archaeology,* November/December 1997.

Shor, Franc, and Jean Shor. "The Caves of the Thousand Buddhas." *National Geographic* 94, no. 3 (March 1951).

Websites

International Dunhuang Project at The British Library (http://idp.bl.uk).

Central section of a painting on silk showing the bodhisattva Guanyin with eleven heads and forty hands. Five Dynasties.

Photo by Madan Mahatta. Courtesy National Museum, New Delhi

Acknowledgments

The long-standing partnership between the Getty Conservation Institute (GCI) and the Dunhuang Academy grew out of a common belief in the importance of the Mogao grottoes as a cultural heritage site of great historical and artistic significance. With its extraordinary range of material heritage, including murals, statues, and manuscripts, Mogao presents the complexity and richness of more than one thousand years of Chinese art and history. It is critical that this place, universally recognized by its listing as a Unesco World Heritage site, be preserved for future generations. So, too, is it important to develop conservation methods that can also be applied to other ancient sites along the Silk Road. As an extension of the Getty's conservation work at Mogao, this book seeks to bring to a wider audience the extraordinary story of this site and its cave temples.

The conservation project and the book that grew out of it would not have been possible without the dedicated work of many people and the unstinting collaboration of several institutions. First and foremost, we would like to thank the Dunhuang Academy and its director, the noted archaeologist Fan Jinshi. She succeeded the academy's former director, Duan Wenjie, and has dedicated her professional life to Mogao since her arrival there in 1963. Li Zuixiong, head of the academy's Conservation Institute and a leading authority on conservation science as applied to the preservation of grotto sites, has been a fine colleague. Wang Xudong, deputy director of the academy's Conservation Institute, along with Li Yunhe and the rest of the staff have proved valued colleagues as well. We gratefully acknowledge the assistance of Zhang Bai, deputy director of China's State Administration of Cultural Heritage, who has provided the support essential for the success of the continuing collaboration between the Dunhuang Academy and the GCI. Huang Kezhong, vice director of the China Institute of Cultural Property, and staff member Zheng Jun are recognized for their continuing participation in the work of the joint team at Mogao.

A number of GCI staff and consultants have worked with great dedication on the GCI's conservation projects at Mogao. I am extremely grateful to Neville Agnew, who has played an instrumental role in the successful collaboration between the Dunhuang Academy and the GCI. We express our thanks to Shin Maekawa, Michael Schilling, Po-Ming Lin, Francesca Piqué, Leslie Rainer, and Stephen Rickerby for their

fine work over the years. Valerie Greathouse, Thomas Shreves, Jane Fujimoto, and Nanda Prato have assisted with bibliographic research and photo archiving.

Several institutions have provided photographs for use in this book. Our gratitude is once again extended to the Dunhuang Academy. We would also like to gratefully acknowledge the British Library and the British Museum, in London; the Bibliothèque nationale de France and the Musée Guimet, in Paris; the National Museum, in New Delhi, India; and the Arthur M. Sackler Museum, Harvard University, in Cambridge, Massachusetts.

The following people also deserve mention for their contributions to this book: Janet Baker, Bowers Museum of Cultural Art, Santa Ana, California; Monique Cohen, Bibliothèque nationale de France; Anne Farrer, British Museum; Asoke Ghosh, Prentice-Hall, India; Jacques Giès, Musée Guimet; Lev Menshikov and Yuro Petrosyan, Russian Academy of Sciences, St. Petersburg; Robert Mowry, Arthur M. Sackler Museum, Harvard University; Jitendra Nath, National Museum, New Delhi; Bent Pedersen, Royal Library of Copenhagen; Abby Smith, Harvard University Art Museums; and David Way, British Library.

We would like to thank Chris Hudson, director of publications at the J. Paul Getty Museum, for his valuable counsel throughout the making of this book. Frances Wood, head of the Chinese Section at the British Library, contributed the benefit of her vast knowledge of the printed documents found in the Library Cave. We extend our gratitude to Wu Jian, of the Dunhuang Academy, and Lois Conner, who together provided most of the fine photographs of the cave shrines seen in these pages. Sylvia Tidwell and Paul Lipari provided valuable assistance. Special thanks go to Vickie Karten, who designed this book, and to Anita Keys, who coordinated its production. Finally, a particular debt of gratitude is owed to the volume's editor, Tevvy Ball, who developed the manuscript for a general audience—restructuring the text, requesting additional photography, and generally ensuring that the remarkable story of the Mogao cave temples be well and fully told.

Timothy P. Whalen
Director, The Getty Conservation Institute

Two tigers. Ceiling of Cave 428 (detail). Northern Zhou dynasty.
Photo by Wu Jian, 1999